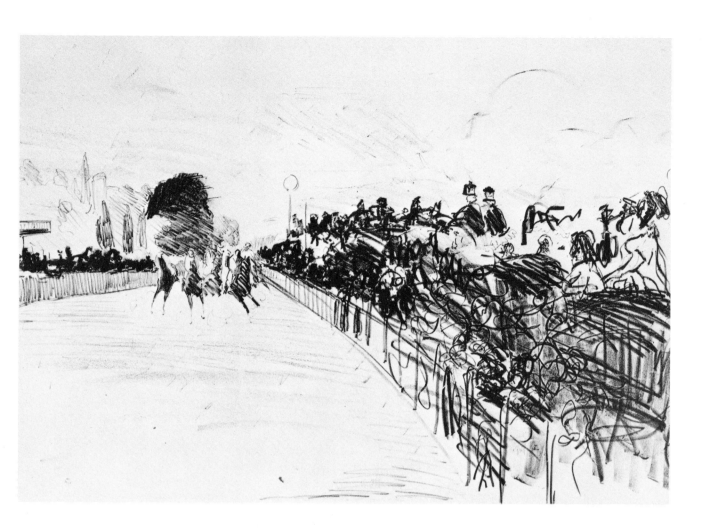

LITHOGRAPHIC
PRINTS from STONE and PLATE

BY MANLY BANISTER

STERLING PUBLISHING CO., INC. *New York* *Oak Tree Press Co., Ltd.* London & Sydney

OTHER BOOKS BY THE SAME AUTHOR

Etching (and Other Intaglio Techniques)
Prints—from Linoblocks and Woodcuts

DEDICATION

To David A. Boehm, my publisher, whose singular ability to get
around every objection has been the motivating force in making
this book possible.

CONTENTS

Just a Word Before You Begin

This is a book for the beginner-lithographer, for the artist who, sensing that he or she is missing something, has turned aside to investigate the graphics field. You are not expected to know anything at all about lithography, so instruction has been simplified down to step-by-step details that are made even more plain with photographs and drawings.

The pictures are not intended to glamorize operations with shots of roomy, super-equipped studios and print shops such as only a large, educational institution can afford. They do tend to show, however, how you, too, can make lithographic prints in whatever small space is at your disposal. They show litho stones that you can pick up in both hands and move around. You don't need a lift truck to cart them across the room. If you cannot afford a large, commercial-type press, this volume also shows you how to construct a small press, made in the design of a box, after an original design invented by Senefelder himself and used throughout Europe by the earliest lithographers.

The lithographic process was developed at the start of the 19th century by Aloys Senefelder (1771–1834), a Bavarian actor and dramatist. He found printing costs too high to be able to afford enough copies of a play to go around the cast, and he searched for a cheap means of printing his own. If Senefelder were alive today, he would find himself confronted by that same old problem—cost.

Lithography is the most recent development of all the various methods that have been used to print text and pictures. Printers began with the woodcut, turned to the copper engraving, the etching, the wood engraving, and to movable type. Then Senefelder came along and in fifteen years developed a process whereby, out of an improbable mixture of chemistry and physics, of art and craft, of skill and luck, it became possible to print many examples of an illustration drawn flat upon a perfectly plane surface of stone.

In the course of his experiments, Senefelder was often without money and unable to proceed. Yet, in his desperation to develop this new method of printing, he somehow felt that he was bound to succeed. It was "lithography time" and Senefelder was self-chosen to bring it into existence.

At one time, Senefelder's funds were so low that he decided literally to sell himself into slavery by joining the German Army, which was then recruiting in a nearby village. He told himself that he would get himself assigned to the Army's printing department, where he would have access to the presses and materials he needed to forward his experiments. To avoid having the call of duty interfere with his precious research, he figured out how he could hire one of his military companions to stand his tours of duty. He would pay such fellows out of the money the Army paid him and still have enough left over for his needs.

He walked all the way to the town where recruiting was under way, but, fortunately for him, the recruiting officer told him that the Army was only for Germans. Being a Bavarian, he was ineligible to join. (This was before the unification of Germany in 1848.)

The fundamental upon which the lithographic process rests is a plain one: The simple fact that water repels grease. If you draw upon a smooth hard surface with a greasy substance, then wet the surface and roll an ink roller covered with greasy ink across it, the ink will adhere only to the original grease and not to the wet surface.

With this in mind, the inventor had to discover a method by which the original drawing, done in grease pencil, could be made to adhere to the hard surface (in this case, a stone) without dissolving when water was applied. The chemical process of "etching" the stone with nitric acid solved the problem by fixing the drawn image to the stone and rendering it no longer water-soluble.

Some of Senefelder's earliest experiments were performed with printed sheets of paper, first wetted, then rolled with ink and printed. The ink adhered to the printing already on the paper and printed off readily enough. In fact, he could get about fifty copies before he had to give up. The only fault was that printed matter came out backwards and was therefore useless.

Stone lithography grew to become a widespread success towards the end of the 19th century and even lingered on into the 20th. However, offset lithography, utilizing thin, metal plates and high-speed printing machines, along with the photographic transfer of images, washed out stone lithography as a practical industry.

Stone lithography and the equivalent method used on plates are practiced today only by students and practicing graphic artists.

As paint and canvas respond to the skilled painter's brush, as marble responds to the sculptor's chisel, as pen or pencil and paper respond to the draughtsman's skill, so also the stone and chemicals, the inks and papers of lithography respond to the artist-lithographer's knowledge, to his skill, his artistic integrity, and his determination.

In former times, the artist-lithographer had to know little beyond how to set his drawing down upon the stone. After that, a commercial printer took over, processed the stone and printed it. There were, perhaps, a few cases where the artist did his own spadework, but never out of necessity. Today's artist-lithographer has to perform the whole show and, in doing so, he makes a virtue of necessity; for the graphic artist would be hard put to find a commercial printing house almost anywhere in the world having either the equipment or the knowledge necessary to print his stones for him.

If you, as a prospective student of lithography, have had experience with other forms of graphic art, such as woodcut and linoleum block, etching or engraving, you have a useful background in some of the mechanical problems you will meet with. You should know, however, that of all the graphics fields open to the artist, lithography is the most difficult. Not that there is anything about it that is hard to learn; it is just that the chemical process has an uncertain way of acting and can sometimes give you more difficulty than results.

From graining the stone to pulling the final proof, there are many places where the process can go wrong. The temperature must not be too hot nor too cold, the humidity range neither too dry nor too wet; the acid-etch too strong or too weak; the printing pressure too light or too heavy; the ink too soft or too stiff, and so on. Yet in spite of all these negative factors, there is indeed a wide range of tolerance in the elements involved in processing a stone or plate. Every time you produce an image on a given stone, it can react differently. The processing can take on variations of one kind or another, providing you with a challenge such as you will meet up with in no other artistic enterprise. And when you meet the challenge head on and conquer it—your victory is readily visible in the quantity and quality of the prints you pull from the stone.

If your taste runs to doing the things that not everybody can, then lithography is surely the right medium of expression for you. In the following pages, you will find a way that is not an easy one to travel, but it is so well marked that you should have little difficulty in reaching your goal.

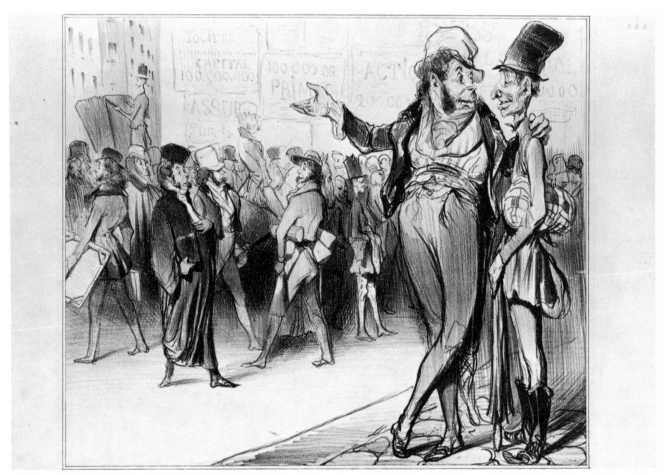

Illus. 1—"All the same, it is flattering to have made so many disciples—" (lithograph, 1838) by Honoré Daumier (French, 1808–79). The National Gallery of Art, Washington, D.C. Rosenwald Collection.

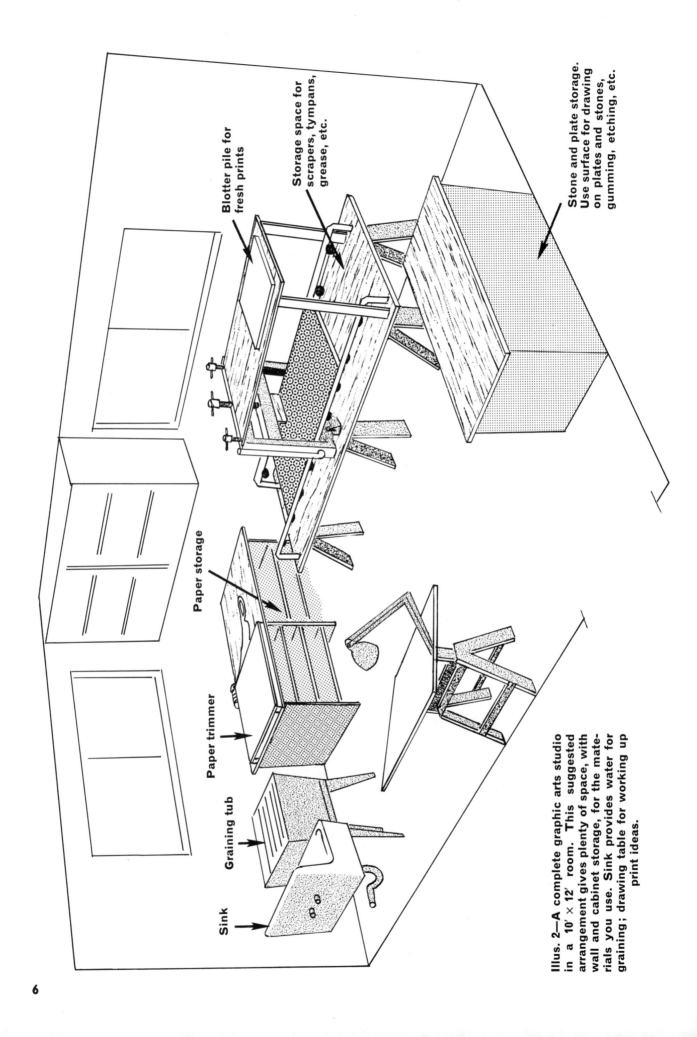

Blotter pile for fresh prints

Storage space for scrapers, tympans, grease, etc.

Stone and plate storage. Use surface for drawing on plates and stones, gumming, etching, etc.

Paper storage

Paper trimmer

Graining tub

Sink

Illus. 2—A complete graphic arts studio in a 10' × 12' room. This suggested arrangement gives plenty of space, with wall and cabinet storage, for the materials you use. Sink provides water for graining; drawing table for working up print ideas.

6

1. FIRST CONSIDERATIONS

Your Own Graphic Arts Studio

Where will you make your prints? In the basement? On the ground floor of your home? In an unused, upstairs bedroom? Or out in the garage? You will probably have to build your studio around your press and the size and weight of that piece of machinery largely determines where it shall be put. If you plan to use very large stones that are very heavy, you will have to have a large press, heavily and sturdily built. You might be able to get such a press into a basement if you took it apart and carried it down piecemeal; but you are better off to establish a very large press some place like the garage, where the cement floor will easily support it.

A light- or medium-weight press might be installed in a basement, particularly if it doubles as a garage, or otherwise has wide doors opening directly upon the out-of-doors to facilitate getting the press inside. If you have no basement, or prefer a ground-floor location, you must position the press so as to protect the wooden floor. Place the press against an outside wall so that its bulk weighs upon the floor supports where they rest on the concrete foundation.

An upstairs room must be ruled out by reason of poor support for the press and the difficulty of carrying a press upstairs—unless, of course, your press is to be the little Senefelder box press described in Chapter 6. That you can put anywhere as it hardly weighs at all.

Illus. 2 shows a possible studio-print-shop arrangement in a room measuring only 10 × 12 feet. It is possible to make do with less room; it is desirable to have more if you can manage it.

The press indicated in the drawing is a lightweight, combination press (for block printing, printing etchings, and lithography). It weighs about 500 lbs. Any medium-weight press, however, can be installed in its place.

As all the work at the press is done at the left-hand end, as you face it, you can gain valuable storage space by fixing a plywood shelf over the right-hand end, as shown. Here is where you will put your backing and tympan out of the way when removing a proof from the stone, and where you keep the pile of dry blotters in which you place your damp prints as fast as you print them.

On the bench next to the paper cutter, which is pushed back into the corner while you print, will be your paper damping pile, from which you will take paper, sheet by sheet, as you print.

Not shown in the diagram is the portable ink slab (see Illus. 60), which you can store in the corner off the right-hand end of the press and bring out to a convenient location beside the press for use. Count your steps and try to keep all your working materials within a range of two or three.

Something else not shown in the drawing is the lighting arrangement. Best are the industrial type—twin-tube, 40 watts each, fluorescent fixtures with built-in reflector and equipped with chains for suspending them from the ceiling. You should have three of them: one over the press, and one over the work table at each end of the room.

Where to Buy Materials

Art supply shops do not generally carry much in the way of supplies for graphic artists beyond a few litho pencils and crayons. You will have to depend mostly on the professional suppliers of graphic materials, with mail-order headquarters located in various places. Get their names and addresses from the display ad columns of any practical artist's magazine. There is probably a copy at your public library.

You can buy nitric acid by the 1-lb. (approx. a pint) bottle at a chemical supply house in your own city or by mail. You won't need more than a pound, as you use it a few drops at a time. Sometimes, too, you can buy silicon carbide grits from a nearby specialty house. Consult the classified section of your phone book.

Stones or Plates?

The tradition of printing from stones is a difficult one to break. It has about it an aura of romanticism that many of us find appealing. I would urge you to print from stones up to as large as you can conveniently handle without specialized, hydraulic handling equipment. This would be a stone about 14″ × 18″ in size (makes an 11″ × 14″ print), and it would weigh about 75 lbs. For larger prints, use metal plates. They weigh practically nothing.

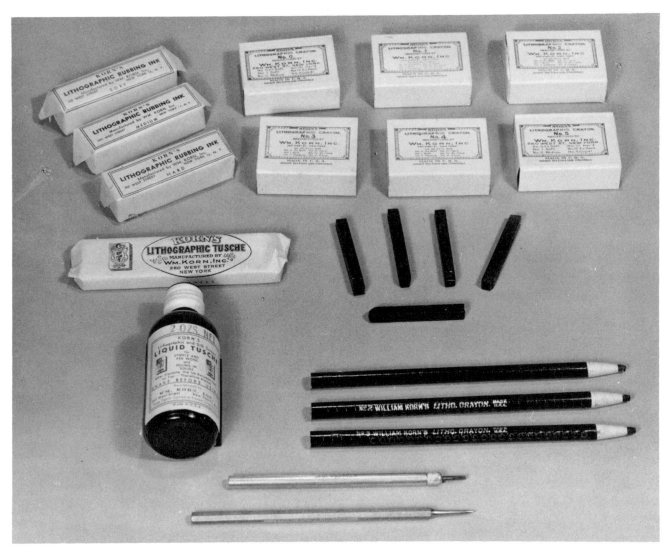

Illus. 3—An array of drawing and corrective materials. (Top) Rubbing ink and all grades of crayons; (left) stick and liquid tusche (drawing ink); (right) litho pencils; (bottom) scraping tools.

In color work, you can use stones for one or two principal colors, and print the rest from metal plates—even from paper plates.

The Lithographic Stone

The word *lithography* is derived from a combination of two Greek words: *Lithos* = stone, and *graphein* = to write. In Germany, where Aloys Senefelder invented the process, lithography is called *Steindruck;* that is, stone printing.

In its heyday, stone lithography was a widespread industry throughout the world. Giant presses were the order of the day, necessary for printing from massive stones of enormous size and weight. The color prints made by the Americans, Currier & Ives, in those days are still coveted by collectors. Some of the gaudy trade lithographs produced around the turn of this century are still to be found in isolated collections.

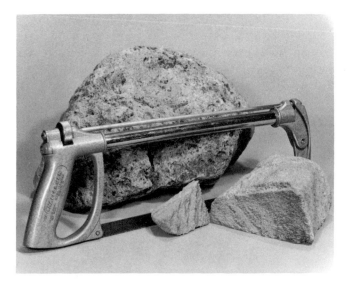

Illus. 4—Pumice, the rock that floats on water. Cut pieces to size with a hacksaw; use them for smoothing the edges of litho stones.

With the invention of the cylinder press, the metal offset plate, and stepped-up production methods, the working of stones became too slow and cumbersome a process to keep up, and so it was discarded.

If you have any qualms about using stone because of its weight, be reassured that the metal plate is at best only a substitute for the stone. The stone provides greater freedom of working. Once your drawing is down, you can change it, remove it, or give it special printing effects simply by scraping with a penknife or similar tool. You cannot successfully scrape a metal plate, and this cuts you off from certain ways of working.

Lithographic stones, both new and used, are available from certain lithographic supply houses. Used stones are as good as new ones, though often overly thin. New stones range from 3″ to 4″ thick, depending on their over-all size. If you buy new stones—at a considerably higher price—you have a choice of yellow ones or grey ones. Yellow stones cost less than grey ones because they are five or six times more plentiful. A yellow stone is softer than a grey one and therefore easier to grind and file the edges of. The grey stone, on the other hand, is capable of receiving a finer grain and can be used to print extremely fine detail.

Still and all, the difference between yellow and grey is not so important, as you can make excellent prints with yellow stones. If you buy used stones, you will not have a choice of color, but must take whatever you get. A stone has to be dry for you to see its true color. When wet, all stones look yellow.

You probably will never see a lithographic stone with a clear, unblemished surface. If it does not show discolorations, there will be one or more hairline "cracks" running across its face. These lines are not cracks at all, of course (Illus. 6). A crack would surely ruin a stone for any purpose other than holding a door open. They are evidence of thin deposits of dark-colored material that occurred from time to time, eons ago, during the period in which the limestone was undergoing formation.

Don't let the hairlines worry you, as they generally do not show up in the print. If you should have a stone that prints such lines, don't throw it away. Keep the fault in mind and, after each inking of the image and before pulling a print, while the stone is still wet, rub the hairline with the tip of a dry forefinger and thus remove whatever ink may be clinging to it. Or, in making the drawing, see to it that the hairline traverses areas of heavy tone or hatching that effectively disguise its presence.

A used stone as thin as 2″ provides a constant risk of breaking every time it is run through the press.

Illus. 5—Label everything you use in lithography. Extreme front left shows some gum arabic crystals in a slate saucer.

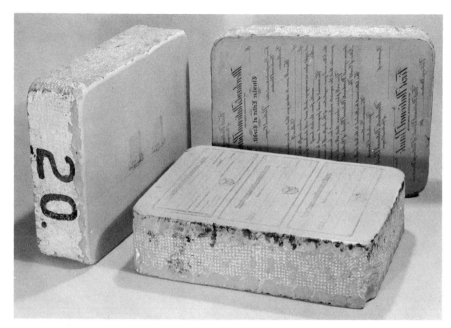

Illus. 6—Typical, small lithographic stones that have been used in the trade for printing documents, checks, letterhead decorations, etc. These stones measure 9″ × 12″, approximately 3″ thick.

That is not saying it *will* break, but if it does, it takes a lot of work with it. To avoid such a disaster, therefore, and to assure a long, useful life for the stone, take it to a stoneyard and have a slab of slate cemented to its back. A 1″-thick slab will give the stone added years of life.

The cementing must be carefully done, of course. The face of the stone and the back must both be plane and parallel to each other. If the cemented stone is not plane-parallel, it will present either of two problems: It will be so far out of parallelism that you will have to grind the face down until it is parallel with the back (or have the job done); or, you will have to use make-ready of some kind every time you prepare the stone for printing (Chapter 9).

Illus. 7 shows a pair of stones that have been backed with slate. Illus. 18 shows one of these that is $\frac{1}{8}$″ thicker under the plunger of the dial indicator than it is at the diagonally opposite corner. A discussion of make-ready for this particular stone is in Chapter 9.

In any case, before using a cemented stone, round off the corners of the slate slab. Slate is soft, so cut them off with a hacksaw, then file them round. Also round off the bottom edges to keep them from cutting into the linoleum on the press bed. Fill the crack between the two sections with some kind of plastic, waterproof filler that will keep out water and grit.

Illus. 7—These typical second-hand stones (measuring 13″ × 17″) were dangerously thin, though usable. The danger of breakage was removed and a long life assured by having a 1″ thickness of slate cemented to the bottom of each stone at a stone yard.

Drawing Materials

You draw on the grained stone with special drawing materials. Illus. 3 shows some crayons (called "chalks" in England), some litho pencils, lithographic rubbing ink, and lithographic *tusche* (adopted from the German word for *drawing ink*). Crayons, pencils and tusche contain combinations of the same materials. Crayons and pencils are graded by number to indicate differing degrees of hardness. You will learn more about these media in the chapters devoted to their use.

Tusche may be bought ready-made and bottled, or as a stick of solid material which must be rubbed off and mixed with water or some non-aqueous vehicle to make a solution useful for drawing and painting.

Ordinary drawing pens and red sable brushes are your means of putting the ink on the stone. Tusche can also be spattered on the stone with a brush, or sprayed with an air-brush, if you happen to possess one.

Materials for Working the Stone

Silicon carbide grits are used for grinding and graining the stone. They are available under several trade names and can be purchased in quantities of 1 or 5 pounds of each grade or grit-size. The cost-per-pound in 5-lb. lots is considerably less than the single-pound price. The higher the number of the grit, the finer it is. The finest you will use are the unnumbered grades designated F, FF, and FFF, increasingly finer in the order given.

Illus. 4 shows some lump pumice. You cut it into easy-to-handle pieces with a hacksaw and use it to smooth the edges of the stone after rounding them off with a file.

Powdered rosin, talc, asphaltum, turpentine, gum arabic, and nitric acid (Illus. 5) are used in chemically processing the drawing to render it suitable for printing from.

The grease shown in the photo is applied to the tympan so that the scraper will slide over it easily. The inks in tin cans (1 lb.) are for rolling in the processed image to strengthen it, and in making the final prints.

Provided with this general picture of what lithography entails, you are now ready to continue with the first step in a long process of operations that will conclude with the production of a lithographic print.

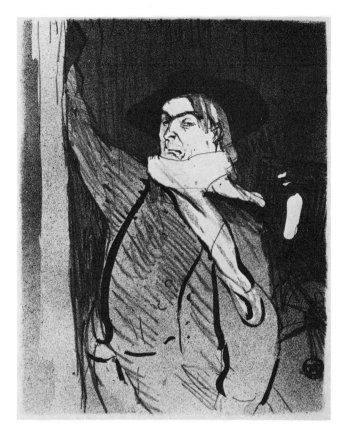

Illus. 8—Lithograph of Aristide Bruant by Henri de Toulouse-Lautrec (French, 1864–1901). The National Gallery of Art, Washington, D.C. Rosenwald Collection. Notice the light and heavy tones produced by splattering tusche with a brush, directly on the stone.

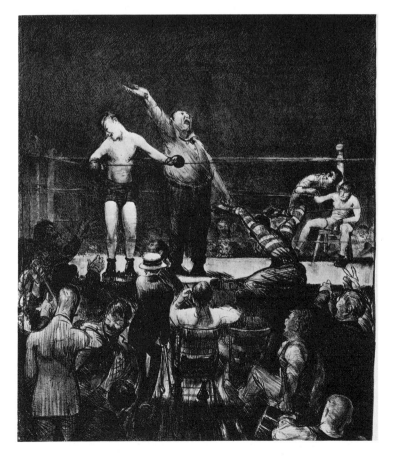

Illus. 9—"Introducing the Champion," lithograph by George Bellows, 1916 (American, 1882–1925). The National Gallery of Art, Washington, D.C. Andrew Mellon Fund. An early painter of the so-called "Ashcan School," Bellows is well known for using boxers and boxing as subjects.

Illus. 10—The sludge shows the track of the figure-8 movement of the levigator as it is moved back and forth and twisted around its central axis in grinding and graining a litho stone. Note the Pyrex disc to which a steel plate has been fixed with epoxy glue.

2. GRAINING THE LITHOGRAPHIC STONE

The Levigator

As long as your litho stones are relatively small and easy to handle, you can lap—or grind—one stone upon another of the same size, with some kind of grinding compound, preferably silicon carbide, between them.

A medium- to large-size stone, however, is too heavy to muscle around in such a manner, and you can either work it over with a smaller litho stone, or use a device called a "levigator" (Illus. 10)—an instrument for making the stone smooth. The levigator is usually a disc of steel, 8″ or 10″ in diameter, fitted with a handle that revolves with your grip. Sometimes, the levigator is drilled through with large holes for the purpose of breaking up suction to keep the disc from grabbing.

First you sprinkle silicon carbide and water on the stone, then lay on the levigator, gripping it by its free-wheeling handle. You then move the device around over the stone in a figure-8 pattern (Illus. 10, 27).

Steel levigators, available from lithographic supply houses, are both expensive and heavy. The 10″ size weighs about 45 lbs. A woman or a slight individual would quickly lose enthusiasm with so much to handle. Presented here is a similar device but lighter in weight (23 lbs.), made from a 12-lb. Pyrex telescope mirror blank and some odds and ends of steel (Illus. 10, 11, 12). You need a Pyrex disc that is moulded with parallel faces in uniform thickness and with square edges for this.*

* Such a disc (Catalog #80,000) is available from Edmund Scientific Co., 555 Edscorp Bldg., Barrington, New Jersey 08007, or from a dealer in amateur telescopic supplies.

Grind both sides of the disc flat against a sheet of well-supported window glass, using #60 silicon carbide grit. Attach the steel plate and handle arrangement to the upper surface of the disc with epoxy glue.

If you have only a small stone, you can grind it with a glass muller or something similar (Illus. 15).

The Graining Sink

Grind your stones in or near a sink, where water is available. A free-standing sink (Illus. 13, 14), unconnected to a drain, can be positioned for use near an installed sink. Leave room to walk around the stone as you grind. Use plenty of water to sluice away the mud incidental to the grinding of each charge of grit, and also for thorough cleaning of the work area when you change from one size of grit to a finer one.

If you feel that you would not mind a little inconvenience, you can take a leaf from the book of the amateur telescope maker and work your stone on the plywood top to a barrel that is half-filled with bricks, gravel or sand. Or, you can work at the corner of a heavy table. With such a set-up, you have to walk from one end of the table, around to the side, and back again, repeatedly.

If you do your grinding on a wooden grating placed in an installed sink, you will have to do all the work with your arms and shoulders, which is very tiring as well as discouraging. Keep it in mind that, whenever you grind a stone, you will be working at it for possibly an hour, and, in some cases, longer.

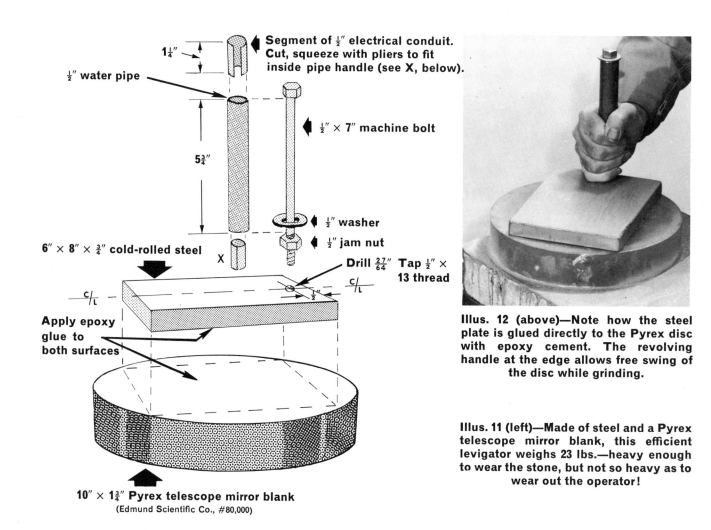

1¼"

½" water pipe

Segment of ½" electrical conduit. Cut, squeeze with pliers to fit inside pipe handle (see X, below).

½" × 7" machine bolt

5¾"

½" washer

½" jam nut

6" × 8" × ¾" cold-rolled steel

X

Drill 27/64" Tap ½" × 13 thread

Apply epoxy glue to both surfaces

c/L

c/L

½"

10" × 1¾" Pyrex telescope mirror blank
(Edmund Scientific Co., #80,000)

Illus. 12 (above)—Note how the steel plate is glued directly to the Pyrex disc with epoxy cement. The revolving handle at the edge allows free swing of the disc while grinding.

Illus. 11 (left)—Made of steel and a Pyrex telescope mirror blank, this efficient levigator weighs 23 lbs.—heavy enough to wear the stone, but not so heavy as to wear out the operator!

Choosing the Correct Grit

Before starting to grain a stone, you need an idea of what your plans are for the drawing. Will you draw with crayon or tusche, or perhaps some of both? Usually, a finer grain is used for a tusche drawing. A #180 grit to #220 grit is suitable for graining a stone for a pencil or crayon drawing. Tusche works best on #220 grain or finer. Draw your first stones with pencil or crayon, as tusche is more difficult to handle and print and you need experience first. Start by using #180 grain.

Before long, you will be able to figure out beforehand how coarse or how fine a grain you need to produce a given effect. It is not uncommon for a lithographer to use grit as coarse as #50 for special effect.

The number of a grit indicates how many particles you can line up to the inch. #220 grit, for instance, is the largest size that will pass through a screen having 220 openings to the linear inch—that is, something like 48,400 openings per square inch. A

given size of grit may have smaller size particles mixed in with it, but it should never be contaminated with grit of a larger size.

Variable Graining of the Same Surface

When you rub two litho stones together with a certain size of grit between them, both become surfaced to the same degree of roughness. The texture thus imparted to the surfaces is called "grain." You may not always want the same grain in every part of a stone, and you may as well know to begin with that you can have two, three or more different sizes of grain in the same print, each devoted to a different part of the stone.

First, grind one grain over the entire surface of the stone. Then, using a different grade of grit for each sub-section of the stone to be re-grained, grind these areas one at a time with a muller or steel tot (Illus. 15, 16), or with the bottom of a water glass or glass bottle, to the texture desired.

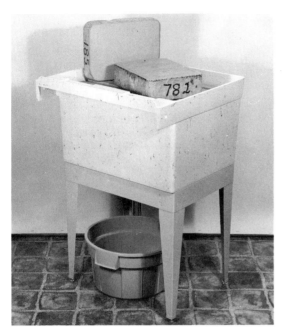

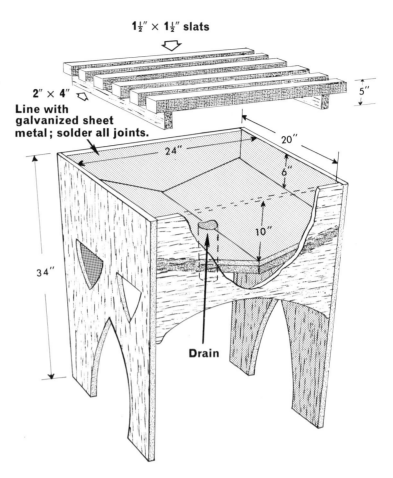

1½″ × 1½″ slats

2″ × 4″

Line with
galvanized sheet
metal; solder all joints.

5″

24″

20″

6″

10″

34″

Drain

Illus. 13 (above)—Plastic tub with steel legs
makes ideal graining sink for stones up to
14″ × 18″. Heavy wood grating inside supports
work.

Illus. 14 (right)—If you prefer to build your
own graining sink, here is a good design.

The Studio Log

If the stones you buy are unnumbered, paint
identifying numbers on the side of each with enamel.
Also acquire a notebook with ruled pages. Use it as
a log, jotting down the number of the stone, the date
grained, the grit-number, and if it was counter-
etched before drawing on it. Jot down the details of
the drawing, its size, title, numbers of pencils and/or
crayons used, if tusche was used on any part of it,
and so on. In short, put down all details, as fast as
they come up, keeping a complete record of opera-
tions. Don't omit the slightest detail—include the
date, temperature, humidity, and time of day for
each step of the procedure.

Later on, you will be glad to have this record as a
reservoir of valuable information. You will find your-
self constantly referring to it to help you over rough
spots that crop up in your processing.

How to Check the Stone for Flatness

Your first step is to find out if the stone is truly
flat, with its face parallel to its back. Lay the stone
on a table with the light coming from behind, and

stand a ruler on edge across the surface. Hollows
show up as light streaming under the ruler. Measure
the thickness around the edge of the stone. If you
have access to a dial indicator (micrometer) and can
mount it on a surface gauge as shown in Illus. 17,
you can use it to check the thickness at any point on
the surface, even in the middle of the stone, down to
a thousandth of an inch. This much accuracy is
more than necessary, because you can overlook all
discrepancies under twenty or thirty thousandths, as
this amount, and perhaps more, is compensated for
in the backing and the scraper leather.

The stone should lie on a flat surface for measuring
with the dial indicator—on a sheet of glass or the
planed steel bed of an etching press, or even a
smooth table top will do. If the stone deviates
seriously from flatness and parallelism, you will
either have to grind at it until you bring it into
shape, or you must use some kind of make-ready with
it whenever you print (see Chapter 9).

Once you have ground a stone surface to perfect
flatness, you can easily keep it that way with proper
grinding.

Illus. 15—Commercial and home-made mullers for special grinding purposes. Top row, left to right: Stainless steel muller, glass muller, home-made muller of $4\frac{1}{4}''$ Pyrex disc with cemented-on, wooden handle. Bottom row: Three steel tots, turned and smoothed on the lathe. Extreme right: Old-fashioned sad iron with revolving handle made from a file handle.

The Graining Process

Lay one of your stones face up on whatever graining stand you have arranged for it and, if it has an old printing image on it, scrub off the ink with turpentine and a soft rag (Illus. 19). Do the same to the second stone, then wash both stones clean with detergent and rinse with plenty of water. If you are working at a table that has no place for the excess water to go, use a sponge and water and wipe the stone clean.

Dash a little clean water on the stone, spread it around with your hand, then sprinkle the surface with grit as evenly as you can. For a $9'' \times 12''$ stone use a half teaspoonful of #180 silicon carbide grit (Illus. 20), and proportionately more for a larger

stone. Pick up the second stone and lay it carefully face down upon the first, their outer dimensions coinciding. Remember that limestone is brittle. The edges chip easily.

Refer to Illus. 18. This shows you, literally step-by-step, how to go about grinding. Four movements are involved in lapping one stone upon another. Their combined purpose is to maintain flat surfaces on the stones.

MOVEMENT 1: Push the stone away from you until one sixth of its width overhangs the bottom stone. Pull it back until the same amount overhangs the near edge of the bottom stone.

MOVEMENT 2: Keep the stone rotating between your hands toward the left, about one full turn for

Illus. 16—Grind one part of stone fine, another part coarse, using muller or tot, according to area.

Illus. 17—Dial micrometer mounted on surface gauge provides precision measurement of stone thickness. Note thickness variations.

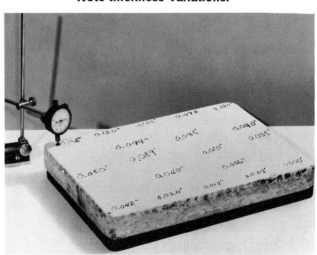

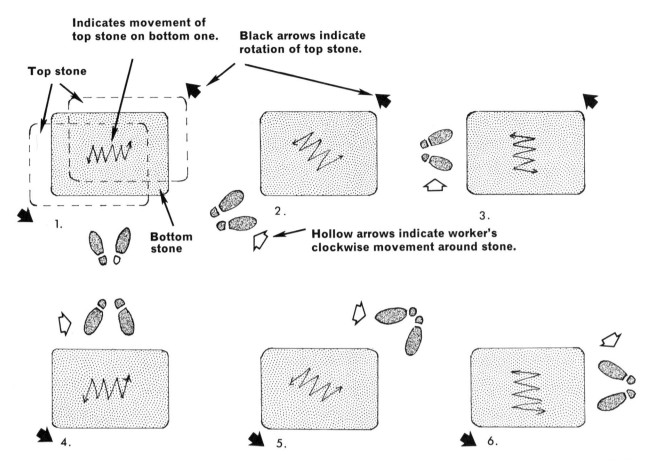

Illus. 18—This diagram shows how the operator moves the stone as well as his position in the course of grinding.

every five or six strokes. As the stone turns, both its diagonal and its length, as well as its width, will in turn stand out perpendicularly to your position, i.e. pointing away from you. Therefore, you will vary the actual length of the stroke accordingly, depending on which dimension is involved in overhanging the bottom stone.

MOVEMENT 3: With each forth-and-back movement of the stone, shift it slightly to the right, so that the center will cover a different path on the next stroke. Keep shifting to the right until the top stone overhangs the bottom one a little, then move it back to the left until it overhangs again.

MOVEMENT 4: Step around the stone in a clockwise

Illus. 19—Step 1: Clean ink from printing image with turpentine and a rag. Wash stone with water and detergent and rinse.

Illus. 20—Step 2: Sprinkle wet stone with silicon carbide grit, about ½ teaspoonful for 9″ × 12″ stone.

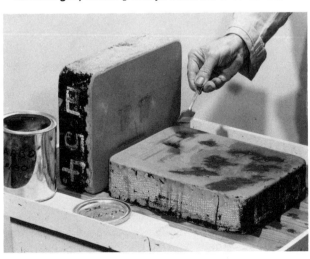

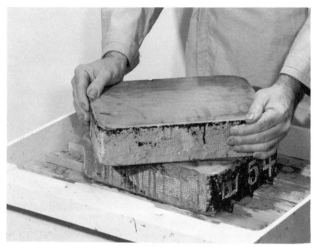

Illus. 21—Step 3: Place one stone on top of the other, lap with grit between (see text and Illus. 18).

Illus. 22—When grit is reduced to sludge, slide stones apart, rinse with water. A sink with running water is the best place for this.

Illus. 23—Final step: Keep stone wet, file edges round. Use coarse rasp first, then mill file. Smooth the edge as much as possible with piece of pumice stone (striated grey shape in foreground).

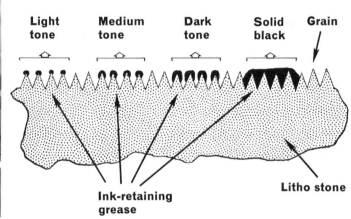

Illus. 24—How the grain of the stone affects the drawing medium in reproducing tones of grey.

Illus. 25—For a final touch, you can polish the edge with a Scotch hone. A few strokes suffice.

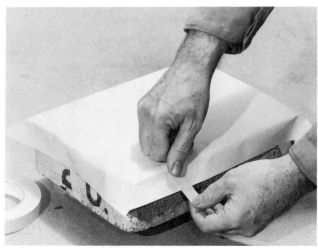

Illus. 26—Protect the grained surface with a cover of newsprint taped to the sides.

direction until you are pushing the top stone back and forth across one of the diagonals of the bottom stone. Repeat movements 1 to 3, then step around to the end of the stone and go through the first three movements again. Follow this by stepping to the next diagonal, then to the opposite width, and so on, as shown in the diagram, continually walking around the bottom stone as you work the top one over it.

If you had an arrangement that would slowly rotate the bottom stone as you work in one place, it would have the same effect.

How to Keep the Stone Flat

This method of grinding would, in time, cause the upper stone to become concave while the bottom one becomes convex. To avoid this, proceed as described below.

To begin, grasp the top stone by diagonal corners (Illus. 21) and get going with the four movements described. After a few minutes of work, you will notice a softening of the grinding sound as the grits break down and wear out. At the same time, a sludge of yellow mud that has formed between the stones takes hold and makes the stone hard to move. Before movement becomes too difficult, stop, slide the top stone carefully off the bottom one and stand it on edge nearby. Wash both stones to remove the sludge (Illus. 22). If you do not have a hose and sink for this, a rag or a sponge and a pan of water will do.

As soon as the stones are clean, you will see that parts of the drawings are beginning to wear away. *Now move the bottom stone aside and lay the top stone face up in its place.* Dash on a little water and some grit, and, using the former bottom stone as a top stone, continue grinding.

By reversing the stones this way each time a charge of grit wears out, you counteract the hollowing and convexing effect mentioned above. In other words, grinding with the second charge of grit effectively cancels out the undesirable effect of grinding with the first charge. The result is that the surfaces of the stones remain flat. As you continue to grind, reverse the position of the stones after each charge of grit is ground, and always grind in multiples of two charges—four, six, eight, and so on, to keep the work even.

If by some chance you should come into possession of a stone that has a hollow or a hump in the middle, or is irregular of surface, just think the situation through and, by means of local grinding, bring it back into shape.

The Limit of Grinding

The #180 grit may grind away the image in as few as two charges, but only if the tones are very light. It may take a number of grindings, up to eight or ten. The longer the stone stands after you have finished printing from it, the deeper the greasy image sinks into the stone and the more grinding it takes to get it out.

You can perhaps avoid some work by grinding the first two charges with #80 or #100 grit. Coarse grit grinds faster. Then switch to #180 and finish grinding.

You have to get rid of the old image entirely. If any remains, it retains its grease-attracting ability and is quite likely to take ink and print along with the new image you want to put on the stone.

When the image has been ground down until it is quite faint, you can test its grease-attracting ability by rubbing it, through a film of water, with a very *small* amount of asphaltum or printing ink. If the color "takes" on any part of the image, you are not yet through grinding. If the image refuses the grease, then you know it will not take ink while printing.

If you intend to draw on #180 grain, you have done all the grinding needed when you have ground the image away. If you plan to work on #220 grain, wash both stones and the grinding place thoroughly, for you must not leave a single coarse grain to mingle with the finer grit, as it will cause scratches.

In the same way as before, grind at least two charges of #220 grit, and don't forget to reverse the position of the stones on the second charge.

If you want a grain finer than #220, wash up again, and grind with grit #F.

Grinding a Very Fine Grain

When you use very fine grit, the stones have a tendency to grab and this results in scratches. For extremely fine grain, you must first make the stone perfectly smooth. This is easier to do than you may think.

Put one of the litho stones aside, as you will not be needing it. Grind a couple of charges of #FFF grit on the remaining stone, using a muller and the grinding technique shown in Illus. 27.

Wash up, sprinkle *powdered pumice* (from a drug or hardware store—chemist's in England) on the stone and continue to lap it with the muller. Lap several charges of the pumice, then wash the stone and run a finger along the margin. The surface should feel silkily slick. Wash up the grinding stand again,

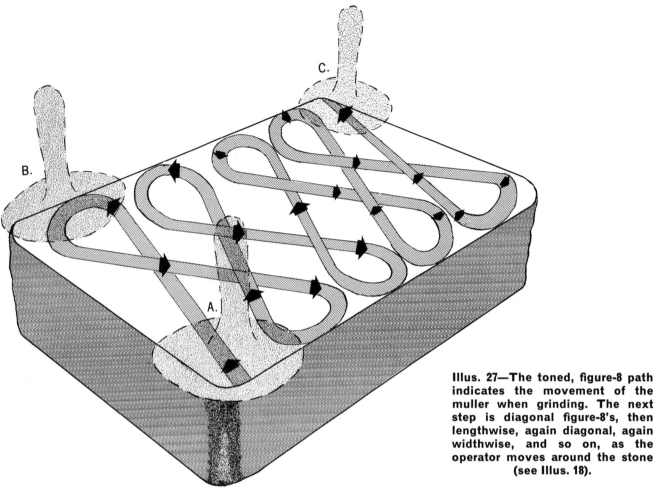

Illus. 27—The toned, figure-8 path indicates the movement of the muller when grinding. The next step is diagonal figure-8's, then lengthwise, again diagonal, again widthwise, and so on, as the operator moves around the stone (see Illus. 18).

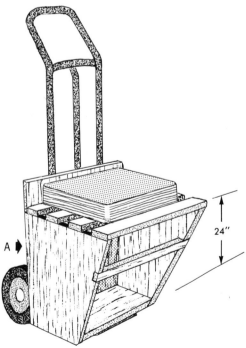

Illus. 28—If a hand truck is available, it can be quickly and easily adapted to a stone tote for moving heavy stones around the studio. Attach carrier to truck frame with U-bolts at A.

sprinkle the stone with #FF or #FFF grit, depending on the fineness of grain you want, and grind two charges of this with the muller, or until the surface is grained all over with a fine, barely perceptible texture.

How to Grind with a Muller

Whenever you grind a litho stone with a muller, or with a stone or levigator that is smaller than itself, you must change your method of attack to make sure the stone is ground evenly all over. If you don't, you may in time taper down an edge or an end, grind a hollow or several hollows in the surface, or do something else undesirable.

Illus. 27 shows how to move the muller or levigator over the litho stone in a figure-8 path. Walk around the stone in the usual way, repeating the figure-8's across each dimension of the stone in turn.

You may at some time find it necessary to work out a method of grinding each stone to a different degree of fineness. Perhaps you want to put a crayon drawing on one stone and a tusche drawing on the other. The first is to be ground with #180 grit, the

second with #220. One solution is to grind both stones with #180; then grind the other with #220 and a muller. Or, grind both to #220, then re-grind one with #180 grit and the muller.

How to Levigate the Grit

If, after smoothing a stone with powdered pumice, you want to be certain that only the finest grit of a given grade is used to grain it, you must levigate the grinding powder before use. This use of the word levigate means to make smooth by removal of the coarse particles.

Pour several teaspoonfuls of #FF or #FFF grit into a jar of water, where you can watch what happens. Stir the water vigorously, then stop and let the grit begin to settle. The coarsest grit, being the heaviest, will settle out first. As soon as you see grit beginning to collect on the bottom of the jar, quickly decant the water and its burden of swimming particles into another jar, leaving the coarsest grit behind. Let this sit until all the grains have settled, then carefully pour off the water and use the levigated powder to grind the grain desired.

Filing and Stoning the Edges

When you finish graining the stone, you will find that the edges are less rounded than they were, possibly even sharp. Sharp edges chip easily and, too, may cut your ink roller.

Keeping the stone wet, round them off with a coarse rasp (Illus. 23), followed by a once-over with a single-cut (bastard) mill file. Use big files, at least 12″ from shoulder to tip. After filing, take a *lump* of pumice and smooth out the coarse file marks, using plenty of water. Take care not to rasp the pumice over the surface of the stone, or it will make deep gouges if you do. Finally, for the smoothest possible edges, go over them with a Scotch hone (Illus. 25), or Scotch stone, a fine razor hone, or some other fine-grained stone.

This completes the surfacing work on the stone, so wash up thoroughly, dump out any slop water that has accumulated in the graining sink or in the tub into which it drains, and set the stones aside to dry. Turn an electric fan on them to speed things up.

Protecting the Grained Surface

Once the stones are dry, do not touch the grained surface with your fingers or any other greasy object. Protect the stones until you are ready to use them with clean newsprint laid on and taped to the sides with masking tape (Illus. 26). Never use *printed* newspaper. The ink on the paper will transfer its grease to the stone and give you endless trouble. For the same reason, never set a stone directly down upon old newspaper. Always lay a board or two down first for the stone to rest on.

Counter-Etching the Stone

If you let a grained stone sit around for more than a few days, the surface may become desensitized; that is, it may lose its ability to attract and hold grease and you will have to re-sensitize it before you draw on it. This simple process is also called "counter-etching," and you cannot tell by looking at a stone whether it needs it or not.

You can use either of two formulas. (1) Dilute 1 part 28% acetic acid with 3 parts of water (or use white, distilled household vinegar having a strength of 5% acidity as marked on the label). Flood the stone with this mild acid and spread it around with your hand. Leave the acid on the stone for 2 or 3 minutes, then wash it off with a flood of water and dry the stone for immediate use. Squeegee it off with a photographers' or window-washers' squeegee for fastest drying if you wish, but never use *that* squeegee for any purpose other than squeegeeing *plain water* from a stone.

(2) The second formula is used in exactly the same way, except that it consists of a saturated solution of potassium alum. To make a saturated solution, keep stirring the alum into a small quantity of water until the powder finally refuses to dissolve, regardless of stirring. There is now more alum in the water than it is capable of dissolving. Such a solution is said to be "saturated." You can mix either solution in quantity and keep it handy indefinitely for use when needed, such as when you want to change or to add to parts of an already processed drawing.

A Handy Stone Tote

If your lithographic work requires you to move stones from one room to another, or from the studio in the house out to the press in the garage, a stone tote is a great thing to have.

Illus. 28 shows how to adapt a hand truck to the task of moving stones about. The stone-carrying deck is high enough off the floor that you do not have to bend far over to pick up the stone when moving it to table or press bed. At the same time, it is low enough so that the stone rides directly over the wheels when the truck is tilted back in its rolling position. The accessory carriage is fastened to the truck frame with U-bolts, which can be quickly removed when the truck has to be used for another purpose.

3. CRAYON DRAWING ON THE LITHO STONE

Pencils and Crayons

You can draw on the stone with litho pencils and crayons, or with any greasy material such as soap, lipstick, oil-based pastel sticks, wax crayons, and so on. However, my advice to you is to stick with the materials made for the purpose and you are less likely to have trouble.

Both grease pencils and lithographic crayons are made of the same materials and come in numbered grades of hardness. The higher the number, the harder the material of which the stick is composed and the lighter the tone you can draw with it. The grades are as follows: No. 1, Soft; No. 2, Medium; No. 3, Hard; No. 4, Extra Hard. Hardest of all is No. 5, called Copal. Crayons come in two softer grades not available in pencils: No. 0, Extra Soft, and No. 00, Extremely Soft.

The pencils have a center similar to a lead pencil that is wrapped in paper. Pulling on the thread at the drawing end tears out the paper for a spaced distance of one or two holes; then you scrape the end of the paper free with your thumbnail and pull it off in a spiral. The crayons are uncovered, being in the shape of little sticks, about 2″ long by ¼″ square.

A No. 3 or No. 4 pencil will do all the drawing you can manage for a while. Vary the depth of tone or intensity of a line by pressing down lightly or firmly as you draw. With a No. 3 crayon alone, you can build up, stroke after stroke, an area of tone that will print as black as if it were put in with the softest crayon.

By using several grades of pencil, you will get more flexibility in your drawing. A No. 2 will make as dark a tone as you could wish for, and the remaining grades of hardness through No. 5 produce increasingly lighter tones without varying the drawing pressure.

You can buy pencils singly or by the dozen—crayons are generally sold a dozen of one grade in a small box. For the quantity of material involved, pencils are the most expensive, but also the most convenient to use. Always sharpen the point of the pencil or crayon by stroking the blade in from the end (Illus. 29) to avoid breaking the point. Point the material by rolling and rubbing it simultaneously on a piece of sandpaper (Illus. 30). You can draw a fine line with a crayon by using a corner; to cover broad areas lay a piece of crayon flat and move it with more or less pressure.

Do not expose too much of the core of a pencil, particularly in hot weather. A long point bends and breaks easily.

Perhaps you will better understand your medium if you know what material you are drawing with. Mostly, it is a very fine grade of Castile soap, to

Illus. 29—Use a razor blade or penknife to sharpen litho pencils or crayons, holding blade as shown to minimize breakage.

Illus. 30—Put a fine point on litho pencil or crayon by rolling and rubbing it on a piece of medium sandpaper.

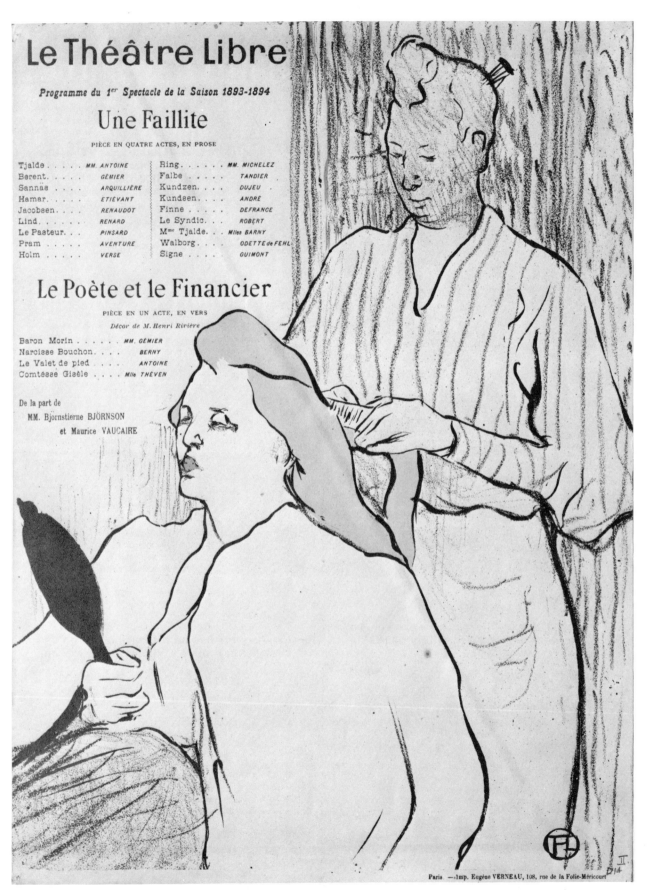

Illus. 31—"Le Coiffeur," lithograph by Henri de Toulouse-Lautrec. The National Gallery of Art, Washington, D.C. Rosenwald Collection.

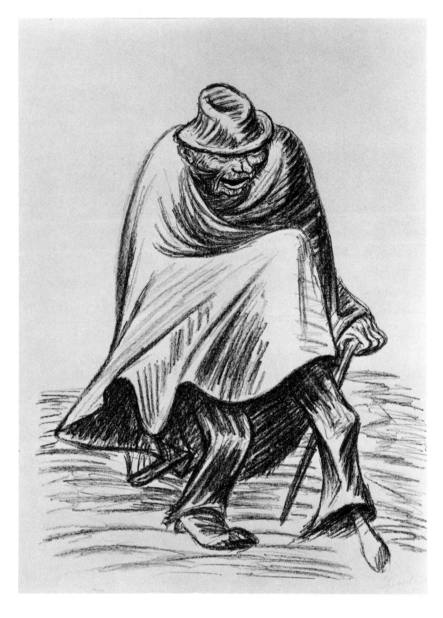

Illus. 32—Lithograph, "The Cheerful One-Legged Man," by Ernst Barlach (German, 1870–1938). The National Gallery of Art, Washington, D.C. Rosenwald Collection.

Illus. 33—Tracing of donkey drawing on tracing paper, with thin white paper flap attached to face of tracing with tape.

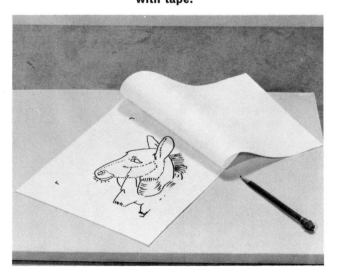

Illus. 34—Lay the flap on the tracing and go over the visible lines with a sanguine Conté crayon.

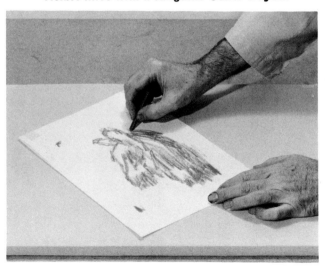

Illus. 35—Rub sanguine down on flap with a wad of cotton.

which varying amounts of wax, shellac, and lampblack have been added. Soap is the ingredient that is acted upon in the chemical process. The amount of wax in the mixture determines its hardness, and the shellac is a binder. Lampblack has no purpose other than to give you the color to see what you are drawing.

Function of the Grain on the Stone

Illus. 24 shows a diagrammatic cross-section of the grain on the surface of a stone. It is composed of many little peaks with valleys between. If you (1) draw a grease pencil lightly over the grain, it leaves behind a trail of particles on the very tips of the peaks.

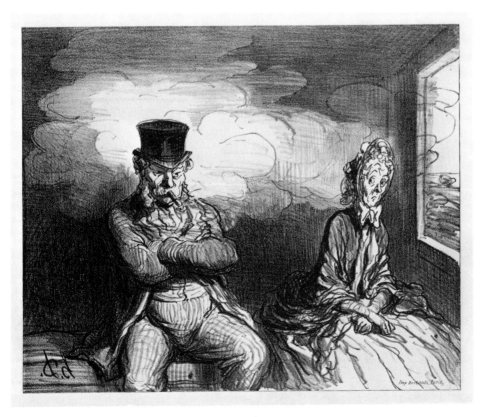

Illus. 36—"The Railways: Agreeable Companions," by Honoré Daumier (French, 1808–79). Daumier made extensive use of the lithograph for social and political satire.

25

By applying more pressure (2), you force bits of grease pencil farther down the sides of the peaks. Finally, when you apply enough pressure (3), the greasy bits of crayon not only cover the peaks but also fill the valleys.

The effect on the stone is (1) a light line with a gauzy appearance; (2) a heavier line with bits of light showing through; (3) a line of solid black. When the stone has been properly processed and run through the litho press, the lines on the stone will print corresponding lines, of the same shade or degree of blackness, on the paper. What you see is what you get.

Drawing

Start by making your original drawing on a piece of drawing paper cut to the size of the stone. The picture area must be small enough to allow for a margin 2″ wide at each end of the stone, and 1½″ wide down each side. This will allow room for the scraper to operate on the stone. When you get so you can operate the press accurately, you can fudge maybe a half inch on the dimensions. Generally, though, the picture area on a 9″ × 12″ stone measures 6″ × 8″ or smaller; on a 12″ × 16″ stone, 9″ × 12″.

The print of the donkey's head (Illus. 40) is a good

Illus. 38—Go over the sanguine lines on the stone with a sharp litho pencil.

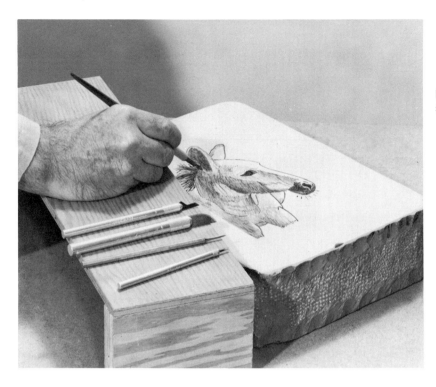

example to follow for your first stone drawing. Don't copy the donkey, but study the lines and shading carefully, then draw a picture of your own on the paper, utilizing *the same range of tones*. These start with solid black (No. 2 pencil) in the donkey's muzzle to strokes with a No. 5 pencil in other areas. No light area or dark area has been made too big. All the tones in this picture average out as medium tones. *This is important!* Do not start off with a very light drawing or a very heavy one until you have had enough experience to know what you are doing. Drawings done differently from the medium-tone style of this little donkey have to be processed differently, and it is by the medium-tone style that you will learn the technique.

There are several stages before you draw onto the stone. First, trace only the main outlines of your drawing onto a piece of parchment tracing paper the same size as the stone and make sure the drawing is centered on it. If you have to indicate tones, do so simply by outlining the area they occupy.

Cut a sheet of lightweight, bond paper (13-lb. layout paper is fine), and tape it to the face side of the tracing with masking tape (Illus. 33). Turn the assembly over and you will see the donkey reversed through the back side of the tracing paper. The drawing must be put on the stone in this reversed (flopped) position so that, when you have printed it, it will be right side up again.

Most parchment papers are made by means of an oil process. If you were to lay such a paper against the stone, some of the grease would transfer over and cause you trouble. To avoid this possibility, take the parchment paper, cover it with white bond paper, and hold the pair against a window or light-box (or perhaps you can see the image well enough without that). Go over all the outlines of the drawing on the bond paper with sanguine (blood-red) Conté crayon (Illus. 34). Conté crayon is made of non-greasy material and hence is safe to use. If you later wish to omit a line after you have traced it on the stone, you can do so, as the Conté crayon simply washes off in the processing. Not so graphite, however, so do not use it for tracing.

Next step, rub down the Conté crayon with a wad of cotton or cheesecloth (muslin) (Illus. 35) to prevent smearing on the stone. This tracing is called the cartoon.

Tracing the Drawing on the Stone

Lay the sanguine-covered cartoon sheet face down on the stone and fasten the assembly with masking tape stuck to the sides of the stone (Illus. 37). You can easily see the reversed image of your drawing through the back of the tracing paper. Go over all the lines of the cartoon with an 8H drawing pencil or a fine-pointed mimeograph stylus, pressing only hard enough to transfer the Conté crayon to the

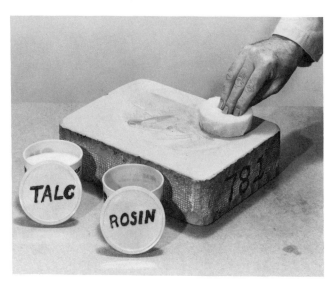

Illus. 40—Apply powdered rosin to the drawing, patting it in with a soft pad.

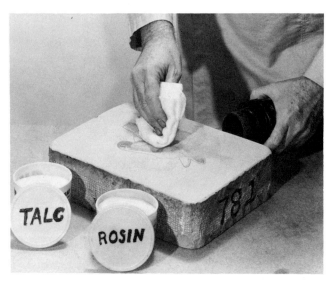

Illus. 41—Remove the excess rosin from the drawing by brushing it into a vacuum-cleaner hose. Repeat Illus. 40 and 41 with talc.

stone. Determine the right pressure by trial, lifting a corner of the tracing to check the density of the transferred line.

Before removing the cartoon from the stone, check from corner to corner, lifting only one corner at a time, to be sure you have not missed any lines.

The Drawing Bridge

To avoid smearing the drawing now lightly transferred to the stone, you should never work directly with your hand resting on the stone, or even on a piece of paper on the stone. Build a bridge over the stone—a piece of $\frac{1}{4}''$ plywood $4''$ wide and several inches longer than the diagonal of the stone (so you can turn it at any angle over the work). At each end glue and nail a piece of thick plywood wide enough to support the bridge about $\frac{1}{8}''$ above the stone. (Illus. 37, 38, 39). If you have several stones of the same size, make the bridge high enough to go over the thickest one; then, when working on the others, you can support them at the correct height with an underlay of plywood, hardboard or cardboard. Never try to work with an adjustable bridge. The whole thing is likely to collapse at a crucial moment. If you have stones of different sizes, make a separate bridge for each size.

Drawing on the Stone

By resting your hand on the bridge, you have perfect support for the most detailed and delicate kind of drawing. With a *sharp*, No. 4 litho pencil, go

over all the sanguine lines on the stone, drawing them in carefully (Illus. 38). Sharpen the pencil frequently, before it gets dull and broadens the line.

Your black-line drawing will be light enough for the lightest outline. Where you want the lines darker, as on the shaded side of the subject, go over them with a No. 3 or No. 2 pencil.

Here are some tips on how to draw on the stone with pencil or crayon. To fill an area with a tone of grey or black, lay down a series of carefully drawn, straight lines, side by side. Draw each line in the same direction and lift the drawing medium at the end of the line.

Do not scribble or you will get something worse than a scribble in the print. If you dash the pencil back and forth, every time it stops to change direction, it leaves a little extra bit of crayon material on the stone. Dozens or hundreds of these crayon bits, carried through the chemical processing, will print as hideously distracting black spots.

Once you have laid down a tone, study it carefully. If you want it darker—or completely black—go over the same area with the same pencil, using the same pressure and drawing the lines the same way, only this time apply the strokes at an angle to the first layer. You can put down layer after layer like this until the tone reaches the depth desired—and remember, what you see is what you are going to get. Do not put down the grease pencil so heavily that it makes a gummy mass on the stone.

If, instead of lines, you prefer a solid tone, you can

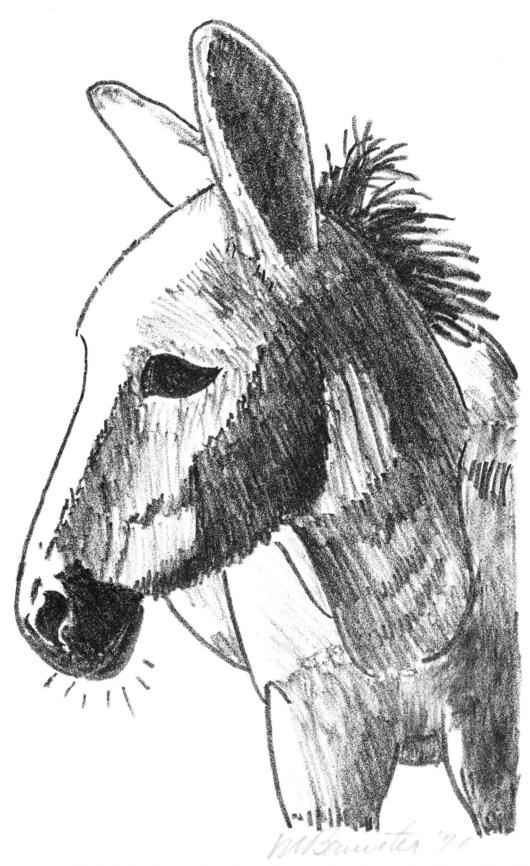

Illus. 42—Lithograph, "Portrait of a Donkey," by Manly Banister. Actual size, printed from a 9″ × 12″ stone, #220 grain; drawn with litho pencils only, grades 2 through 5.

try rubbing the area in question with a piece of chamois skin stretched over your forefinger. Rub the crayoned area lightly with a circular motion. If you have inadvertently laid down an uneven tone, too dark in some places and too light in others, you can even it up by rubbing in this manner.

Scraping

Now and again, your pencil will deposit an extra dab of grease here and there on the drawing. All such droplets will show up in the print if you leave them where they are, so get rid of them while it is easy to do so. Pick them off with the end of an etching needle, a scratchboard tool, a penknife, the corner of a razor blade, an X-acto knife, or similar tool.

If you think a line looks too light, go over it again with added pressure. If the line seems too dark, scratch away some of the excess color (Illus. 39). Scrape away only the drawing material. Do not dig grooves into the stone.

By the same token, for effect, you can lay down a tone of solid black, then reduce it to whatever tone of grey you desire by scraping away the excess crayon. (This kind of work is possible only on stone, never on a plate.) Another way to get this kind of tone is to remove the grease pencil with a sheet of gelatine; or, you can use a piece of "fixed-out" photographic film (fixed-out film has no image on it and is clearly transparent). Lay it gelatine-side down on the drawing. If you cannot tell by sight which is the gelatine side, place a corner of the sheet or film between slightly moistened lips. The side that sticks to the lip is the gelatine side. Go over the lines you want to remove with a hard pencil or mimeo stylus, working on top of the film.

When you lift the film, the crayon will adhere to the gelatine.

You can control the amount to be removed by pressing on the film lightly or heavily. The film can be used over and over, but when it becomes loaded with crayon, wash it off with a rag and turpentine.

If you develop your own films customarily, you can fix out a roll of unexposed film by leaving it in the hypo bath until the silver dissolves and it shows clear. You do not need a dark room for this. Wash the hypo from the gelatine in the usual way.

If you don't develop your own films, send a roll of cheap, unexposed black-and-white film to the photo-finisher. Mark the envelope: "UNEXPOSED FILM. FIX OUT, WASH, AND RETURN UNCUT."

Don't worry if you make a few drawing mistakes at first. Just do it as well as you can with previous

instructions in mind. If you want to make corrections, the time for them is before the drawing is "fixed." You can also make corrections after the stone has been processed, but the procedure is more complicated.

If you gouge into the stone while scraping, the marks may fill in and give trouble by showing up in your print, so scrape with care. Also, deep scratches make extra work whenever you grain the stone, as you have to grind them out.

To be able to produce effects by scraping is a big advantage of working on stone. You could, if you wished, make an entire drawing by scraping alone, after first painting the surface black all over with a couple of coats of tusche.

But suppose you don't like your drawing and feel it would be wasted effort to go on through the rest of the procedure to print it? Simple enough at this stage. Just stick the stone under a faucet and wash off the drawing. You may need a little detergent and some scrubbing to remove the last traces. Then dry the stone, place the same or a new tracing back on it, and start out again.

In Chapter 8, you will learn about drawing on the stone with tusche, but postpone thinking about that method for the moment.

Powdering the Drawing

To make your drawing stay put on the stone through the preliminary processing stages, you will have to *fix* it—that is, treat it to make it stay in place. You need for this both powdered rosin and talcum powder—the unscented, purified talc sometimes called "French chalk" and available at pharmacies and lithographic supply houses.

Some lithographers mix the powdered rosin and the talc half and half and apply both at once to the drawing. Or, you may prefer, as others do, to keep the rosin and talc in separate containers, and apply each powder with its own plastic sponge, powder puff, or cheesecloth pad. In a separate container, keep ready a cheesecloth pad for brushing the powders off the stone.

Using the second method, apply the rosin to the drawing first, patting it into the greasy material so that the dust gets well worked in (Illus. 40). Next, brush the excess rosin away with the cheesecloth pad. If you don't want the dust flying all over your studio, suck it up with a vacuum cleaner hose as you brush it off (Illus. 41). Repeat with talc, patting it into the drawing and brushing away the excess.

The powders not only protect the drawing against being dissolved in the first application of aqueous

fluid, but cling so closely to the bits of grease pencil (or tusche) on the stone that they form a slick, protective shield against the acid which would otherwise bring harm to the drawing.

At this stage, you can stop for a while, if you wish.

Protect the drawing with a piece of clean newsprint taped to the stone; or, you can go ahead with the chemical processing, if you are prepared for it, as described in the next chapter.

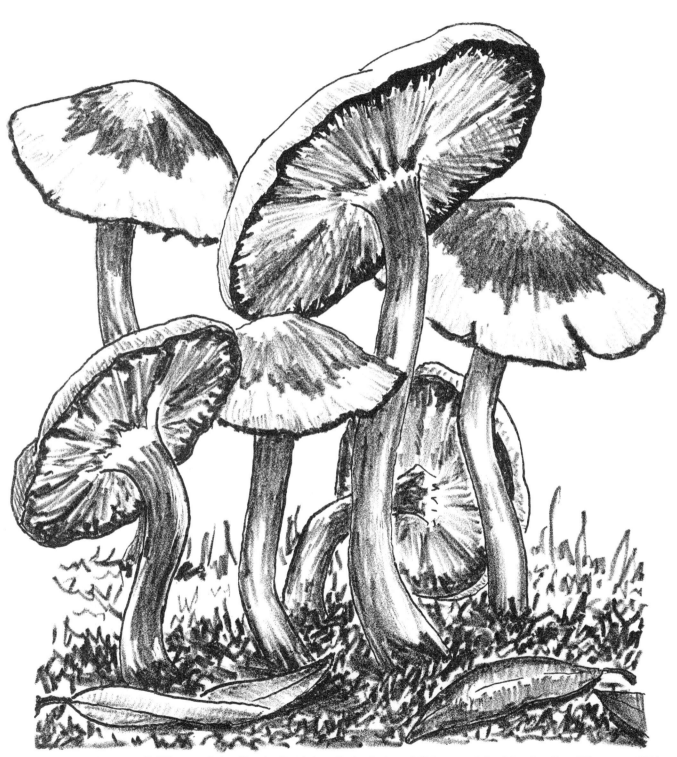

Illus. 43—"Mushrooms," lithograph by Manly Banister. Actual size: 6¾″ deep × 6½″ wide. On 9″ × 12″ stone, #220 grain. Combination litho pencil, crayon, and tusche drawing. Outlines and some blacks drawn in with tusche.

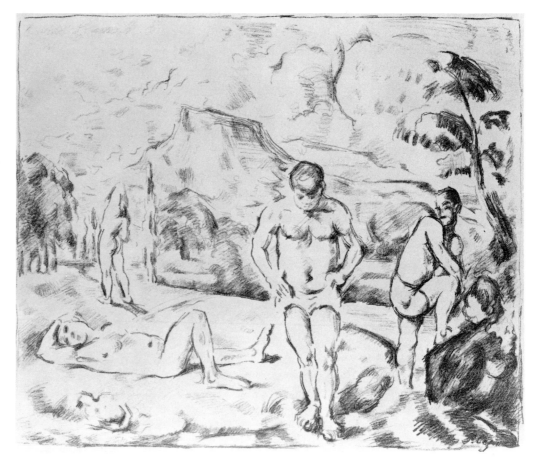

Illus. 44—Lithograph, "The Bathers," by Paul Cezanne (French, 1839–1906). The National Gallery of Art, Washington, D. C. Rosenwald Collection.

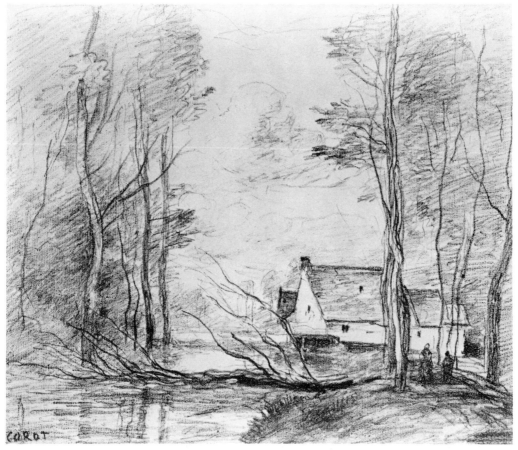

CORDT

Illus. 45—Lithograph, "The Mill of Cuincy, near Douai," by Jean-Baptiste Camille Corot (French, 1796–1875). The National Gallery of Art, Washington, D. C. Rosenwald Collection.

4. THE FIRST GUM-ETCH

General Considerations

There are so many factors to consider in processing a given litho stone that nobody can keep track of them all. Therefore, there is no single method of processing that will take care of every situation. The stones you have are slightly different from other stones—no two stones are really absolutely the same. The temperature and humidity vary from day to day; who is to say exactly what proportions of the different grades of crayon you have used in your drawing? You cannot look at a stone after it has been etched and detect more than a superficial difference in the image. Whether or not a stone has been sufficiently etched is a completely invisible condition. You will develop judgment only through experience with your stones.

In general, the heavier the crayon drawing, the stronger the acid etch must be. The lighter the crayon drawing, the less acid is needed in the gum-etch. Some lithographers practice applying a number of *light* etches in succession; others go in for stronger etches and fewer of them.

Too much acid in the etch will burn the image so that you cannot print from it; too little will cause the image to spread and turn black all over. It is better to have too little etching than too much, because the under-etched condition can be corrected. Local over-etching can also be corrected, but a totally over-etched stone is a miserable proposition and can be cured only by re-graining and re-drawing.

But, before discouragement sets in, let me assure you that it is far easier to under-etch than to over-etch, and there is a broad range of permissible activity between the two.

The Gum-Etch

The basic materials used in processing the stone are gum arabic, and nitric acid. In this book, the formulas are for the acid commonly sold in the United States, called analytical reagent, which is 70% pure nitric acid, the remainder being water and various other impurities. In England and Europe, it is generally 40% pure nitric acid. So check the acid you buy, and if the percentage of purity is a commercial 40% grade, increase the number of drops of nitric acid added to the gum solution by about 50%; i.e., use 14–15 drops whenever 10 drops is specified.

Here are a few don'ts. Don't inhale the fumes from the acid bottle. Don't get acid on your hands, skin, clothing, or in your eyes. An acid burn can be serious, requiring the care of a physician. The nitric acid label is printed in red ink and you will find on it cautions regarding the use of the acid as well as antidotes for its misuse. So read the label very carefully before you open the bottle.

Gum arabic comes from the African acacia tree. You can buy it in large lumps, in smaller crystals, or preferably as a fine powder, each grade costing a few pennies more per pound than the previous grade. You don't save anything buying lumps or crystals in the quantity you will use, however, and you would waste considerable time with them. These require you to mix your gum solution the night before you intend to use it, as the pieces take all night to dissolve. You then must strain the gum through several layers of cheesecloth to remove the bits of bark, slivers of wood, seeds, and so on, floating around in it.

You can mix powdered gum, on the other hand, in warm water and, a half hour later, it is ready for use. There is no difference whatever in the chemical

Illus. 46—A suggestion for safe storage of the acid-etch brush. Cling plastic cover keeps out dust.

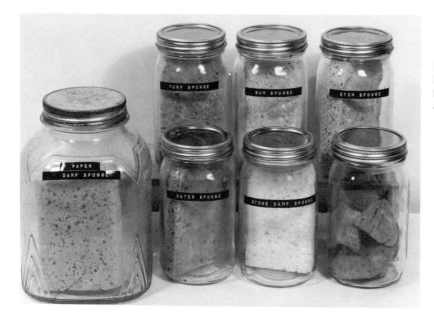

composition or reaction of the various types of available gum.

Gum arabic remains fresh and usable for two or three days after mixing. When it goes sour, throw it out. (You can tell when it is sour by the strong smell and taste of the ordinarily odorless and tasteless solution.)

There is a commercial product on the market called AGUM-O that possesses all the good properties of gum arabic and none of the bad. It is used plain or with acid for the same purposes. Even if you don't use it all the time, it is good to have a bottle handy, as you can instantly mix up a gum-etch with it if one is suddenly needed. The solution does not go sour, but keeps indefinitely.

For stones up to about 12″ × 16″, about 2 ounces of powdered gum will make all the solution you need. Measure the powder in a 2-oz. graduate, by volume (Illus. 48). Then pour it into a jam jar and add $2\frac{1}{2}$ fluid ounces of warm water and stir with a clean wooden stick (an ice cream stick or tongue depressor will do) plainly marked PURE GUM. Never use that stick for anything but the pure gum. Mark other sticks WATER-ACID and GUM-ACID or GUM-ETCH, and reserve them for stirring these solutions only.

When gum arabic dissolves, it becomes a thick, syrupy fluid which has a slick, greasy feel. Strung out between thumb and forefinger, it will stretch a string $\frac{3}{16}$″ to $\frac{1}{4}$″ long before it breaks. If the string breaks too soon, the solution is too thin. Add gum to it. If it feels thick and gummy, thin it with a little water.

Pour one ounce of the solution into the 2-oz. graduate, then cap the mixing jar and put it aside. With an eye-dropper, suck up a little nitric acid into the glass barrel and count carefully as you drop *ten*

drops only of acid into the fluid ounce of gum (Illus. 49). The solution will smoke a little, but that is normal. Stir it well. Immediately take off the rubber bulb and run water through both the barrel and bulb of the eye-dropper. If you don't do this right away, surface tension will cause the acid to crawl up into the rubber bulb and rot it. Buy eye-droppers at a pharmacy, a half-dozen or so at a time.

Etching the Stone

To get the stone ready for etching, place it on the press bed or on a work table and assemble near it the following items:

1. A small saucer into which you will pour the gum-etch.

2. A 3″-wide Rubberset (acid-proof) brush, or a cellulose sponge.

3. 2 sheets of clean newsprint the same size as the stone.

4. A squeegee (optional) and a pad of soft cloth.

5. A timer—a watch with a second hand will do.

Take a little gum-etch on the stirring stick and smear it along one margin of the stone. If the etch begins to effervesce immediately, it is far too strong for a crayon drawing of medium tone. You must add pure gum to the etch to weaken it. However, your 10-drop-per-ounce solution is rather weak and it should take it from a half to a full minute to react with the stone. The first etch should be weak, as a weak etch has less tendency to attack the drawing.

Here are a few of the things that affect the etching of a given stone: (1) The stone's color, whether yellow, light grey, medium grey, or dark grey. (2) The ambient temperature and humidity. (Best working conditions are at normal humidity of 50%

Illus. 48—2½ oz. water + 2 oz. (by measure) of gum arabic powder. Mix in jar at right.

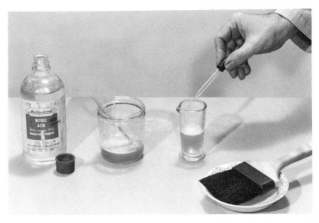

Illus. 49—Measure 1 fl. oz. gum arabic solution, add acid drop by drop, as described in text.

and a temperature between 68° and 72° F. This is not always possible, of course, unless your studio is carefully air-conditioned.) (3) The thickness of the gum. (4) A few unknown factors—perhaps even the local gravitational attraction. That is why you do not try to etch a stone fully at the first attempt, but give it a rather weak treatment to begin with, then strengthen it later on.

A darker drawing than the drawing of the donkey might call for 12 to 15 drops of acid; a lighter

Illus. 50—Brush gum-etch on the drawing for 4 minutes, working etch away from lighter tones into the darker ones.

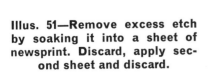

Illus. 51—Remove excess etch by soaking it into a sheet of newsprint. Discard, apply second sheet and discard.

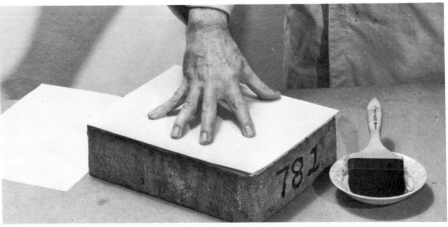

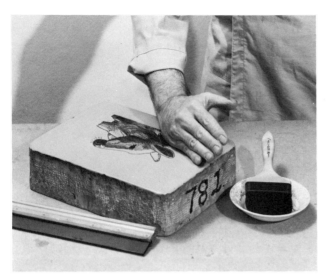

Illus. 52—Smooth out etch by quick wiping with the hand (or a squeegee). Finish with a soft cloth.

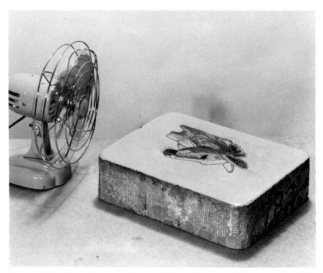

Illus. 53—Dry the etch on the stone with an electric fan. Let stone sit in the etch at least 24 hours.

drawing for 6 to 8 drops; and, if the entire drawing is done with a No. 5 pencil, as few as 2 or 3 drops would do. This should give you the general idea, and you can interpolate for other kinds of crayon drawings yourself.

The gum-etch makes the undrawn areas of the stone resistant to the further application of grease. Once the stone has been etched, you cannot draw on it again until it has been re-sensitized—that is, counter-etched. The acid in the etch goes to work on the drawing and "unsaponifies" the soap in the grease pencil. That is, it changes the soap into a chemically different material which is no longer water-soluble and which is firmly fixed to the stone. At the same time, the new material has an increased affinity for grease, which makes it all the better for printing.

Dip the gum-etch brush (or cellulose sponge) into the saucerful of gum-etch and paint a stroke quickly across one end of the stone. Dip the brush again and paint a second stroke next to the first. Continue dipping and stroking until the entire stone is covered with the gum-etch.

Now take the brush and commence brushing the etch away from the lightly pencilled parts (which do not need much etching) toward the heavier parts (that do) (Illus. 50). If you have more etch than you need, pour fresh etch from time to time on the stone and brush it around. Keep doing this for *4 minutes by the clock*. Sometime before the time is up, the stone may start to effervesce more or less strongly; or, it may not. In either case, do not be alarmed.

At the end of 4 minutes, lay the brush aside, take one of the sheets of clean newsprint and lay it on the etch-covered stone. Rub it down so that it will soak up the etch (Illus. 51). When the paper turns dark, peel it off and throw it away. Rub down the second sheet, peel it off and discard it.

If you wish, you can squeegee the remainder of the etch from the stone, but etch is hard on the rubber, and you must never use a squeegee that has been in etch for any other processing purpose. Better, use the edge of your bare hand (the acid has been just about used up) with quick, skimming movements (Illus. 52) to smooth out the etch on the stone. When the etch starts turning tacky, finish by rubbing it down with a soft rag. Then turn a fan on it (Illus. 53) and fan it dry.

That is all there is to applying the first gum-etch. You can now let the stone rest for 24 hours, or 2 or 3 days, if you wish.

Sponges

You should provide yourself with a minimum of six cellulose sponges and keep them in wide-mouth glass jars (Illus. 47). No sponge must ever be used for more than one, single purpose. If you contaminate your sponges with chemicals, you will next contaminate your stone, which will contaminate the ink and damping water, and make a mess of your printing.

Label the sponge jars as follows: (1) ETCH SPONGE; (2) PURE GUM SPONGE; (3) TURPS (turpentine) SPONGE; (4) STONE DAMP SPONGE; (5) PLAIN WATER SPONGE; and (6) PAPER DAMP SPONGE. These are their labelled uses and, since you never need to have more than one sponge out at a time, there is little excuse for getting them mixed up. Rinse each sponge well after use (except the Turps Sponge, use only turpentine to keep it soft).

Other Methods

Some lithographers paint the etch on as described, then leave it alone for the full 4 minutes. If brushing the gum around tends to dissolve the drawing (black streaks will appear in the etch), stop brushing and let the etch sit for the remainder of the period of time. You can, from time to time, carefully pour a little fresh etch into the used etch that covers the darkest areas to be sure these areas get sufficient treatment.

Once the coating of gum-etch is dry, you will see a subtle difference in the appearance of the drawing. The process of chemical change has begun to take effect and the difference is a visible one.

Always, once you start a step-by-step process, you must follow it through to its conclusion. Only when the process is completed can you safely stop. After the first gum-etch is the first convenient stopping place.

It is said that leaving the stone to sit in the dry etch has the property of improving the chemical action. It certainly does not harm it, in any event. However, some lithographers leave the stone only a half hour, an hour, or a few hours, before continuing. Others wash the etch off as soon as it is dry, and go on with the next step in the procedure.

These are all things you can try out for yourself and see how they work for you. For the present, let the stone alone for at least 24 hours.

Cleaning Up

Clean up your base of operations, mopping up spilled gum and water. Pour out any left-over etch and run copious quantities of water after it, down the sink. You don't want the acid to eat away the joints of your plumbing. Keep the left-over pure gum, however, as you will be using it.

Rinse the acid brush out thoroughly and put it away in some such keeping arrangement as shown in Illus. 46. Certainly, do not leave it lying around to pick up hard particles of grit that will scratch up the drawing the next time you use it.

Illus. 54—"Water Creature," color lithograph by Harry van Kruiningen, Amsterdam (Dutch, 1906–). Courtesy of the artist.

Illus. 56—"Sixth Avenue," lithograph by John Sloan (American, 1871–1951). The National Gallery of Art, Washington, D.C. Note the scratch work on the breast and arms of the principal figure in this lithographic crayon drawing.

Verlaine — 2² tirage — 1933 - Georges Rouault

Illus. 57—"Verlaine," lithograph, 1933, by Georges Rouault (French, 1871–1958). Notice the casual lightening of tones done by scraping the drawing on the stone. The National Gallery of Art, Washington, D.C. Rosenwald Collection.

Illus. 58—"Maternité," lithograph by Pierre August Renoir (French, 1841–1919). National Gallery of Art, Washington, D.C. Rosenwald Collection. Study the delicate rubbed tones in the faces and surroundings of mother and child.

5. THE SECOND GUM-ETCH

The following procedure goes through four steps: (1) Wash out the drawing on the stone. (2) Roll up the stone with Crayon Black ink (more about the ink on page 44). (3) Apply a water etch. (4) Apply the second gum-etch. Before you touch the stone, you will have to roll out some ink on a slab (Illus. 60–61); as, when you need ink, you will need it at once, you need now to know something about ink and inking equipment.

Ink Rollers

Most important in the rolling-up procedure is the ink roller. Do not use one that is too big for the stone—it inks up the edges and you must either stop and clean them, or allow them to print (Illus. 68).

For a 9″ × 12″ stone, a 6″ or 8″ brayer (*bry*-er) is the best size. You can use the litho pattern hand roller (Illus. 59, 64) on larger stones. About 4″ in diameter, it is available in lengths of 12″ and up. A 12″ or 14″ size will serve both stones and plates from 12″ × 16″ to 16″ × 20″.

The roller surface may be of leather, rubber, plastic or composition. Gelatine composition rollers (Illus. 63 and 76) are very delicate and must be used, if at all, with a full charge of ink. The stone must be as dry as possible without being too dry. If water gets through the ink to the gelatine, it will cause it to swell. This finally results in pitting and pebbling, rendering the roller unfit for use. It is, however, a good roller for proofing, where it is not overworked.

Other rollers are more rugged, but handle them carefully to avoid damage to the inking surface. Rubber and composition rollers can be cleaned after each printing session with kerosene and turpentine, and stored in the original shipping box until required again for use. Litho pattern hand rollers are expensive. If you can afford only one roller, it should be rubber or plastic, as such a roller can be used with all colors of ink.

Most lithographers prefer the leather roller, particularly for black ink, reserving the rubber roller for use with colored inks only. It is true that the leather roller performs in a superior manner, but its drawback is that it cannot be cleaned except superficially, and therefore a given roller can be used only with a given color of ink. You should keep one leather roller for black ink only, and have three more

for use with color. Divide your colors into groups and have a separate roller for each group, as follows: Very light colors; medium colors; dark colors.

The small, soft rubber brayers made by Speedball for block printing (Illus. 77) work fairly well on small stones.

Breaking In the Leather Roller

You can sometimes buy leather rollers already broken in for a small, extra charge. If you break one in yourself, note first that the leather is covered with a soft, fuzzy nap pointing one way around the roller.

Step 1: Place the roller in its cradle (Illus. 66) and smear a liberal quantity of lightweight, #00 lithographic varnish (burnt plate oil) over the leather. Work it in by rubbing with your hands and keep adding varnish as it sinks in, until the leather will finally take up no more.

Step 2: With the back of a stainless steel table knife, scrape the roller from end to end in a narrow swath (Illus. 67). Start *alongside* the seam and continue around, stopping *beside* the seam. Never scrape the seam itself or it will give you trouble in printing. As you scrape, pull the knife toward you with the blade angled *against* the nap. After once

Illus. 59—Diagram of roller types.

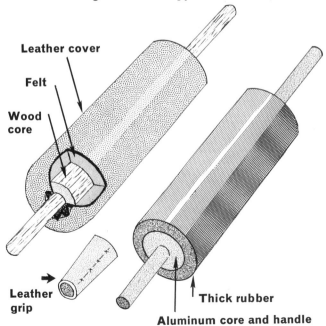

Leather cover

Felt

Wood core

Leather grip

Thick rubber

Aluminum core and handle

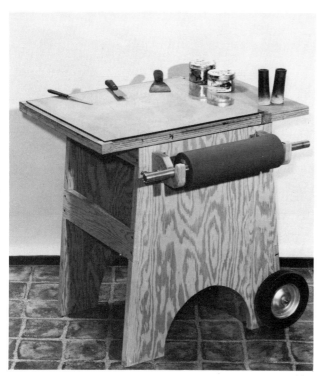

Illus. 60—A portable ink slab with folding roller cradle on side. Note leather roller grips on table top at right.

Illus. 61—Construction details of portable inking table.

21″ × 32″ plywood top, covered with battleship linoleum; 30″ high.

20″ × 24″ × ¼″ glass ink slab

Aluminum-angle slab retainer

Folding cradle for ink roller

8″ wheels

around, go round the roller again, this time angling the blade in the opposite direction so that it scrapes *with* the nap.

Step 3: Repeat Step 1.

Step 4: Repeat Step 2. Space the job out. It needn't be done all at once.

Step 5: Wipe the roller down with a coarse rag until it is practically dry. Apply some stiff litho varnish (#7) to the roller as if it were ink and roll it out on the ink slab. Keep rolling until the varnish is spread out in a thin coating. Notice that the varnish is pulling the nap from the roller, and the slab is fuzzy with it.

Step 6: When the varnish gets too full of nap, scrape the roller clean and wash the ink slab with kerosene.

Step 7: Repeat Steps 5 and 6 two or three times, until the varnish rolls out clean, pulling no more nap from the roller. Clean roller and slab.

Step 8: Roll in Crayon Black (chalk black) ink softened with a little #3 litho varnish. For the next two or three days, whenever you pass the ink slab, take the roller out of its cradle and roll it a few times over the ink. Crayon Black is non-drying and can safely be left, but cover the slab and roller with a

piece of corrugated cardboard that is supported high enough above them to keep from touching them. This keeps off dust.

When you are ready to use the roller for actual printing, scrape it down again, clean the slab and

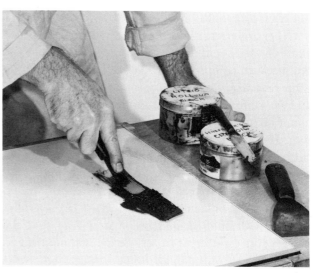

Illus. 62—First work the ink on the slab by mulling and kneading it with the flat side of a flexible putty knife. The wide wall-scraper (right) is used to scrape ink off the slab.

42

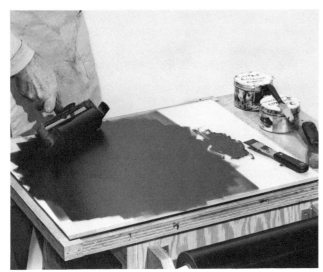

Illus. 63—For small stones, you can use a brayer. Roll out the ink on the slab to a smooth, even consistency.

Illus. 64—Using the litho pattern hand roller for rolling out ink on the slab.

roll up a fresh charge of Crayon Black, Litho Black, Stone Black, or whatever ink you will use to print the edition.

The Nap Leather Roller for Color Printing

To break in a leather roller for use with color, choose a colored ink that is representative of the color group it is to be used with. Follow Steps 1 through 7, then:

Step 8: (for colored ink roller) roll up in a representative color and let sit a half hour or so. (Never leave colored ink on a roller for a long period. It dries quickly and you will have to break the roller in all over again.) Wash the ink off with turpentine and wipe dry with a rag. If you are not ready to use the roller at once, rub on a heavy coating of mutton tallow or vaseline (petroleum jelly) and wrap it in cling plastic for storage. For use, scrape the grease off, wash thoroughly with turpentine, dry with a rag, then roll in ink. Clean the roller immediately after use and, if it is not to be used again for several days, put it down once more in grease and plastic.

You can buy *smooth* leather rollers for use with color only. Some lithographers prefer these. The

Illus. 65—A selection of knives for working the ink. 1—stiff-bladed wall scraper; 2—putty knife with flexible, 4″ blade; 3—painters' palette knife with 4½″ blade; 4—trowel-shaped palette knife.

Illus. 66—A cradle for the ink roller, used in washing up.

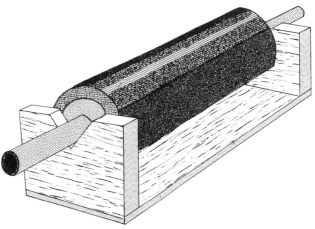

Illus. 67—Scrape the leather roller from end to end with the back of a table knife. Angle the blade against the nap, then with it.

advantage of the smooth roller is that it does not require scraping, only washing with turpentine after use or storage.

Care of the Leather Roller (Black Ink)

After use, scrape it down, then roll it again in black ink (Crayon Black). A thick coating will keep the roller in good shape without attention for several days. Or, you can leave ink on the slab and roll the roller in it every day, whether it is used or not. This can go on indefinitely.

For occasional use, cling plastic around a coating of Crayon Black will keep the roller in condition for a couple of weeks. For a longer time, apply a thick coat of mutton tallow or vaseline and wrap in cling plastic. Scrape the roller, wash with turpentine and wipe it dry before use.

The Ink Slab and Mixing Tools

A marble or slate stone is often used for rolling out ink, but such a stone is expensive, bulky, heavy and often in the way. Better for your purpose is a 20″ × 24″ piece of $\frac{1}{4}$″ plate glass. You can place the

glass on a table for use, or make a portable unit for it (Illus. 60–61), so you can push it back out of the way when you aren't using it.

Illus. 65 shows tools for working the ink—a stiff wall scraper with 3″-wide blade, flexible putty knife, and a couple of palette knives.

Lithographic Inks

Some lithographers use regular offset inks as manufactured for the commercial printing trade. If these are too soft, you can stiffen them with magnesium carbonate. Most, however, cultivate a preference for inks prepared especially for stone lithography and the hand-operated transfer press. You can buy such inks at lithography supply houses (see Appendix) but be sure you buy "stone inks" or equivalents (Stone Black, Stone Autumn Brown, etc.) especially compounded for this use.

Crayon Black ink is a stiff, heavy-bodied ink containing a great deal of pigment. It is used for rolling up the stone with ink, for proving and printing. Roll-up Black should be a very stiff ink for roll-up purposes, but sometimes it is made too loose.

Any ink that is too stiff to roll out can be softened by adding a very small quantity of some softer ink, or a little #3 litho varnish. Add magnesium carbonate to stiffen a soft ink and work it in with a putty knife. Magnesia also reduces the gloss of the ink, making it matte or dull.

Rolling Out the Ink

Take about a level tablespoonful of Crayon Black ink from the can with the putty knife. Squeeze it down at one end of your ink slab. Press it down, pick it up, turn it over, press it down again. Work it vigorously to loosen it up (Illus. 62).

Dab a little ink here and there on the roller with the putty knife, then run the roller back and forth on the slab. If working with a brayer (pronounced bry-er) (Illus. 63), lift the roller after each forth-and-back stroke and let it spin. With the litho pattern hand roller, pick it up and shift it about a quarter-

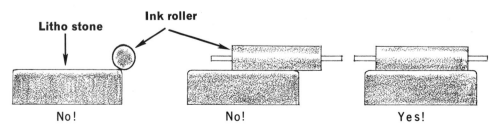

Illus. 68—Over-running the stone with the ink roller as at left and center puts ink on the edges that will soil the printing paper.

Litho stone Ink roller

No! No! Yes!

Illus. 69—Wash off the old etch with a sponge and fresh water; or take stone to a sink and turn the faucet open on it.

Illus. 70—When old etch is completely removed, dry the stone in the blast of an electric fan.

turn or so, holding the handles in leather hand grips. In addition, after every three or four rolls, stop, take hold of the right-hand handle with your left hand, cross your right hand over and take hold of the left-hand handle, and turn the roller completely around, end for end. *This is important!* It assures smooth, even rolling-out of the ink and even coverage over the roller.

If your studio is cold, you may find it difficult or impossible to roll out the ink. If so, add soft ink or varnish as noted above. In hot weather, even the stiffest ink rolls out without trouble. To make the ink

stiff enough for printing, you will have to add magnesium carbonate to it.

The perfectly rolled-out ink should have a smooth, velvety look about it. Put a piece of white paper under the glass slab. Add ink to the slab and roll it out until the layer becomes just opaque enough so that you cannot see the shine of the white paper through it. The roller should pull at the ink with a soft, whispering sound. If the sound is too shrill, the ink is too thin; if it is too dull and sloppy sounding, there is too much on, so scrape some off with the wall scraper and roll the remainder out smooth.

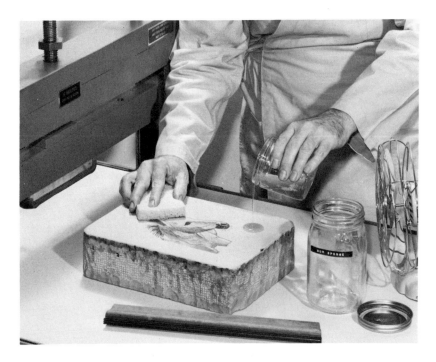

Illus. 71—Pour a puddle of pure gum arabic on the stone and spread it round with a sponge.

Processing the Stone through the Second Gum-Etch

Step 1: Clean the Gum-Etch Off the Stone

Set the stone on your press bed, work table, or on a wooden grating in a sink. Flood it with water and wash off all traces of the old etch with the etch sponge (Illus. 69). Rinse well. With a squeegee devoted only to removing clean water from the stone, or with the edge of your hand, wipe off the superfluous water and dry the stone with an electric fan (Illus. 70). The fan should have a long cord and a body- or line-switch, as you will use it in printing and it will have to ride the press bed back and forth.

Step 2: Gum Up the Stone with Pure Gum Arabic

Pour a little gum arabic on the stone (Illus. 71), and rub it about with the gum sponge or the flat of your hand, covering the entire stone.

Illus. 73—Sprinkle turpentine on the stone to wash out the drawing. Don't put too much on.

Illus. 74—Wash out the image with a rag dipped in turpentine and asphaltum. Use circular strokes, light pressure.

Only a very *thin* coating of gum may be left to dry on the stone, so take a rubber squeegee, which must be used *only* with *pure* gum, and draw it slowly and carefully across the stone in several directions (Illus. 72). Wipe the blade clean with a rag between strokes. Finally, smooth the gum coating with strokes of the edge of your hand, then rub it down with a rag. Fan the stone dry.

Step 3: Wash Out the Drawing

Now you have to get rid of the black coloring matter in the drawing and you do this with turpentine. The purpose of the gum coating in Step 2 is to protect the undrawn areas of the stone from the turpentine, which would otherwise foul up the printing later on. It must be thin so that the drawing projects through it, and so that the turpentine can get at it.

Sprinkle a teaspoonful or so of turpentine from a bottle fitted with a clothes-sprinkler head (Illus. 73) having all but the central holes stopped up with metal cement. Wipe the turpentine evenly over the stone with the turps sponge, then take a turpentine-wet rag and carefully go over the entire drawing, rubbing with a *light*, circular motion (Illus. 74). The color will dissolve and smear around, leaving the drawing only a pale ghost of itself.

Now dip the rag in a little liquid asphaltum and rub this into the drawing to add to its grease content and improve its attraction for printing ink. The drawing will now turn brown and become more clearly visible. Instead of asphaltum, you can use black printing ink.

If the color refuses to depart from some parts of the drawing, don't scrub. The trouble is that the gum is too thick at this spot for the turpentine to penetrate, so just leave it.

Once the image looks good, dry the turpentine mess on the stone, using the fan. You can work with sponge and water now, but it goes better if you put the stone directly under a faucet and turn the water on heavily enough to flood the stone abundantly. The water dissolves both the dried turpentine and the gum and washes them away. If you have left any spots of undissolved color, take your turpentine-asphaltum rag and wash them out now, through the protective film of flowing water.

If some parts of your drawing are paler than others, you have rubbed too hard and removed the asphaltum. Replace it now through the water film with the turpentine-asphaltum rag. Continue to flood the stone until all excess oily material is washed away, then shut off the water, wipe the stone with the edge of your hand, but do *not* dry it!

Although some lithographers apply asphaltum as described as a regular practice to every stone, others deplore its use except when the image may be under-developed—not fat enough—and have need of extra grease-attracting ability. Since you cannot tell by looking at the drawing whether asphalt is needed or not, go ahead and use it. It will help bring

Illus. 75—Damp the stone with a wrung-out sponge prior to applying the ink roller.

Illus. 76—Roll the stone with a brayer four or five times, then re-damp the stone before rolling again with fresh ink.

Illus. 77—Small, rubber brayers like this can be used on small stones and are useful in color inking, especially when applying color selectively.

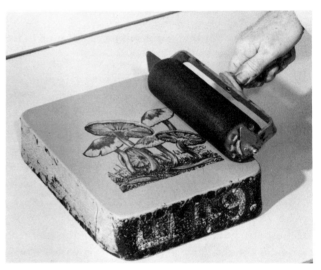

Illus. 78—The leather brayer is best for black ink—or, it can be used for color, too. See text.

the drawing up to printing strength more quickly and you will waste less time and material at the printing session.

Step 4: Roll Up the Stone with Crayon Black Ink

If you were to let the stone dry while the drawing is unprotected with ink, it would very quickly go blind—that is, the image will be reduced to a condition where it refuses to take ink and you will never be able to print from it. Therefore, you must ink the drawing on the stone at once.

Have ready at the printing site, two plastic buckets, one of them half filled with water (Illus. 69). Under the press bed is a good place to keep the buckets. Carry the dripping stone to the press bed, take the stone damp sponge out of its jar, dip it in

water, and wring it out into the empty bucket. Carefully wipe the face of the stone, removing all *excess* moisture. The stone must be *damp*, not *wet*, and it will take a little practice for you to recognize the appearance of a just-right damp stone. Wipe with the *edge* of the sponge, without pressure, squeezing the sponge into the empty bucket as needed, until the surface looks soft and velvety and you cannot see any water standing on it.

Generally, when inking the stone, roll the brayer crosswise to the drawing first, then in its longer dimension, and finally, diagonally, first from one corner, then from the other. This is to be sure that you are applying the ink as thoroughly as possible. This is a fine way to ink up a big stone, but, where

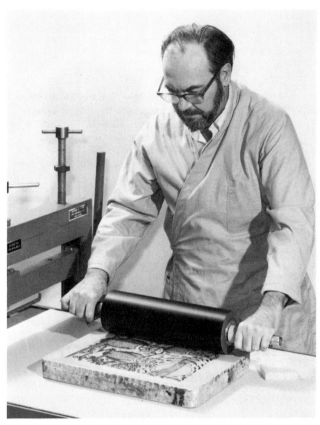

Illus. 79—Rolling in a larger stone with the litho pattern hand roller. The stone must be kept damp so as to reject the ink.

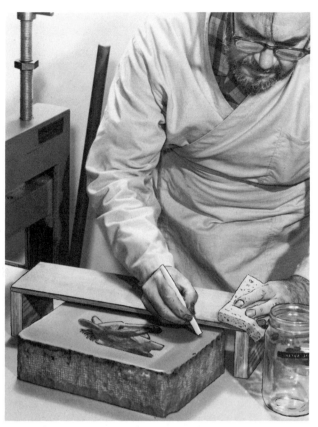

Illus. 80—Erase dirt and smudges from the margins with snake slip.

roller and stone are much of a size, you can safely run the roller at most in two directions and sometimes only in one. It is better not to roll in any direction that allows any part of the roller to overhang an edge of the stone. Inked edges are a nuisance to clean.

Now, roll the ink roller quickly on the ink slab, wipe the stone again, then run the roller three, four, or five times back and forth across the drawing, lifting it between rolls to let it turn and thus present a fresh surface to the drawing. If the ink tends to come off on the margins of the stone, stop, put the roller aside and set about removing the inked edge.

With a dry forefinger (keeping the stone damp), rub loose any ink or scum that has been laid down where you do not want it and wipe it clean with the sponge. Rinse the sponge by dipping it in clean water and squeezing it into the slop bucket.

NOTE: Never let the stone dry out while rolling it with ink. If you do, the clear areas will take ink and turn black. If this happens, stop at once. Damp the stone, re-roll the roller in fresh ink, then roll it *swiftly* across the stone, snapping it up at the end of the roll. Slow rolling deposits ink on the drawing.

Fast rolling picks it up. Continue damping the stone and rolling quickly until the excess ink is removed. If this doesn't work, scrape the ink slab and roll out the remaining ink. Do this several times, until the roller is covered by only a *thin* layer of ink, then repeat the damping and snappy rolling procedure. A few stubborn stains on the stone can be removed by rubbing them away with a dry finger and wiping off the residue with a sponge.

If for some reason the excess ink stains resist, at least partially, such treatment, you will have to flood the stone with water at the sink and wash out the entire drawing with turpentine, giving special attention to the unwanted smears. Then remove the excess water and roll the stone again with ink, after you have replaced the ink removed from the stone.

Again dampen the stone and roll it four or five rolls; dampen the stone, roll the roller in ink on the slab to re-charge it; dampen the stone and roll the roller across the image four or five times again. Apply three such inkings to the image on the stone. If you are using a small-diameter brayer, apply a larger number of inkings to make up for the smaller

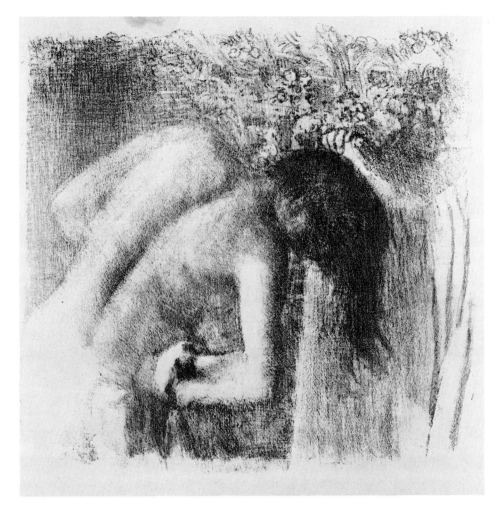

quantity of ink being carried to the stone each time.

Each time you roll the roller or brayer in ink, then several or more times across the stone, you have performed an "inking." If the image still looks a little light, keep on inking until it comes up to strength, looking as it did when you drew it in all its different tones.

Roll the roller in fresh ink and put it aside in its cradle. Some lithographers go ahead and print at this stage, pulling a few proofs to see how the stone is doing. This procedure, however, can sometimes give you more trouble than satisfaction, so it is strongly recommended that you do not try to pull a proof from the stone until it is fully processed.

Step 5: Powder the Stone with Rosin and Talc

Do this as described in Chapter 3—Illus. 40–41.

Step 6: Clean the Margins of the Stone

Dampen the *plain water sponge*, wring it out, and carefully wipe the excess powder from the *margins* of the stone. Wet them well. If they show dirt or ink spots, or if you rolled the roller over the edges and got ink on them, now is the time to clean them up. Keeping the affected parts wet, rub off what you

can with a dry fingertip, then carefully scrape away the remainder with snake slip (Illus. 80), an artificial abrasive stick that works best when wet. You can also use a thin stick of Scotch hone. Excess spots within the drawing should be dampened and cleaned out in the same way, or scraped away with the point of a knife. Scraping the stone removes from the scraped spots the protection given it by etching, so these areas will now have to be re-etched.

Step 7: The Plain Water Etch

This step takes care of re-etching and, at the same time, adds extra sharpness to the drawing, preparing it for the final gum-etch. Work this at the sink, where water is handy and plentiful.

Since printing ink powdered with rosin and talc is more resistant to acid than similarly treated grease pencil, you can increase the strength of the etch by a considerable amount. Pour an ounce of tap water into your 2-oz. graduate, add *twenty* drops of nitric acid, and stir it up.

Pour a little of this etch on a corner of the stone and immediately brush it around the margins of the stone (not over the drawing) with the etch brush.

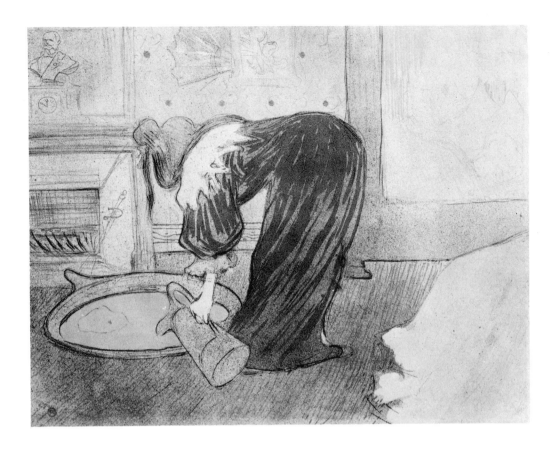

Illus. 82—"Femme au tub," lithograph in color by Henri de Toulouse-Lautrec (French, 1864–1901). The National Gallery of Art, Washington, D.C. Rosenwald Collection.

The solution will effervesce instantly and furiously, but it quickly dies away. Dip the corner of the brush into the etch from time to time and feed it to the margins, keeping them wet. This long, preliminary etch is to re-etch and harden the margins, so watch the clock on this for *2 solid minutes.*

At the end of this time, dash the remaining water etch (about half of it) across the drawing and quickly spread it about with the brush. Move the brush around in the effervescence for anywhere from 10 seconds to a full minute, depending on the general depth of tone of the drawing. The donkey received the treatment for one minute.

The drawing snaps up in appearance as the etch bites into it and, when it looks positively brilliant, open the faucet and flood the stone with water, thoroughly rinsing the surface clean of etch.

Squeegee the surface, then dry with the electric fan.

Step 8: The Second Gum-Etch

To one ounce of pure gum arabic, add 10 to 12 drops of nitric acid for a light drawing, 15 drops for a medium drawing (the donkey), and 20 drops for a drawing having a lot of heavy blacks.

The quantity of acid you use is not critical and, at the worst, you might merely over-etch a few extremely light lines so that they would print even lighter than you put them down, so don't worry about the quantity of acid to use, but note carefully what you are doing for guidance next time.

You want the same items on hand that you had before, when gum-etching the stone; so, pour the etch into its dish, dip in the etch brush (which you rinsed thoroughly after the last use), and brush the etch about on the stone for the next 3 or 4 minutes. Remove the etch by soaking it up twice with newsprint, wipe the stone down with your hand, then polish with a cloth.

If you would like a breather at this point, you can let the stone sit in the etch for 30 minutes to 4 hours before going on, or you can wait until the next day to pull the first prints from it. If you leave it, you can also leave the Crayon Black ink on the roller and ink slab (but covered), and it will be ready for you when you are ready to print.

On the other hand, at the end of the etching time, if you prefer, you can simply wash the etch off the stone and rinse it and dry it for Step 9.

Step 9: Gum Up the Stone with Pure Gum Arabic

Again, you must gum up the stone with a *thin* coat of pure gum arabic, precisely as you did it before, in preparation for again washing out the drawing.

Now you may either leave the stone until the next day, or wash it out immediately and get started at printing.

51

Illus. 83—Lithograph, "Cherubs," by Manly Banister. Some old-fashioned cherubs, sporting in the Empyrean. Drawn with pen and tusche; black areas brushed in.

Illus. 84—"Les Cigales et les Fourmis" (The Locusts and the Ants). Lithograph by Paul Gauguin (French, 1848–1903). The National Gallery of Art, Washington, D. C. Rosenwald Collection.

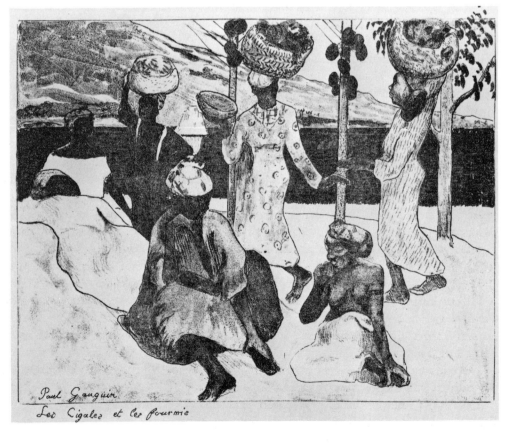

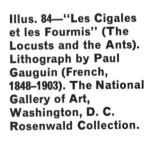

Paul Gauguin
Les Cigales et les fourmie

Illus. 85—"De slang rooft het levenskruid" (The Serpent Steals the Plant of Eternal Life), color lithograph by H. van Kruiningen (Dutch, 1906–). Courtesy of the artist. This is one of a series of color lithographs made for a bibliophile edition of The Gilgamesh Epic, illustrating the passage where Gilgamesh, the Sumerian epic hero, returning to the upper world with the plant of life, has it stolen from him by the serpent as he bathes.

Illus. 86—"Off the Coast," lithograph by Lyonel Feininger (American, 1871–1956). The National Gallery of Art, Washington, D.C. Rosenwald Collection.

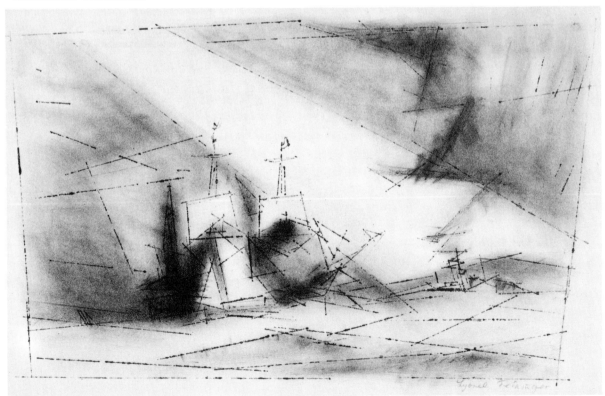

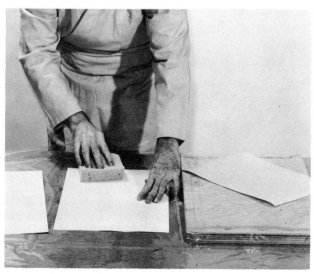

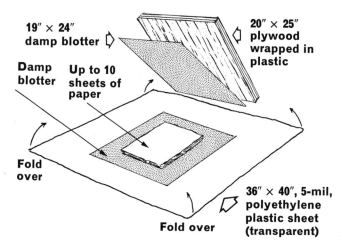

19" × 24" damp blotter ⇨

20" × 25" plywood wrapped in plastic ⇦

Damp blotter

Up to 10 sheets of paper

Fold over

Fold over

36" × 40", 5-mil, polyethylene plastic sheet (transparent) ⇦

Illus. 88—Diagram of the damp pile.

Illus. 87—Damp the paper and/or blotter not too heavily with a sponge. Note plastic-covered plywood at right.

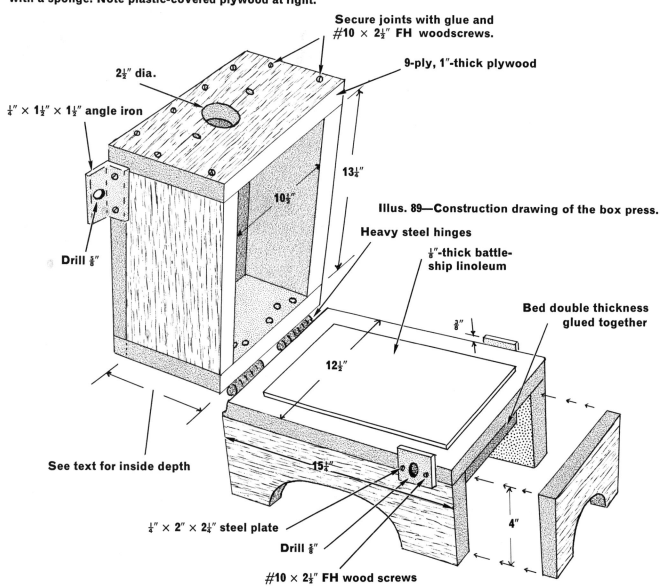

Secure joints with glue and #10 × 2½" FH woodscrews.

9-ply, 1"-thick plywood

2½" dia.

¼" × 1½" × 1½" angle iron

13¼"

10½"

Illus. 89—Construction drawing of the box press.

Heavy steel hinges

⅛"-thick battle-ship linoleum

Bed double thickness glued together

Drill ⅝"

12½"

⅜"

See text for inside depth

15¼"

4"

¼" × 2" × 2¼" steel plate

Drill ⅝"

#10 × 2½" FH wood screws

54

6. PAPERS AND LITHOGRAPHIC PRESSES

Paper

Before it will do you any good to wash out the stone and prepare it for printing you have to have two things: (1) something to print it on; and (2) something to print it with. These are, respectively, printing paper and a lithographic transfer press, either hand-operated or motor-driven.

Your first step is to decide how many prints you want or think you will need. This number can be anywhere from 5 or 10 to 50 or 60. The group of prints pulled from a stone is called the "edition." After the edition is pulled, the stone is re-grained to destroy the printing image so that no more prints can be made from it.

You could, of course, print a few proofs from the stone, then gum it up and, after these were sold, proving there was a demand for them, print up some more, and so on. However, in the first place, this practice ties up the stone. Unless you have an endless number of stones at your disposal, you would soon be out of work. In the second place, if you are printing in color, it is best to print the entire edition at once, because you never again can get the exact same mixture of colors, and the prints would vary in appearance from printing to printing—and this is not to be permitted.

For the present, anyway, keep your editions small and you will at least have the joy of knowing that you are not wasting expensive print paper. Pull all the prints you intend to make in one session for best results.

The basic paper for you to stock is newsprint. You can buy it at a paper house, sometimes at a well-stocked art supply shop in cut sizes or large sheets. Don't buy the coarse, woody-looking kind, but the blue-white kind with a smooth surface. You will use it for making rough sketches, for menial service in the processing, and for pulling the first proofs from a stone, while you are bringing the printing image up to strength.

You must make your own decision about the kind of paper you want to make your final prints on. At first, I suggest some inexpensive, machine-made papers. Don't print on papers having a strong or coarsely grained surface. Such papers are ideal for offset lithography, but the great pressure of the scraper board in the litho transfer press flattens out

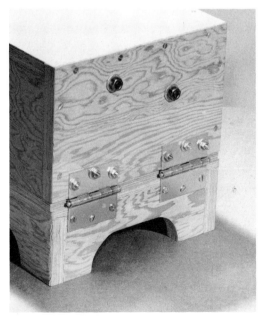

Illus. 90—Note heavy hinges, tilted position of rear-bearing retaining bolts. If 1″ plywood is unavailable, glue two pieces of ½″ ply together.

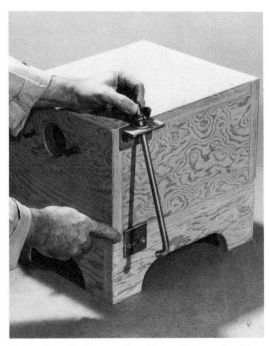

Illus. 91—Note construction of press locking rod. Operates quickly, holds securely.

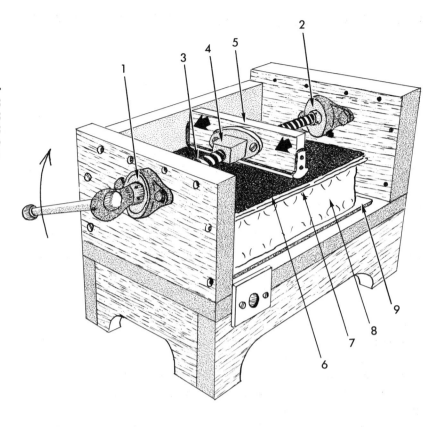

Illus. 92—Cut-away of box press, showing: (1) Front bearing; (2) rear bearing; (3) 1⅛″ bench screw; (4) bench-screw nut; (5) scraper board; (6) greased tympan; (7) print paper and backing; (8) litho stone; (9) ⅛″-thick battleship linoleum tacked to press bed.

all such grain, giving the printed sheet a look of curious, double identity.

Some papers (manufactured in different countries but available almost everywhere) that will do for beginning prints are: Curtis Rag (white), Perfection Alexandra, Graphic Heavy Weight, Basingwerk (slick surface), and Rives Light. When you get on to the processing and feel that you are not wasting paper, try some of the following: Rives, BFK; Arches Heavy Weight (hand-made); Rives Heavyweight (a slightly cream-colored sheet); Copperplate; and so on. In addition to machine- and hand-made rag papers, the market also provides an extensive line of Japanese-type papers, from thin, tissue-like sheets, to heavy. These papers are unsized, made of rice straw and similar basic materials, and often have a very beautiful appearance. Try the heavier papers, such as Kochi, for black-and-white prints and simple color work. For very inexpensive work, Tableau is a paper that resembles the Japanese papers, and Printmaster has the appearance of parchment or vellum.

In addition, you can print on hand-made, rag watercolor paper to good effect, in all available weights. Choose hot-pressed (smooth) or cold-pressed (medium) surface. Rough watercolor paper is too coarse.

There is one pleasing thing about a good, hand-made rag paper. It will last for centuries. Who knows? Perhaps one of your prints will still be around a few hundred years from now. It is a kind of immortality that you may enjoy thinking about. (See Appendix for list of papers and suppliers.)

For the proper handling of paper, you must know the felt side from the wire or screen side—that is, the face from the back. The easiest way to tell which is which is to look for the watermark. Hold the sheet up to the light. If the watermark has readable lettering, you are looking at the face side. From the back, it reads backwards.

If the paper has been cut and the piece has no watermark, examine both sides carefully. The rough side is the wire or screen side, the back of the sheet. Always print on the face side. To avoid difficulties, always store paper face side up. When it goes to the paper cutter, cut it face side up, and stack the cut sheets the same way. When printing, turn the face side of the paper downwards against the stone; this is the only time the paper should ever assume any position other than face up.

Damping Paper for Printing

Paper takes the ink better when it is slightly damp, resulting in a nicer looking print. Of course, some lithographers do all their printing on dry paper and do quite well at it. To print on dry paper, you must ink the stone more heavily and apply more pressure in the press. However, I suggest you slip a dry sheet in among the damp sheets you print and compare the difference.

Of course, when proving on newsprint, print on dry paper. When the print looks good on dry newsprint, it will look about equally good or better on damp rag paper.

Only a little moisture is needed to condition the paper. Too much might make it refuse the ink and defeat your purpose. Illus. 87 gives an indication of the damping procedure. Lay down on the table a sheet of 5-mil, polyethylene sheet plastic measuring about 3 feet by 4 feet. (Buy it at a lumber yard or mail order house.) You should have two weighting boards prepared, cut from plywood, one measuring 13″ × 20″ (to cover half a blotter sheet), the other 20″ × 25″ (to cover a full-size, 19″ × 24″ blotter). You will use one or the other on top of the paper pile, depending on the size of the paper you have cut. (Cut your print paper to the same size as the stone; or, it can be an inch or two larger in each dimension, or even smaller, if the drawing on the stone is quite small.)

Place the right size of blotter on the sheet of plastic, in the middle, and, with the *paper damp sponge*, dab water into it all over—but not enough to make it really wet. Divide your quantity of print paper into piles of 8 or 10 sheets. Lay one such pile *face up* on the damp blotter, cover it with a second blotter and damp it as you did the first one. Lay on the second pile (if there is one), cover with a blotter and damp it, and so on, until all the paper is laid down. You should finish with a blotter on top. Now lay on the sheet of plywood, wrapped in 5-mil plastic which is stapled or tacked to the back. The plastic protects the wood from moisture.

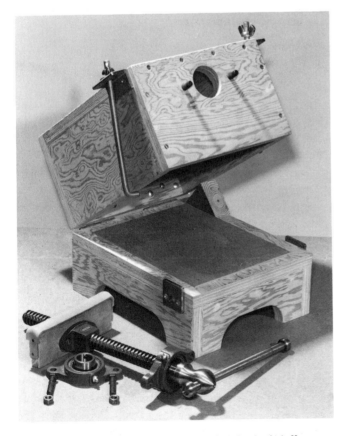

Illus. 93—Construction and mechanical details are readily visible in this photo. Bearings are 1⅛″ size, full size of the bench screw.

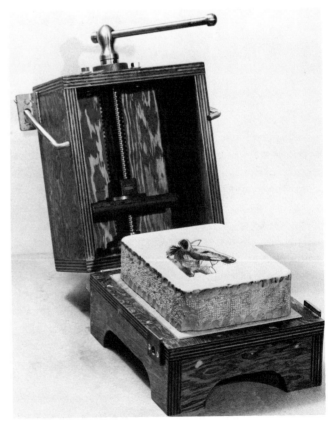

Illus. 94—Litho stone on press bed, ready for printing. Note how front bearing is mounted outside the box, rear bearing inside.

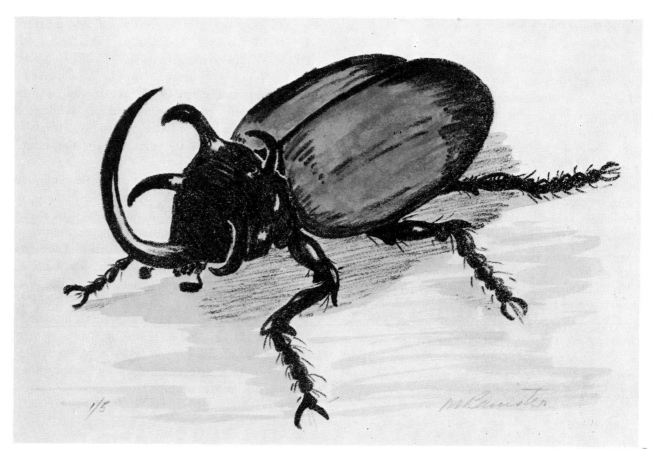

Illus. 95—"Rhinoceros Beetle," hand-colored (acrylic) lithograph by Manly Banister. #180 grain. This print was made with the box press shown in accompanying photos.

Bring the loose sheet plastic up and fold it over the sheet of plywood on all four sides. This prevents moisture from escaping from the damp pile. To keep the paper from buckling the pile must be weighted down, so place a weight, such as a litho stone, on top. (See Illus. 88.)

It is best to damp down the paper the night before you print so that the moisture in the blotters will have plenty of time to penetrate all through the pile. A very heavy paper, such as Graphic, or a heavy watercolor paper would not acquire enough dampness this way; so, in addition to damping the blotters, you should reduce the size of each paper stack to 3 or 4 sheets and lightly damp each sheet as it is laid down.

Quick methods of damping paper are generally not very successful because, if the paper is not evenly penetrated with moisture, it is likely to show the strokes of the damping sponge in the print. However, if you have at least 2 or 3 hours to spare, you can in

an emergency set the paper down this length of time beforehand and hope for the best.

If, when you take paper from the pile, it feels limp, it has been over-damped. A sheet of damped paper should feel almost as crisp as a sheet of undamped paper, but cooler to the touch. Too damp paper can be spread out on sheets of dry blotter and the excess moisture will dry out as you print. A little excess dampness can be evaporated by simply waving the sheet in the air while the stone is drying, particularly if the humidity in the air is low.

The Lithographic Box Press

If you have the idea that you need a big, expensive press to make lithographs, perish the thought! As long as you are content to make small prints, you can build your own press for a cost of about $30–$35 from easily available materials. (See Illus. 89 to 94.)

When Aloys Senefelder was experimenting with the lithographic process, he thought at first that he

could print with an ordinary letterpress. He quickly learned, though, that such a press was incapable of summoning up enough pressure to make a satisfactory print.

The etching press had its own shortcomings. The top roller tended to knock the paper askew and smear the print. He soon realized that he had to invent a special kind of press to go with his special kind of printing process. (How it ever occurred to him that a sliding, scraping pressure was necessary has never been made clear.)

He thereupon invented the litho transfer press, which was equipped with a leather-shod scraper board, made to glide over a greased tympan, and was fed through the press atop the stone by turning the roller under the press bed. Today's transfer presses are direct, or slightly modified, descendants of Senefelder's original conception.

In his book, *The Invention of Lithography*, Senefelder reproduced sketches of some of his designs and offered construction plans for sale. He sold a great many such plans, among them a design for a small press made like a box, which operated by turning a bench screw.

If the idea of the bench screw is unfamiliar to you —it is a long, steel screw with Acme threads, having a cross-handle to turn it by and a nut for it to fit into (Illus. 93).

Harry van Kruiningen of Amsterdam, the distinguished Dutch graphic artist, teacher, and author, searched out Senefelder's original drawings for the box press. He built an example of the device, printed many lithographs with it, and finally included a photograph of it in his book, *Techniek van de Graphische Kunst* (Technique of Graphic Art), published by Lemniscaat of Rotterdam, copyright 1966.

The box press described here has been adapted by the author from van Kruiningen's reproduction of Senefelder's design. I have made a number of lithographs with it, including "Rhinoceros Beetle," reproduced in Illus. 95.

The dimensions given in the drawing (Illus. 89) accommodate a stone 9″ × 12″ in size and slightly more than 3″ thick. The inside depth of the box must correspond to the thickness of the stone—that is, construct this dimension to suit the stone you have. The same design, widened by an inch, would accommodate a 10″ × 12″ stone. Unless a longer bench screw is available, 12″ is the maximum length for the stone.

Illus. 96—"Drawing Hands," lithograph by Maurits Cornelis Escher (Dutch, 1898–). The National Gallery of Art, Washington, D.C. Rosenwald Collection.

Illus. 97—"Daphne verandert in een laurier boom" (Daphne Changed into a Laurel Tree), lithograph by H. van Kruiningen (Dutch, 1906–). One of a series of color lithographs for a bibliophile edition of Ovid's Metamorphoses. Courtesy of the artist.

The bench screw used here (Illus. 93) is an English-made device, most beautifully constructed, with a diameter of $1\frac{1}{8}''$ and a usable length, exclusive of the knob on the end, of $15\frac{1}{2}''$. By the time the thickness of the bearings, the nut and scraper board, and the front of the box are deducted, the useful length is reduced to $10''$. The screw has three Acme threads to the inch.

In order to work easily, you must mount the screw in ball bearings at both ends. You will find details on the scraper board and leather in Chapter 7.

Illus. 90 shows the back where the box is hinged to the base with heavy gate hinges, secured with stove bolts. Note how the mounting holes for the rear bearing are set at an angle. This tilt is required so that the grease fitting on the bearing will clear the stone when the box is closed.

Illus. 91 shows the detail of the box locking device, made of threaded, $\frac{1}{2}''$ rod and fitted with washers and a wing nut. When the turned-over end of the rod is fitted into its socket, the wing nuts are then turned down until the box is completely closed.

To print with the box press, follow explicitly the directions given in Chapter 7 on printing. Grease the scraper-board leather and the tympan as for use with any press. Each time you pull a proof, you must first wind the scraper board all the way to the back of the box. When the box is closed, the scraper comes down on the tympan. At this point, the front of the box must remain open about $\frac{1}{2}''$. If it does not stay open, build up the thickness of the stone by underlaying it with cardboard, hardboard, or similar until it does. From here, further pressure can be applied by adding to the number of blotters in the backing.

Loosen the wing nuts until the ends of the locking bars engage in the holes. Now twist the wing nuts simultaneously, bringing the front of the box down to a fully closed position.

Revolve the bench screw clockwise with a steady movement. It goes somewhat better if you grip the crossbar near one end with a pair of clamping pliers and use this for a handle.

When the scraper automatically stops (after about 30 turns), release the locks with a quarter-turn of the wing nuts and lay the box back. Continue as described in Chapter 7, remembering to run the scraper to the back of the box before pulling another proof.

Although it is comparatively slow in operation, presses such as this were used all over Europe in the early part of the 19th century to produce thousands of lithographic prints.

If you want a professionally built press, you can buy practically any design that appeals to you at whatever price you can afford. If you intend to go all out and use large, heavy stones, you will have to have a heavily built press to stand up under such crushing weight.

Often, you have a choice of a hand-operated press or one that is run by an electric motor. By all means, get a motor-driven press, if you can afford it. Although modern presses are built with gearing to reduce the effort of winding the stone through the press, you will find damping and inking the stone strenuous enough without adding unnecessary extra labor.

If you have heard of breaking the stone by having the scraper board over-run it—that is, fall off the end of the stone—don't worry about it. The motor is geared down so slow and the pressure is so great, that the over-run is only barely perceptible. As soon as the switch is shut off, the machine stops almost instantly. However, as far as that goes, you can over-run a stone with a hand-operated press if you don't keep your attention fixed on the stone, where it belongs.

On pages 62–63 are representations of some popular litho transfer presses. One press is not to be particularly recommended over another, as all will do the job their manufacturers build them for. The choice is yours—depending on price, weight, and desirable features.

A lithographic press bears the same relationship to printing lithographs that a car bears to an excursion in the country. The nicer and more expensive the car, the more you enjoy the ride; but still and all, there are bicycles and motor scooters for those who can't afford a Rolls-Royce!

The presses shown on these two pages are typical of the lithographic transfer press which has been developed from Senefelder's original designs. One style calls for a lever at the side which, when depressed, causes the press bed to rise and force the stone against the scraper.

A later invention is the top-lever press which prints by the same means as the side-lever press, but the design of it is such that pulling the lever forces the scraper board down upon the stone, thus providing the printing pressure required.

There is no difference in the quality of results between the two kinds of presses.

The combination presses, of which at least two models are available in the United States, feature relatively low cost and lightness of weight—both appealing to the occasional lithographer. They can be established in a studio having a wooden floor and are designed with a removable upper roller so that you can print from wood blocks, linoleum blocks and etching plates, as well as from litho stones and plates. When the top roller is removed, the leather-shod scraper board is mounted in its place.

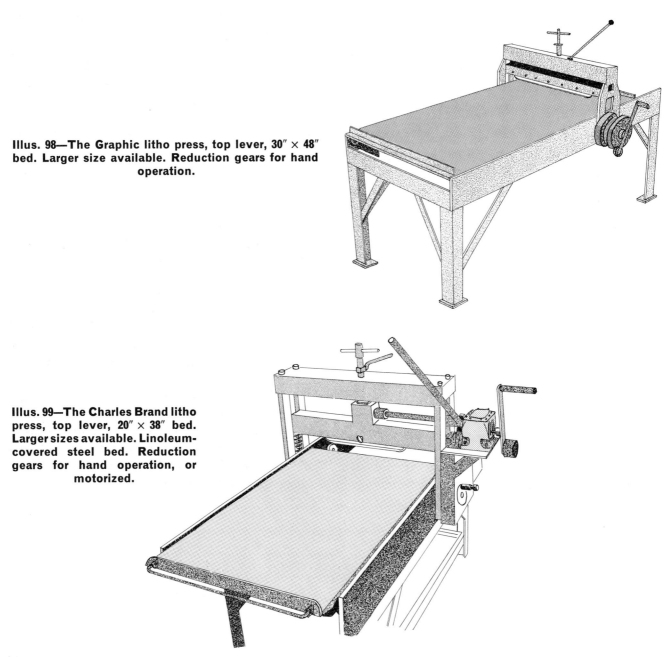

Illus. 98—The Graphic litho press, top lever, 30″ × 48″ bed. Larger size available. Reduction gears for hand operation.

Illus. 99—The Charles Brand litho press, top lever, 20″ × 38″ bed. Larger sizes available. Linoleum-covered steel bed. Reduction gears for hand operation, or motorized.

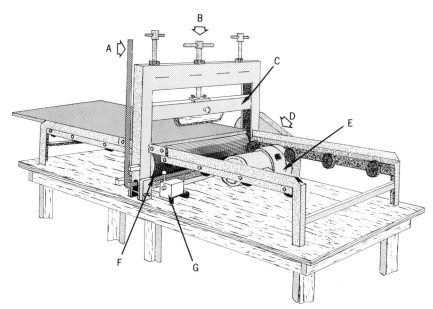

Illus. 100—Wright combination press. Choice of hand or motorized operation. **A**—side lever; **B**—pressure adjusting screw; **C**—scraper board holder (scraper replaced by top roller assembly for printing blocks, etchings); **D**—guard over drive-chain and sprockets; **E**—gear-head motor; **F**—drive roller; **G**—reversing switch. Bed size is 27″ × 48″.

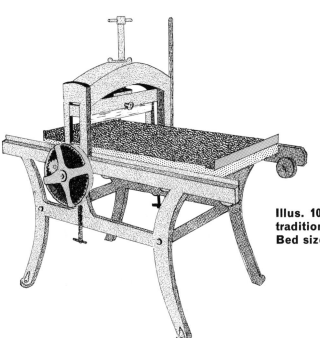

Illus. 101—The Rembrandt litho transfer press, traditional styling, geared hand drive; side lever. Bed size 26″ × 42″ and larger. May be motorized.

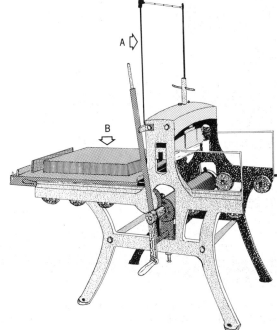

Illus. 102—The American Graphic Arts litho hand press has special features: **A**—tympan held in frame attached to press; **B**—18″ × 24″ steel "stone" for printing from plates. Bed size is 23″ × 31″.

Illus. 103—"Three Owls," lithograph by Manly Banister. Drawn directly on the stone, using pen, brush and dry-brush (hog-bristle). The cloud streak across the moon was put in with litho pencil and scratched.

7. PRINTING THE LITHOGRAPHIC STONE

The Scraper Board

The scraper board (Illus. 104, 107) generally is purchased separately from the press; or, you can make it yourself from a 3″ wide by ¾″ or ⅞″ thick piece of rock maple or some other hardwood. Plane or shape a double bevel on one edge (Illus. 107A).

If you have stones of different sizes, you need a scraper for each size. Do not use a scraper that is too short; it concentrates the pressure in the center of the stone with the likelihood of breaking it. Do not use a scraper that is too long. If it overhangs the stone on either side, or both sides, it will be ruined by the pressure, ruining also the tympan and backing. The ideal length is 1″ shorter than the width of the stone.

If buying, get a 3′ length and a 4′ length of scraper leather. This is enough to make several scrapers of different lengths. (For the box press, you need a board 8″ long and a 12″ length of leather.)

Before shoeing the scraper, try it in the carrier. If it is a little too thick in spots to seat properly, plane or sand it as needed.

The Scraper Leather

Scraper leather comes in a strip, ¼″ thick by 1½″ wide and up to 4′ long. You can buy pieces at a given price per foot or fraction thereof. Cut a piece 4″ longer than the board and soak it overnight. With a knife and sandpaper, round off the corners of the bevelled edge of the board so that they will not cut into the leather.

Nail one end of the wet leather to an end of the scraper, using a large-headed nail. Grip the board in a vice, bevelled edge up (Illus. 107C). Take hold of the free end of the leather with pliers and *stretch* it the length of the board, bringing it down over the end. Check to make sure that the board is perfectly centered with respect to the strip, then, still holding it tight, drive a second large-headed nail through the leather to secure it. As the leather dries, it shrinks and hugs the edge of the board, conforming to its shape.

When the leather is thoroughly dry, cut off the excess with a sharp knife, then trim it in at the sides on the ends (Illus. 107B), so that it will not interfere with seating the scraper in the carrier. Use a square and mark a centerline down one side of the board as a guide for centering when installing it in the press. Smear the leather liberally with grease.

The Tympan and Backing

The *tympan* can be a piece of red pressboard or a sheet of thin metal. Brass, zinc or aluminum are recommended. Aluminum is the most readily available. You can get it at most hardware stores or builders' supply houses. It is used for flashing on roofs.

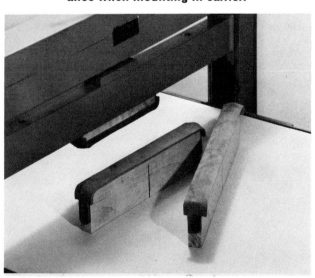

Illus. 104—Typical hardwood scraper boards, shod with leather. Note how leather is trimmed for clearance when mounting in carrier.

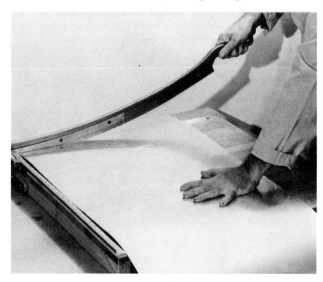

Illus. 105—A large (24″) paper cutter is a must for cutting print paper and tympan metal (shown). Guarantees clean, straight edges.

Illus. 106—Red pressboard must be thoroughly brushed with grease before use.

Cut the tympan about 2″ wider and longer than the stone (Illus. 105). If it is red pressboard, break it in before using by brushing it all over with mutton tallow, lard, or something similar. Let the grease soak in, then brush on more. Do this several times before use; otherwise, the scraper is likely to chatter. When not in use, cover the greased side of the tympan with cling plastic and hang on a nail by means of a corner-punched hole.

Backing is inserted between the print paper and the tympan to take up any slight discrepancies in flatness of the stone and to provide a yielding surface under the tympan to even the pressure of the scraper board.

Backing consists of two sheets of white blotting paper (or half a dozen sheets of newsprint), cut to the size of the stone. Study Illus. 110 for the proper way to "pack" a stone for printing.

Preparations for Printing

Place your two plastic buckets under the press bed, or nearby where they can be quickly reached. One must be half-full of clean water for damping the stone, the other one empty. Set the *stone damp sponge* and the electric fan on the press bed and have a few sheets of newsprint ready-cut to the size of the stone for pulling preliminary proofs.

Also, have some freshly mixed gum arabic in a jar and an ounce of gum-etch (with 10 drops of nitric acid in it). You may not need either one, but if you do, you will need it in a hurry.

Since you rolled out Crayon Black ink while processing the stone, that is already done. If not, roll out some Crayon Black, Litho Black, Stone Black, or whatever you are using. If you would rather print with a colored ink, such as Burnt Umber, Burnt Sienna, or whatever, have it rolled out and ready. If the ink is at all loose-bodied, firm it up with magnesium carbonate. If you have none, try a little cornstarch from the kitchen cupboard, but make sure it is only a little—not over 12% of the bulk of the ink or it will give you trouble.

Inking the Lithographic Stone

Take the stone to the sink and wash out the drawing with turpentine and asphaltum, as described in Chapter 5. Carry the *wet* stone to the press and set it down in the middle of the press bed. The expensive presses usually are provided with a bed covered with battleship linoleum. If yours has no such covering, you must provide it with a piece of ⅛″-thick battleship linoleum at least large enough to go under the stone with some to spare. The purpose of the linoleum is to take up the shock of printing and

Illus. 107—Cross-section of the scraper is shown at A. At B, note how the leather is trimmed in on the ends. At C, installing the leather scraper shoe. Take especial care to keep the board centered on the leather strip.

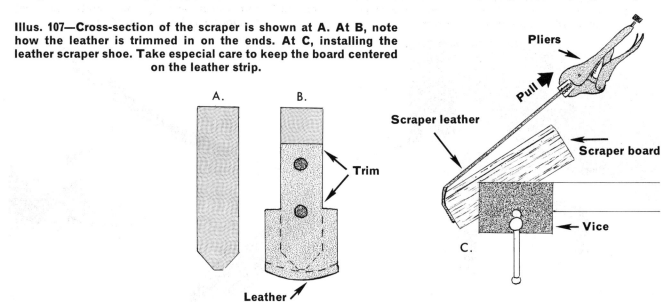

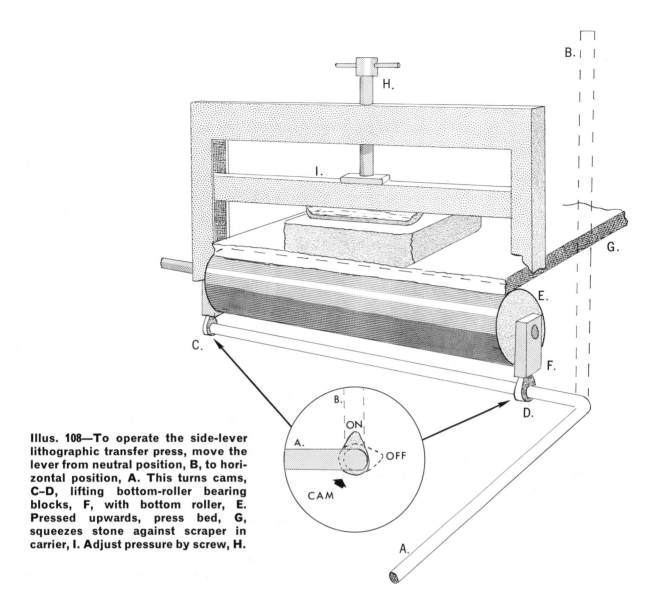

Illus. 108—To operate the side-lever lithographic transfer press, move the lever from neutral position, B, to horizontal position, A. This turns cams, C–D, lifting bottom-roller bearing blocks, F, with bottom roller, E. Pressed upwards, press bed, G, squeezes stone against scraper in carrier, I. Adjust pressure by screw, H.

thereby to keep the stone from breaking. Never print a stone without a linoleum underlay!

Remember that your drawing is unprotected and you must work quickly—but *not* hurriedly!—to protect it with a coating of ink.

Dip the stone damp sponge in the bucket of water and wring it out into the empty one. Wipe the stone down, removing all the excess water. Now turn to the ink slab and roll the roller in the ink. Damp the stone again. Make sure by inspection that it is only *velvety damp* and *not* wet. Roll the roller three or four times across the drawing, turning the roller after each roll. The drawing is now partially charged with ink. Dampen it.

Adjusting the Stone

With a little ink on the stone to protect it, you can now properly adjust the stone with respect to the scraper. Keeping the stone damp, push the press bed so that the leading edge of the stone comes under the scraper. Sight along the stone to ascertain whether the scraper is centered over it. If it isn't, move the stone until it is. Push the bed on through until the trailing edge of the stone comes under the scraper. Check to see that it is still centered over the stone. The scraper must be centered over the stone the full length of its travel and not be allowed to overrun the edge on either side.

Inking the Stone

Maintain this rhythm: (1) damp the stone; (2) roll the roller on the ink slab; (3) damp the stone; (4) roll the roller three to five times on the stone, lifting and turning the roller after each forth-and-back stroke; (5) damp the stone; (6) roll roller on ink slab; and so on, repeating this procedure for each *inking* of the stone. Do not fail to damp the stone both *before* and *after* rolling the stone with ink.

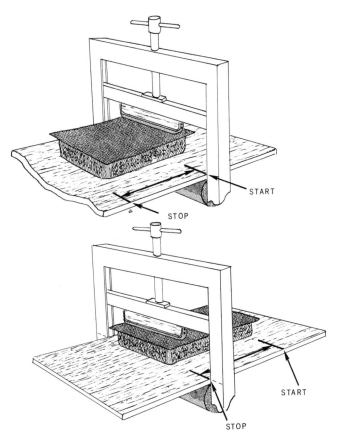

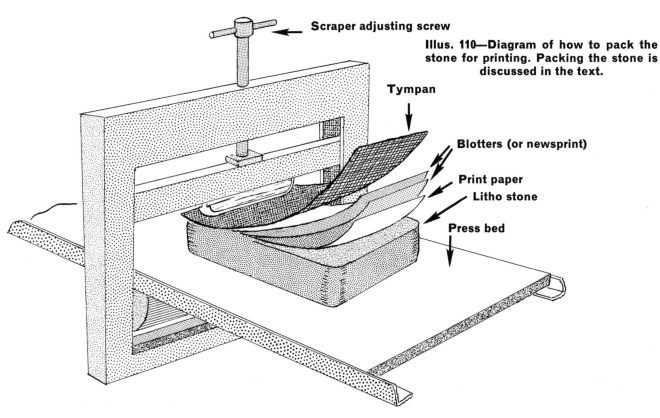

In this manner, apply a total of *three inkings* to the stone.

From time to time, you will find it necessary to re-dampen the stone damp sponge, as it picks up ink and gets dirty. Do it this way: simply dip the sponge in clean water, then wring it out in the slop bucket, several times if necessary. Never wring it out in the water reservoir. Keep an eye on the damping water. As soon as it starts to get dirty, pour it out and replace it with fresh.

After the third inking, put the roller in its cradle and check the stone for scum or spots that may have collected. Clean these off by rubbing with a dry fingertip while the stone is damp and wipe clean with the sponge.

Adjusting the Press Pressure

Turn on the fan and dry the stone. Leave the fan on until every last drop has dried, as damp spots stain the paper. Take a piece of newsprint by diagonally opposite corners and lay it on the stone. On top of it place two blotters, and, on top of these, the tympan, greased-side up (Illus. 110).

Use cardboard clips or facial tissues when you pick up the tympan, to avoid getting grease on your fingers. Hold the leading edge of the tympan down with a wad of facial tissues so that it will readily pass under the scraper, then position the stone so that the scraper is set in about 1″ behind the leading edge.

Illus. 109—To use the marked press bed in printing, adjust bed with **START** mark at press frame. Run stone through until **STOP** mark comes even with frame.

Scraper adjusting screw

Illus. 110—Diagram of how to pack the stone for printing. Packing the stone is discussed in the text.

Tympan

Blotters (or newsprint)

Print paper

Litho stone

Press bed

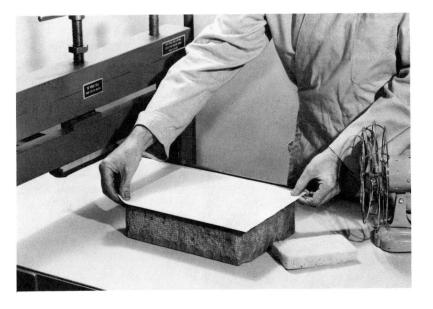

Screw the scraper adjusting screw downwards till the leather *barely touches* the tympan. Test the pressure by pushing the side- or top-lever downwards to a horizontal position (Illus. 113). If the lever goes down easily all the way, there is no pressure on the stone. Return the lever to neutral and turn the adjusting screw down a little. Try again. Keep adjusting and trying until, about two thirds or three fourths of the way down, the lever meets with resistance and you must put your weight on it to make it lie down flat. Don't *force* it!

Illus. 108 shows how the cams operate in applying pressure. Study the illustration until you understand it.

When the pressure seems about right, leave the lever down and push the electric switch to *Forward*, or start cranking the stone through the press by hand. Keep your eye on the stone. (Some printers like to go by a mark on the press bed, Illus. 109.) When the scraper arrives at a position about 1″ from the trailing edge of the stone (Illus. 114), stop the press. Release pressure and pull the press bed all the way back. This manoeuvre will probably leave the tympan sticking to the scraper.

Removing the Print from the Stone

Pick up the stone damp sponge in whichever hand is most convenient, and, with the other, remove the blotter backing and set it aside. Do not snatch the print from the stone. Steel yourself to have no interest in it, for your first concern must be for the stone. Just be patient.

Carefully lift one end of the print off the stone. At the same time, reach under with the sponge and wipe a swath of dampness across the stone (Illus. 115). Lift the print a little more and wipe another swath, and so on, until the print is completely removed. Lay the print aside—don't even look at it—and wet the stone thoroughly. Then, and only then, may you look at the print. It is undoubtedly too light.

Continuing to Print

Repeat the inking process with three inkings, dry the stone and run a second proof through the press. If this one is considerably darker, never mind the pressure. If it is only a little darker, turn up the pressure a little more and run a third proof. You should know if you have sufficient ink on the slab or not. This leaves only the pressure and the working of the stone at fault if the prints continue too light. After the second or third print (or sometimes even

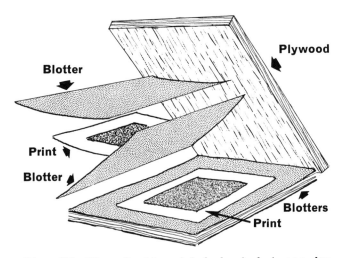

Illus. 112—Place freshly printed sheets between dry blotters and weight down. After printing, change blotters several times.

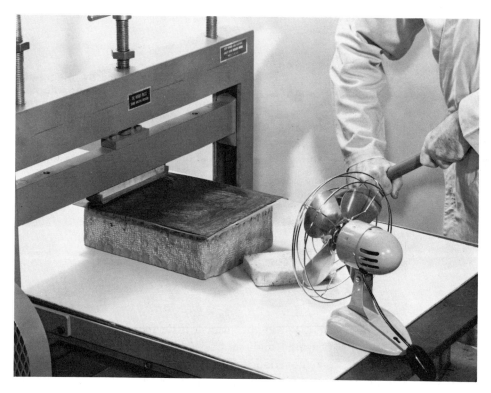

Illus. 113—Start of press run. Move side lever downwards to lift stone against the scraper. Note stone damp sponge, small fan with line switch, and white battleship linoleum covering press bed. As soon as pressure is applied, start the press. Do not let the stone sit under pressure as this forces grease through pressboard tympan, spoiling the backing.

after the second), the print appears fully up to strength and you can open up the plastic damp pile.

Take out the first sheet of paper and hold it ready while the stone is drying in the blast of the fan. When the stone is dry, shut off the fan, take the paper by diagonally opposed corners and lay it face down on the stone. Back it up and run it through the press.

If the last proof on dry newsprint looked good, this print should look good too, but newsprint is easier to print on than edition paper. The print may still look too light, so give it a little more pressure,

Illus. 114—The end of the press run. Note the position of the scraper with respect to the stone. Stop press in this position and immediately release the pressure by lifting the side lever back into its neutral position.

Illus. 115—Remove print carefully from stone. First take away backing; lift print, wipe swath across stone with damp sponge; again lift print a little farther, and wipe again. Do not let stone sit in dry condition.

and run through another sheet. This one should be just right. From now on, you will need less ink—cut the number of inkings, or, the number of rolls per inking.

(If you are using the home-made box press, the only way to increase pressure is by adding another blotter or two to the backing.)

Printing Precautions

Do not have too much or too little ink on the ink slab and roller. Do not apply more pressure at the press than needed. Do not leave water on the stone when you roll it with ink (it makes the ink scum and finally makes such a mess you have to clean up and re-ink roller and slab). Be sure your paper is not too damp.

In the summer, try to print in the mornings, when it is cooler. In very hot weather, give up the idea of printing entirely—you will run into more trouble than a few prints are worth. Temperatures much above 75° F (25° C) are murder on the stone. It acts as if it is under-etched.

Also, hot weather softens the ink and it will leave scum on the stone—you spend more time cleaning the stone than printing. If the weather is also dry, you run the risk of the stone taking on ink, as it will dry out before you can conclude an inking.

Except when paper is on the stone for printing,

the image must always be kept inked and wet. Do not stop immediately after pulling a proof, but always damp the stone and re-ink at once. If you want to take a few minutes off, away from the press, cover the stone with a wringing wet cloth, but do not leave it for more than 10 minutes.

As you know, the crayon lies on the little peaks of the grain in quantity consistent with the pressure with which it was applied. In the same way, the ink clings to the bits of unsaponified material composing the drawing. The ink, though, is somewhat fluid (particularly in hot weather) and therefore it is affected by gravity. It runs—and when it runs, it goes downhill, into the little valleys between the peaks of the grain. The drawing ceases to look sharp; it is melting and flowing together, filling the interstices between the bits of drawing material. If you pull a print, the image looks dark and fuzzy.

You will get a similar fuzzy appearance from printing with *too much ink* and/or *too much pressure*. Excess pressure will always squeeze the fluid ink out into places where it does not belong, destroying the quality of the print.

If you observe this effect right away, you can try cleaning the drawing with *gum-etch* on a soft cloth. Rubbing over the fuzzy places should cause the ink to lift from the untreated parts of the stone. Rinse off the gum-etch with a wet sponge, wipe down the

stone and continue printing after reducing either the amount of ink on the slab or the pressure at the press, whichever seems at fault.

Gumming the Stone

If the stone starts to act up and you don't know what to do about it, don't go on trying to print. Stop where you are and gum the stone with pure gum arabic so it can sit safely by while you figure out what to do.

You will find further discussion of possible printing troubles in Chapter 9.

Also, if you want to knock off for lunch or something that will take you away from the press for an hour or two, simply gum up the stone with pure gum arabic (do not powder the drawing). When you return, wash off the gum under the faucet, give the stone a single inking, and go on printing.

However, if you plan to leave the stone until the next day or longer, you should powder it with rosin and talc before gumming up. When you do this, you will have to wash out the image again with turpentine and asphaltum before going back to printing.

Illus. 112 shows how to put your damp prints in the dry-blotter pile. Lay the print on a blotter, face up, and lay another blotter on top. Place the plywood sheet on top to hold the prints flat while they dry. The print should not set off any ink on the blotter. If it does, it is a sure sign that you are using too much ink, so cut down.

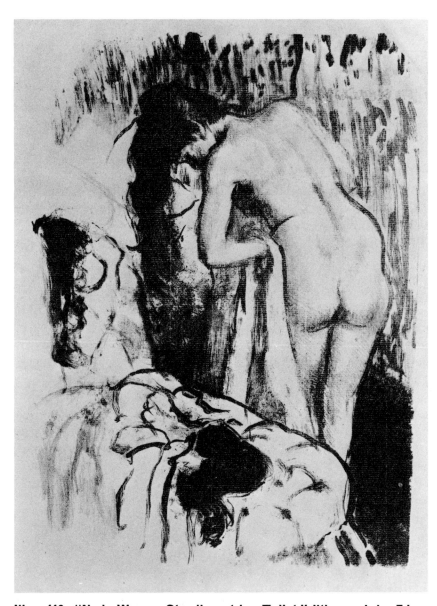

Illus. 116—"Nude Woman Standing at her Toilet," lithograph by Edgar Degas (French, 1834–1917). The National Gallery of Art, Washington, D.C. Rosenwald Collection.

If you forget to weight the blotter pile or, for some other reason, one or more prints come out of the drying process buckled, it is only a nuisance, not a disaster. Never try to mount a buckled print. It will never look good.

Soak a buckled print (or prints) in a tray (several days later, when the ink is dry), drain, place between dry blotters under a board and weight. Change blotters in about 15 minutes, again in a half hour, and again an hour later. That night, change blotters once more, and leave the prints under pressure until the following morning. Prints so treated should never give you any more trouble with buckling.

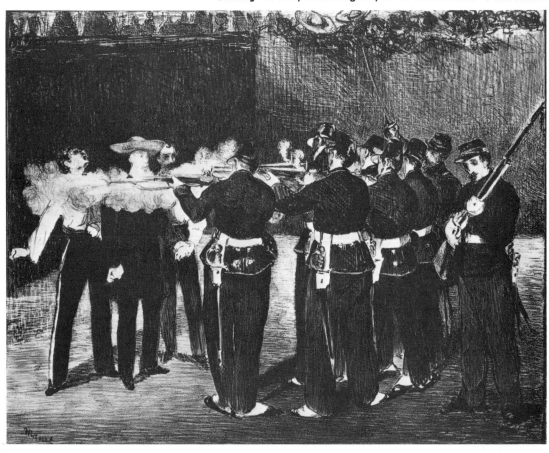

Illus. 119—"Frog," lithograph by Manly Banister. Drawn on a 13″ × 17″ stone in a combination of tusche and crayon. (See text.)

8. DRAWING ON THE STONE WITH TUSCHE

Liquid Tusche

The addition of tusche to your selection of drawing media allows you to create a wide range of interesting effects, impossible with crayon alone. Tusche is available in bottled form and in the shape of a stick of hard, abradable material. You can use either or both.

Remember, it has been said that tusche works best on a fine-grained stone. #220 is the coarsest practical grain, and the finest is a smooth, grainless surface finished with powdered pumice.

You will save a lot of trouble by buying liquid tusche for your general ink work. Save the stick tusche for special effects. Tusche comes in bottles containing from 2 oz. to a pint. All you need now is 2 oz.

Before using, shake the bottle vigorously. When tusche sits, greasy particles condense out and float up into the neck of the bottle. Shaking re-dissolves them. Use an ink-well when drawing (Illus. 124) so you won't knock the bottle over and spill it. After you finish drawing, the remaining tusche can be poured back into the bottle—*so long as you have not diluted it.*

What drawing instruments to use? That depends on the effect you want. Use the same drawing tools you use with India ink, regular steel drawing pens with finest to coarsest nibs, a reed pen, red sable brushes, hog-bristle brushes for dry-brush and spatter effects, and so on.

Tusche must be deposited *opaquely* on the stone. Remember the axiom: what you see is what you get. If you put down a messy-looking puddle of tusche, it is going to reproduce in the print as a messy-looking puddle. This means that you must often paint on two or three coats to get a good-looking black. You may even have to go over pen lines a time or two. The stone does not absorb moisture like paper, so give the liquid depth when you brush or pen it on. As the moisture evaporates, the color sinks down and comes to rest on the stone. You do not

Illus. 120—The stone from which the "Three Owls" print was made.

Illus. 121—Rubbing stick tusche in a saucer. The addition of distilled water turns the rubbed material into lithographic drawing ink.

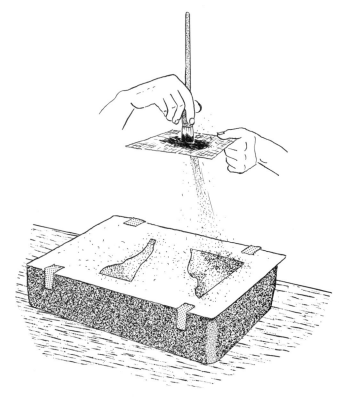

Illus. 122—Lithographic rubbing ink is rubbed off the stick with a piece of chamois skin, then rubbed on the stone.

Illus. 123—When spattering tusche, cover the stone with a "stencil" with openings where the spatter is to go, while the rest of the surface is protected.

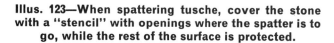

have to wait for lines to settle if you use a drawing bridge (Illus. 124). If the work dries too slowly, turn a fan on it, preferably a hair-dryer with a heating element.

A thin, brownish, mottled line will print with that same appearance. So keep your eye peeled and go over lines as often as necessary.

A solid or textured tone does not have to be all tusche. Lay it in with #1 litho pencil or #0 crayon. Put the crayon down loosely, then take pen or brush and go around the edges of the area and across the middle. Work the tusche in, dissolving the crayon where the two come together. This is how the spots on the frog were drawn (Illus. 119).

Stick Tusche

Dry tusche comes in a bar measuring about $1\frac{1}{8}''$ wide, $\frac{3}{8}''$ thick, and $4\frac{3}{8}''$ long. Expose an end by pulling back the paper wrapping and rub it against the inside of a china saucer that has been warmed (Illus. 121) until some of the material comes off the stick and adheres to the saucer. Make up only enough tusche for the work you are going to do, as stick tusche will not keep and must be made up fresh for each day's work. (Liquid, bottled tusche keeps indefinitely.)

Add a few drops of distilled water and stir the tusche in the saucer with your finger until the color loosens and dissolves. When mixed to a brushing or drawing consistency, liquefied stick tusche is identical with liquid tusche and is used the same way. Make a trial pen line on drawing paper. If the line is too grey, scrape the bar with a single-edge razor blade or knife edge and let the scrapings fall into the solution. Stir until dissolved. If the solution is too thick, thin by adding a drop or two of distilled water.

Mixed with distilled water, stick tusche is identical with liquid tusche. Both may be reduced for tonal washes with distilled water.

Tones and Textures

Tusche is used to paint tones and textures on the stone. Diluted tusche makes light tones, the more it is diluted, the lighter the tones.

Try out your dilutions on a clean, unused stone. For best results, wet the stone first (that is, the area where the tusche is to be applied), then flow the tusche on heavily. Surface tension will keep it within bounds. As the puddle evaporates, the grains of color held in suspension dart around through the solution, cling together, and finally are deposited in the strangest pattern . . . like a fine-grained cloud, when diluted with distilled water.

If you dilute either kind of tusche with tap water,

Illus. 124—A typical drawing set-up for drawing with tusche. Note pen and inkwell, brushes, compass for drawing the circle of the moon, bridge for supporting the hand above the surface of the stone.

even stranger patterns are formed, depending on the mineral content. If your local water is "hard"—or if you use bottled mineral water—you will get fantastically traced patterns. The minerals cause the color grains of the tusche to lump up and string out in lacy filaments in an unpredictable manner. When the tusche is dispersed in an aqueous vehicle (water of any kind), use the same water for painting the stone beforehand.

Different and varied effects can be produced by mixing and diluting dry tusche with turpentine, naphtha (lighter fluid), gasoline, benzol, denatured alcohol, grain alcohol, and so on. Do not use kerosene (paraffin oil) or stove oil, as these are non-drying.

To vary the effect, use a different vehicle for painting the stone before flooding it with tusche. If turpentine-tusche is painted on a surface flooded with plain water, bizarre effects spring into being.

If the area to receive the wash is bounded by crayon lines, take care not to dissolve them by careless brushing. If you want a tone of grey with a darker tone painted into it, the safer practice is to paint the area first with turpentine-tusche, let it dry, then put in the dark accents with water-based tusche.

Washes tend to print somewhat darker than they look when dry on the stone.

Where you have laid delicate tones into a drawing, do not brush gum-etch about on it, as such vigorous action may dissolve the tusche. Flow the etch on and let it sit passively. Sometimes a tone may seem to disappear entirely, only to re-appear when you ink the stone.

Lithographic Rubbing Ink

Also a hard material in bar form, rubbing ink comes in three grades: Soft, Medium and Hard. To use, stretch a piece of chamois skin, or fine silk or cotton, over your finger and rub it on the bar (Illus. 121). When the chamois is charged with ink, transfer it to the stone with light rubbing.

If you overload the chamois or press too hard in rubbing on the stone, you will squeeze the ink particles into the grain and fill it up. As a consequence, the area will print solid black instead of a tone. Rubbing ink also prints darker than it looks, so apply it lightly.

Dry-Brush Effects

Used in a dry-brush manner, the hog-bristle brush (as used by painters) produces interesting effects, with both saturated and diluted tusche. The "bright," or short-bristled brush, works best.

Dip the tip of the brush into the tusche, then press the bristles against the rim of the ink-well to squeeze out as much as possible. Then brush the bristles against a rag or blotter. Test on a piece of paper; when right, apply to the stone.

Some dry-brush effects are produced by lightly brushing with the tips of the bristles, others by dragging the side of the brush across the surface. If the bristles deposit too much tusche, spoiling the dry-brush effect, scrape away the excess with an X-acto knife or similar tool.

Spatter Tones

You can also use the hog-bristle brush to create spatter tones (Illus. 123). By drawing the tusche-filled bristles over a wire screen held above the drawing, the tusche is made to spatter over the surface below. Practice first on newsprint, protecting the surroundings with a cover of newspaper.

Dip the bristles in tusche, press out the excess, then draw the bristles across the screen. The higher you hold the screen, the smaller the spattered drops. The amount of tusche in the brush and the speed with which you draw the brush across the screen are both factors in determining results.

Continue experimenting until you can control the effect, then spatter over the stone. Cover with newsprint the areas you do not want spattered.

Some of the lithographs included in this book for examples show considerable use of spatter. Study them.

Reverse Designs

A spatter or design that prints white on a black ground can sometimes be effectively used. For a reverse spatter, dip the brush in a thin solution of gum arabic instead of tusche. Spatter the stone with it. When it is dry, flow on a wash of turpentine-tusche, or tusche dissolved in some other non-aqueous vehicle (this is to avoid dissolving the gum, which is soluble in water).

You can also draw with a brush or produce dry-brush effects. Use a pen for drawing intricate designs. You can see better what you are doing if you mix a drop or two of methyl violet into the gum. When it is dry, flow on tusche as described above. Litho pencil or crayon can also be used with, or instead of, the tusche.

When the stone is processed, the dried gum dissolves and carries away with it the overlying tusche, leaving the reverse design visible on the stone.

Textures

Pour a pool of tusche into a saucer. Dip into it with crumpled facial tissues, paper towel, rag, natural sponge, or what have you. Try first on a trial sheet. If you picked up too much tusche, take some off against a rag or blotter. The material should be almost dry. Try using a handful of string, some steel wool, absorbent cotton, or planer shavings. Press the material against the stone, then lift straight up to avoid smearing.

Processing the Tusche-Drawn Stone

Process the tusche-drawn stone in the same steps as you did the stone drawn with crayon. Use, however, a stronger etch.

The etch for tusche must effervesce immediately on contact with the stone. You can get this reaction by adding *twenty drops* of nitric acid to one fluid ounce of gum arabic. If this solution does not produce immediate effervescence on your stone, keep adding acid, a drop at a time, to the mixture until it does. Follow this brief resumé of procedure:

Let the stone sit in the etch overnight, then wash it off and lay on a thin coating of pure gum arabic. Wash out the drawing with turpentine and asphaltum, and roll up the drawing with Crayon Black ink. Powder it with rosin and talc, clean the stone with snake slip, and make any final changes in the drawing, scratching out unwanted lines, etc.

Do *not add* anything to the drawing without first counter-etching the area or areas where the addition must be made. With a pointed brush, paint these places with acetic acid solution or white vinegar. Let sit for a couple of minutes, then wash off with water. Dry the stone and draw in the lines desired. Remember, once the stone has been etched, you must *always* counter-etch to re-sensitize the stone before adding to the drawing, then re-etch to fix the addition(s).

Put an ounce of water in your 2-oz. graduate and add to it a minimum of *twenty drops* of nitric acid . . . more if the drawing is a very strong one. Touch some of this etch with a small brush to the corrections in the drawing and allow them to effervesce, then apply the water-etch all around the margins with the etch brush. Let sit for 2 minutes, then spread the remainder of the water-etch over the drawing for a full minute; then flood the stone with water to wash it off.

While the stone is drying, drop *twenty-five drops* of nitric acid into one fluid ounce of gum arabic—more

if necessary. Brush the etch on as usual, but do not brush it around. Let the etch sit on the stone for 4 minutes without disturbance, then pick up the excess with newsprint and rub down the remainder with a rag (keep your bare hand out of etch that is this strong). Or, you can wash off the etch immediately and continue with processing.

If you leave the etch on, fan it dry and let it sit for one-half hour to 4 hours or until the next day, as convenient. Then wash off the old etch and gum up with a thin coat of pure gum and dry it.

Again, you have a choice of washing out immediately with turpentine and asphaltum and starting at once to print, or you can let the stone sit in the protection of the gum coating until you are ready for it.

Just before printing, wash out the stone and place it still wet on the press bed. Ink it up with Crayon black, Litho Black, Stone Black, or whatever you plan to print with, and go ahead and print.

However, it is not as easy to print a tusche-drawn stone as it is one drawn with crayon, so be prepared. Read Chapter 9.

The Transfer Process

The term "transfer" has two meanings in lithography. One meaning is to transfer a texture from something like canvas, lace, embossed paper, the grain of a piece of wood, type that has been set up in a form, woodcuts, linocuts, and so on, to the surface of the stone.

The other kind of transfer deals with transferring a drawing that has been made on a separate piece of prepared or unprepared paper. In other words, instead of drawing in reverse on the stone, you draw on paper exactly as the design is to appear when printed, and transfer the drawing from the piece of paper to the surface of the stone.

Why do this? Well, there are several reasons. In the first place, the grain of the paper—fine or coarse —will be transferred to the stone in the lines and strokes of the drawings. You can thus achieve effects that are impossible when drawing on the stone alone.

If the lithograph is to contain handwriting or lettering, it is easier to do this in a straightforward manner on paper than it is in reverse on the stone. Also, the transfer method saves several laborious steps in tracing and drawing. The drawing is worked up to its final finish on the paper, then transferred to the stone in a single step.

Illus. 125—When drawing on transfer paper, use a bridge to keep from touching the surface. Also, place clean paper under the hand holding the paper down.

The Transfer Stone

To prepare the stone for a transfer, you must first consider the drawing itself, the type of transfer paper to be used, and the effect you hope to achieve. If you draw on a paper having little or no grain and transfer to a stone finished with #180 grain or coarser, the drawing takes on the grain of the stone. If the paper has a definite grain and so has the stone, the two grains might conflict with each other, producing an undesirable effect.

Therefore, when working with transfers, it is best to rely on the paper alone for grain effects and to work with a smooth stone. Prepare the stone by lapping a couple of charges with #FFF grit and the glass muller, then finish off with several laps of powdered pumice, until the surface is smooth. Do not grain the stone, but work on this smooth surface.

Commercial transfer papers are available from lithographic supply houses, the Yellow Everdamp being a popular type. (See Appendix.) You can, however, prepare your own transfer paper, or use any kind of paper—bond, drawing, watercolor—without any preparation at all. Best is a fine-grained drawing paper or hot-pressed watercolor paper of about U.S. 70-lb. weight (153 g.). It also comes in heavier weights—140-lb. (300 g.) and 300-lb. (650 g.). Cold-pressed can also be used but will

result in a coarser grain. The three prints in Illus. 133, 134, 135 were all made on Arches cold-pressed watercolor paper (available worldwide).

If you draw on untreated paper, use only litho pencils and crayons. Tusche sinks in and fails to transfer. If you have made a preparatory drawing, rub Conté crayon on the back of the drawing and transfer the outlines to the transfer paper. Trace the drawing face up as it is not to be reversed at this stage. It automatically gets reversed when you transfer it to the stone. Finish the drawing completely, using any or all grades of crayon and pencil.

Prepared Transfer Paper

A prepared paper makes a better transfer than an unprepared sheet. Your first step in preparing the paper is to soak it in water until it is limp, then blot off the excess water between blotters. Lay it out on a sheet of tempered hardboard (or board with a waterproofed surface) and tape it down with gummed paper strips (Illus. 126).

When the paper dries, it stretches taut. You can use either the prepared liquid starch (from the grocery store), or the kind that is available in spray cans. Either brush on the liquid starch or spray it on as thinly as you can, and in both cases, brush it out with strokes running the length of the paper, and let

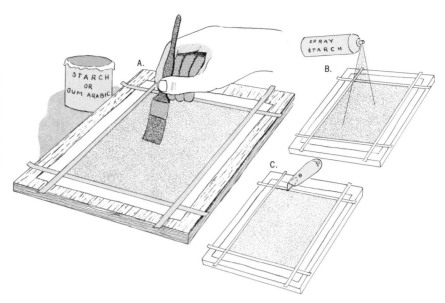

Illus. 126—Tape transfer paper to a waterproofed surface with gummed paper tape while wet. When dry, brush or spray with prepared starch (A) and (B), or brush with thin gum arabic. Apply four coats, let dry between coats (see text). Cut paper loose as shown at C. The treated paper must lie flat.

it dry. Brush the next coat out crosswise to the first and let it dry. Brush the third coat lengthwise again, and the fourth crosswise. Let the paper dry between coats. When the fourth coat of starch is dry, the paper should be perfectly flat. Cut it free of the tapes (Illus. 126C).

Instead of starch, you can use a thin solution of gum arabic with twice as much water as usual. Apply it as described above.

Transfer Ink

If you are going to transfer a texture, as from a leaf, a piece of wood or cloth, or similar, you will need a special ink called *transfer ink*. Use a brayer to roll the object up in transfer ink, then transfer the inked texture to prepared transfer paper, either by printing it in a printing press or, you can lay the transfer paper face down on the inked object and go

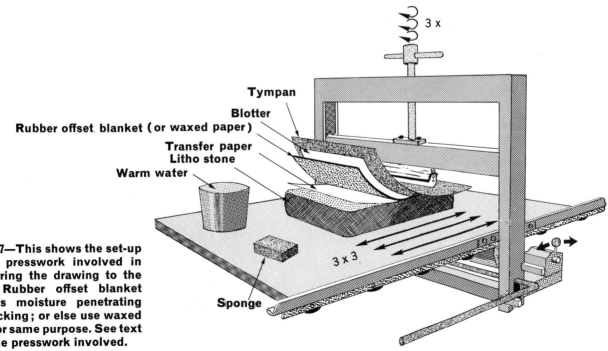

Illus. 127—This shows the set-up for the presswork involved in transferring the drawing to the stone. Rubber offset blanket prevents moisture penetrating into backing; or else use waxed paper for same purpose. See text for the presswork involved.

over the back of it with a spoon or baren, the same way as you would pull a proof from a woodcut or lino block.

The Transfer Drawing

Draw directly on the transfer paper, using litho pencils and crayons. Always use a drawing bridge (Illus. 125) to keep your drawing hand from touching the paper. Hold down the transfer paper with your other hand, with a sheet of clean bond paper between. You must protect the face of the transfer paper from contact with your hands and other greasy objects.

If you plan to draw wholly or partially in tusche, do *not* use prepared liquid tusche or tusche that has been dissolved in water. These will dissolve the coating on the paper. Instead, use tusche that has been dissolved in turpentine, alcohol, benzene or something of the kind.

Transfer Presswork

The method of working the press to effect the transfer is important. Even though you may have just finished graining or smoothing the stone, it must be counter-etched immediately before making the transfer. Use white vinegar, acetic acid, or the alum solution previously described. Rinse the stone afterwards, dry it, and place it in the center of the press bed and install a scraper of the right length in the carrier.

Now dampen the stone *slightly* by brushing it with just the edge of a sponge that has been dipped in clean water and wrung out. Lay the transfer paper face down on the stone. Place on top of it a sheet of newsprint that has been dipped in water and blotted dry.

If you wish, you may buy a rubber offset blanket at your local printers' supply house. Place this, rubber-side down, on the wet newsprint. Its purpose is to keep the water going one way, downwards. Place a blotter on top of the blanket and on that, the tympan. If you do not have a blanket, insert a piece of unwrinkled waxed paper and lay two sheets of blotter backing on that, followed by the tympan. (See Illus. 127.)

Adjust the pressure on the stone so that it is very light and run the stone forward through the press. Then stop and, without relieving the pressure, run it back to its starting point.

1. Remove and discard the newsprint, and dampen the back of the transfer with a sponge dipped in warm water. Replace the packing and

Illus. 128—Lantern transferred from unprepared paper.

Illus. 129—Old man transferred from liquid starch paper.

Illus. 130—Barn transferred from spray starch paper.

Illus. 131—"Lantern," lithograph by Manly Banister from the stone in Illus. 128. Original drawing on untreated, 70-lb. Arches watercolor paper, cold pressed.

Illus. 132—"92-year-old Man," transfer lithograph by Manly Banister, from the stone in Illus. 129. Drawn on 70-lb. Arches cold-pressed watercolor paper, treated with liquid starch.

Illus. 133—"The Old Barn," transfer lithograph by Manly Banister, from the stone in Illus. 130. Drawn on c.p. Arches wc paper, spray starch.

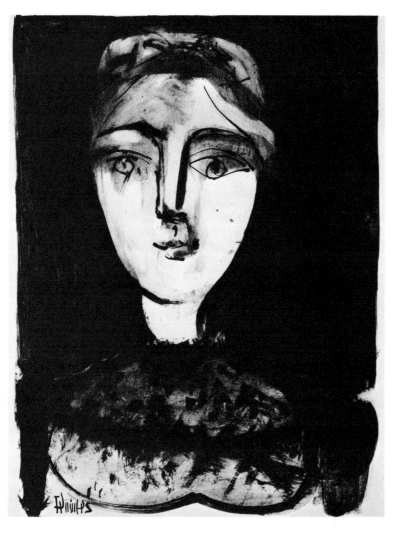

Illus. 134—"Head of a Girl," lithograph by Pablo Picasso (Spanish, 1881–). The National Gallery of Art, Washington, D.C. Rosenwald Collection.

Illus. 135—"Minotaur et Pêcheurs," lithograph by Pablo Picasso. The National Gallery of Art, Washington, D.C. Rosenwald Collection.

tympan, turn the pressure-adjusting screw to add a little more pressure, and take the stone back and forth through the press for a total of *three round trips*.

2. Lift the backing, dampen the transfer paper again, and again increase the pressure by turning the adjusting screw downwards a little. Make a total of three more round trips through the press.

3. Repeat the damping, increase the pressure and run the stone forth and back three more times. (This is shown diagrammatically in Illus. 127, where each arrow on the press bed indicates three round trips of the stone, and each twisted arrow on the adjusting screw means an adjustment downwards.)

Remove the backing and carefully lift a corner of the transfer paper and examine the "take" on the stone. If it does not look good, you can keep on damping and running it through the press until it does, but it should be good enough by now. Carefully strip the transfer paper off the stone. If the paper sticks, stop! Don't tear it loose. Damp the back at that spot until the paper loosens and you can proceed.

Processing the Transfer Stone

When transferring a drawing from an unprepared paper, you can make corrections, additions, or deletions as soon as the stone is dry. Then powder the drawing with rosin and talc to fix it, rubbing it into the heaviest tones gently with your fingers. Then apply a thin coat of gum arabic, squeegee the excess away, and dry.

If you have prepared the transfer paper with starch or gum arabic, do not attempt corrections at this stage nor try to wash the coating of starch or gum from the stone. Water will dissolve the drawing. You can, though, wipe the margins clean, taking care to avoid the drawing. Dry the stone, powder with rosin and talc and gum it up with pure gum.

After an hour or two, carefully remove the gum, using a damp sponge and wiping gently. The starch will come off with the gum. Since pure gum arabic has a slight etching action when used by itself, the image is now strong enough to be cleaned and rolled up with ink.

When you draw on the stone, *all* the crayon or ink you use goes to make up the printing image. The *transferred* image, however, contains only *part* of the drawing material used—the rest stays on the transfer paper. So, the image requires strengthening before you can etch it.

Carefully roll up the stone with Crayon Black ink until the drawing comes up to full strength. Keep the stone damp! When the image is strong enough, dry the stone with the electric fan and powder the image with rosin and talc.

Mix up an etch of 10 drops of nitric acid to one ounce of gum solution (or AGUM-O). Use a stronger etch if there is tusche in the drawing. From this stage on, continue processing in the usual way.

If the drawing needs additions or corrections, wait until the next day. After you have washed the etch away and dried the stone, counter-etch either the entire stone or just the areas where changes are to be made. After doing your scraping or drawing, re-etch the changes. If there is a possibility of getting this etch into the drawing where it is not wanted, you can first cover the stone with a thin coating of pure gum. While the gum is still wet, apply the etch *through* the gum, using a red sable brush.

You can let the stone dry and sit for a while, then clean off the gum and continue with the water-etch, followed by the second gum-etch, and so on.

9. FAILURES, IRRITATIONS, AND GRIEF IN PRINTING

The Under-Etched Stone

Peculiarities arising in the course of printing take different forms. If you are prepared for things to happen, you generally will not be disappointed. Therefore, whenever you start to print, always have ready for instant use a little pure gum arabic solution as well as an ounce of weak gum-etch (10 drops of nitric acid to 1 ounce of gum solution).

If the stone is prone to collect ink scum, it is possible that it is under-etched. If your ink is loose-bodied, however, it will cause scum in the same way. But, if your ink is stiff enough, if there is not too much of it on the roller, and if the stone is not too wet when rolling up, then under-etching must be the cause of the scum. Then the solution to your problem is to re-etch the stone and try again. After re-etching, it is a good idea to let the stone sit until the next day.

Hot weather makes the stone act as if under-etched and it then attracts scum. Wait for cooler weather to print, or be prepared to clean the stone with gum-etch, followed by rinsing with water, before pulling *each* print.

Each Print Is Darker than the Previous One

For the first three or four proofs, it is natural and expected that each print will be darker than the preceding one—*but only until the image on the stone comes up to printing strength.*

Once you get that just-right proof, you must thereafter repeat all the motions that produced it—the same amount of ink, the same amount of pressure, the same number of inkings, each inking being composed of the same number of rolls across the stone, and so on. As long as these remain the same, the appearance of the prints must remain the same, unless something is radically wrong.

If, following the perfect print, you get a print that is darker and, after that, darker still, you are in trouble. Stop right where you are. When a stone is acting up, you cannot cure it by continuing to print, any more than a backyard mechanic can cause an engine to cure its trouble by running it all afternoon.

A stone that darkens like this is very badly under-etched. I don't care if you did follow directions. Another time, another drawing, the etching you gave it would have been sufficient. This time it is

not, and the cause is more difficult to find than the cure. Examine the stone image. Note how the ink is *spreading* all through it, creeping over edges, filling spaces, giving the whole thing a fuzzy, gummy look. Any light or medium tones you may have are already filling in and tending to print solid black.

First, check your ink. Perhaps you are over-inking.

If too much ink is applied to the stone, the press pressure will squeeze it out from where it belongs. If there is too much pressure on the scraper, the same thing happens, even though the amount of ink is right. In such cases as these, though, the fuzziness is like a halo around each line and area, subtly different from the under-etched look.

Perhaps instinct may help you to recognize the appearance of an under-etched stone, and perhaps it won't—not until you've seen a few. Ask yourself: Do the lines and tones have a fuzzy look? Are the fine dots spreading out and getting larger? Have some medium tones filled in until they are solid black or nearly so? The last question is the key to the trouble.

If your answer is yes to all three questions, then this stone is closing up on you—it is under-etched and you had better do something about it *now*. In a few more prints, it may turn totally black and the image will be irretrievable.

Your first move is to scrape down the ink slab several times, rolling out the ink on the roller in between, until the ink lies in a very thin layer on both slab and roller. Take this barely-inked roller and run it briskly over the damp stone, lifting it up and away at the end of each roll. This will pick up most of the excess ink. When you have removed all the ink you can by this means, put the roller back in its cradle.

While the stone is still damp, rub the tip of a *dry* forefinger over any scummed areas, or spots or stains. Wipe the residue away with a damp sponge.

Now, dip a clean, soft cloth into the gum-etch and go over the drawing carefully, rubbing the etch into every place where the excess ink still stubbornly clings. This will dissolve the ink out. When the drawing looks good and clean, wash off the etch, dry the stone, and re-damp it for inking. If subsequent prints come from the stone in good condition, you have solved the problem and all is well.

If the print starts to darken again, however, stop everything, clean up the image with gum-etch, rinse, ink up as if for printing, then powder the stone with rosin and talc. Gum-etch the entire stone, using the same strength you used the last time. Leave the stone to sit in the dried etch until the next day, then wash off the etch and gum up with pure gum. *Wash out the drawing with turpentine only*—use *no* asphaltum. Begin again to print as from the beginning, starting with newsprint proofs until the image builds up to printing strength.

You may repeat the re-etching process as often as the stone tends to run closed on you, until you have produced the number of prints your edition requires. In the happiest circumstances, however, one re-etching is enough.

Keep in mind that you cannot bluff a litho stone, so don't keep on printing once it starts to act up. You can make a bad situation worse. If you cannot decide at once what is wrong and what to do about it, gum up the stone so that it will keep. This is why you must always have some fresh gum on hand—or a bottle of AGUM-O. It is always ready for use.

Scum

Sometimes a stone will seem to scum up out of pure cussedness and for no visible reason. Under-etching will cause scum, but so also will an ink that is too soft—stiffen it with magnesium carbonate.

Too much ink causes scum. Scrape down the slab and roll out what ink is left. If you have to, clean both slab and roller down to bedrock and re-ink.

Too much water on the stone causes scum. Wipe the stone down drier.

Hot weather makes scum, too, as it both softens the ink and makes the stone act as if under-etched. Avoid hot-weather printing unless your studio is air-conditioned.

If the roller deposits scum on the margins of the stone at the beginning and end of each pass, you can whip some of it off with the snappy technique of rapid rolling, but this takes ink off the drawing, too, so use it sparingly.

Between each inking, as you dampen the stone, first apply excess water to float the scum away—rubbing gently with the sponge helps. What is left will usually yield to a light rubbing with your fingertips. However, don't be too fussy until the stone is entirely inked.

At this time, wash off what scum you can, rub off as much more as will yield to your fingertips while the stone is still wet (if the stone is dry, you will only smear the ink, not remove it), then take some of the weak gum-etch on a rag and carefully wash away the remaining scum as well as any heavy ink marks the roller may have left by over-running the edges of the stone. Wash off the gum-etch with fresh water and dry the stone for printing. If you have to, you can repeat this treatment before each print.

If your clean-up job has been less than perfect and some small spots have resisted scrubbing with gum-etch, don't worry about them. Anything that will not yield to scrubbing with gum-etch will not set off on the print.

If such spots get out of hand and continue to broaden, the only thing to do is to erase them with snake slip or Scotch hone and water. Then give the margins a *strong* water-etch of 30 to 40 drops of nitric acid per ounce. Keep this strong etch away from the drawing (as well as your hands). After several minutes of treatment, rinse the stone, fan it dry, and sponge a coat of pure gum arabic over the entire stone. Squeegee the gum and wipe it down, then fan it dry. Wash the dried gum away and ink the stone as needed to keep on printing.

If the ink is too soft, it will deposit scum. Clean both slab and roller to get rid of all the loose ink. Work enough magnesium carbonate into some fresh ink to make it stiff, then roll it out on the slab.

The Image on the Stone Turns Black While Inking

You are rolling ink on the stone and everything is going fine. All of a sudden, most or all of the stone suddenly turns black before your eyes! What happened? I'll tell you what happened. You went to sleep on the job and let the stone go dry.

A *dry* stone, so far as the ink is concerned, is not one so dry that you can scratch a match on it. It is a stone that is not damp enough to repel the ink, that is all. There is a very narrow margin between being too damp and too dry. Long before a stone is bone dry, it is in a condition to accept ink all over and you must keep this in mind.

This is most likely to happen when the temperature is warm and the humidity is low. Warm, dry air greedily sucks moisture from the stone, more quickly than you would think.

If you don't want to give up printing until weather conditions change for the better, you will have to apply fewer rolls to the stone per inking and increase the number of inkings to get the same amount of ink on the stone. Even this can lead to trouble, so perhaps you can doctor the damping water to control its rate of evaporation.

The best thing for this is common rock salt, such as used in water softeners or for throwing on icy

sidewalks to thaw them out. Lacking rock salt, use kitchen salt instead. First, mix up a reservoir of *all* the damping water you think you will need so you don't have to stop periodically, whenever the water needs changing, to mix more. Mix at least a large bucketful, but never dip the sponge into this—pour a little salt water into the plastic bucket you use at the press.

A series of experiments conducted to determine the real effect of additives on the damping water resulted in some fairly astonishing conclusions. All the tests were conducted in summer, ambient temperature 85° F (30° C), humidity 50%. The solution was brushed on a medium-grained stone simultaneously with a similar brush-load of fresh water, for comparison.

When rock salt was added to the damping water at the rate of one level tablespoonful per American gallon of water, the drying time, as compared to that of an equal quantity of fresh water spread over an equal area, was extended as much as 50% (several trials were made and the drying times averaged). The addition of more salt failed to increase the time.

Tests made with a dark, bitter-tasting beer that had been allowed to stand until it went stale, resulted in practically the same drying time as for salt water. However, even at the low rate of two tablespoonfuls per American gallon of water, the studio soon reeked like a saloon and the beer turned the damping water yellowish. However, neither salt nor beer appears to affect the quality of the print in any way.

The addition of gum arabic solution or glycerin to the damping water, though, appeared to have the opposite effect. Two teaspoonfuls of either, added to an American gallon of damping water, caused the test solutions to evaporate in *half the time* required by fresh water.

The Over-Etched Stone

The over-etched stone produces a print that is spotty and ragged-looking. Some parts take the ink fully. Others have more or less refused it, printing with a fuzzy halo. And still other parts do not print at all. If the stone produces a print as bad as this, there is nothing you can do about it except re-grain the stone and start over, letting past experience be your guide.

Sometimes a drawing may be locally "burned"— which is the same thing as being over-etched, but the effect is confined to a small area, or perhaps only a line or two, with the remainder of the drawing printing quite well. You may inadvertently have put a strong etch on the place or places in question without knowing it, as when you were etching the margins of the stone. You can readily detect such non-printing lines or areas on the stone, because they refuse ink entirely and show up white.

Ink up the stone as for printing, then powder the inked image with rosin and talc. Mix ½ oz. of 28% acetic acid with 1½ oz. of water, or use white, distilled vinegar. (The most economical way to buy acetic acid is in the form of *glacial acetic acid*. To make 28% acid, mix 3 fluid ounces of glacial acetic acid with 8 ounces of water.)

Brush the weak acid solution (or vinegar) on the parts remaining white, using a watercolor brush. Let the acid sit for a couple of minutes, then soak it up into a damp rag, brush on clean water several times and blot it up with a clean blotter. Fan the stone dry.

When dry, the counter-etched lines—the ones to which you have just applied the acid—are once more sensitive to the reception of grease. You can draw right over them again with litho pencil, crayon or tusche. Rub a little rosin and talc into the redrawn parts with a fingertip, then, using gum-etch on a watercolor brush, re-etch the new drawing for 3 or 4 minutes. Rinse the gum-etch away, dry the stone and gum it up with a thin coat of pure gum arabic. Fan the gum dry, wash out the drawing with turpentine and asphaltum, and return to printing. You will be able to distinguish no difference in the print between the original and the replaced parts of the drawing. An accident removed the top half of the horn and half of the near front leg of the rhinoceros beetle in Illus. 95. The burned parts were replaced as described above.

To Make Additions to a Drawing

Suppose your stone is completely processed, you have pulled a few proofs from it, and you are dissatisfied with the drawing. Perhaps some of the blank areas in it would look better and would bring the composition into better balance if you filled them with additions to the design.

First, wash the entire stone with water and a clean sponge, then fan it dry. Re-damp it and roll it up with ink, as if you were going to print it, then powder the inked image with rosin and talc.

Wherever you want to add more drawing, dampen the stone lightly—use a pointed brush for very small areas. Now brush in the acetic-acid solution or saturated potassium-alum solution to counter-etch the areas. After a couple of minutes, wash off the counter-etch with a flood of water and dry the stone.

Draw with crayon or tusche, as suits you, powder the new drawing with rosin and talc, and etch it for

Illus. 136—"Femme de Profil," lithograph by Odilon Redon (French, 1840–1916). The National Gallery of Art, Washington, D.C. Rosenwald Collection.

Illus. 137—"Sappho," lithograph by Jean-Baptiste Camille Corot (French, 1796–1872). The National Gallery of Art, Washington, D.C. Rosenwald Collection.

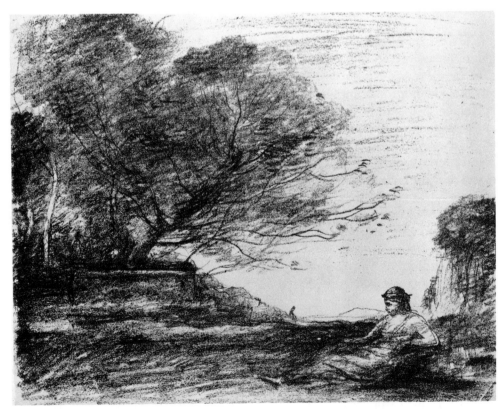

about 3 or 4 minutes. Wash the stone and dry it, and again apply first water then etch to the newly drawn areas. After another 3 or 4 minutes, wash away the etch, dry the stone, and gum up with a coat of pure gum.

To print the stone, wash it out as usual with turpentine and asphaltum, ink it up and print it.

Erasing Part of an Etched Drawing from the Stone

If all you want to do is get rid of some parts of a drawing—not replace them with new drawing—simply scrape off the unwanted parts with snake slip, Scotch hone, or a glass-fibre brush. Afterwards, clean the area thoroughly, using a knife point or similar to remove the last tiny bits of color. If you leave any particles of the old drawing, they will take ink and print.

Re-etch locally, wherever erasure was made, taking care not to let the gum-etch run over into the other parts of the drawing. To be sure it does not, you can rely on the old trick of painting the etch on *through* a wet coat of pure gum.

Let the stone dry (do not brush or disturb the coating) and sit overnight, or at least for a few hours. Then wash the stone, re-gum with pure gum, fan dry, and wash out with turpentine and asphaltum before printing.

If you plan to replace the erased drawing with a new design, another problem confronts you. You must erase the original drawing *without damage to the grain of the stone.*

This means that scraping methods are absolutely out. Scraping utterly destroys the grain. So, you must *erase the drawing chemically.* To do this, dissolve caustic soda (plain old lye) in water until it will take up no more. Handle this saturated lye solution carefully—wear a face shield if you have one to protect against splashes. Also, wear rubber gloves to protect your hands, for concentrated lye will burn your hands. It will also eat holes in your clothes, so wear a rubber apron.

Put about a half ounce of water in a graduate (to keep the quantity small) and add the caustic as required.

If you don't want to use lye, you can use 70% nitric acid, straight from the original bottle. Use the same precautions as when handling lye.

First, dip a cotton swab in benzene and remove the coloring matter (crayon, tusche, or printing ink) from the parts to be erased. Apply the caustic with a round toothpick, *carefully.* Dip the toothpick in the solution, then put it point down on the stone and let the solution clinging to it run off on the stone.

Keep a wet rag handy to wipe up if the lye solution gets out of control.

When the treated parts have been dissolved by the lye, flood the stone with water to clean it, then fan it dry. Dampen the stone again and counter-etch with vinegar, acetic acid, or alum solution. Wash clean and fan dry. Put in whatever drawing you want, then powder the additions with rosin and talc and gum-etch for several minutes. Wash and dry the stone and again etch the parts locally. Wash up again, dry the stone, then gum up with pure gum. Before printing, wash out the drawing with turpentine and asphaltum; then roll with ink and print.

The Drawing Refuses to Take Ink

The drawing will refuse to accept ink if the ink is excessively stiff. If so, reduce it with a drop or two of #3 litho varnish. Or, you may have rolled the ink out too thin. If so, the roller has no excess ink to give up to the drawing, so dab more ink on the roller and roll it out.

If everything is right in the ink department, look to your processing. Did you wash out the drawing with turpentine *and* asphaltum? The drawing may be too lean to attract the ink. In this case, take the stone to the sink and *flood* it with water. Take some turpentine and asphaltum on a soft rag and rub it into the drawing, working *through* the sheet of water to protect the bare areas of the stone. When the drawing looks evenly brown all over, reduce the wetness on the stone to dampness and roll it up with Crayon Black ink.

If the drawing still refuses to accept enough ink to print, even after you have pulled as many as four proofs, gum the stone up again with pure gum, squeegee it off and wipe it down with your hand and a rag. Fan completely dry, then wash out the drawing with turpentine and asphaltum, wipe the stone as clean as you can, and leave the remaining turpentine to dry on the surface. When this is dry, flood the stone with water and, at the same time, take more turpentine and asphaltum on the wash-out rag and rub up the drawing some more. This ensures adding the maximum amount of grease to the drawing.

Usually, before now, the stone will have taken to printing, but sometimes a drawing simply will not respond as it should, and will fight you every inch of the way. If the stone fails to print suitably, damp it all over and *rub it carefully and lightly with powdered pumice on a damp rag.* Too much rubbing could erase the image, or at least damage it, so be careful. Afterwards, wash the stone thoroughly under the

faucet and leave it drenched, with the faucet flowing fast enough to replace the water as quickly as it runs off. Through this coating of water, again rub the turpentine-asphaltum rag over the drawing. Fan the stone dry.

Damp the stone and roll it up with Crayon Black ink, powder the drawing with rosin and talc, and re-etch with gum-etch of the same strength previously used on this drawing. After a few minutes, rinse the stone, fan it dry, and gum it up with pure gum. Wash out the drawing with turpentine and asphaltum, then roll up with Crayon Black or a stiff press black and go ahead and print.

On the other hand, if none of these measures has proved effective, you might as well give up. The stone has been determined to beat you and it has. Re-grain it and start over.

If a print is merely light in tone, appearing under-inked (and if additional pressure on the scraper does no good), it may be because the paper is too damp. Spread 4 or 5 sheets at a time out upon dry blotters and let them be drying while you print. If the paper is too dry, turn the adjusting screw downwards for more pressure; or, better still, gum up the stone with pure gum and re-damp the paper.

Delicate Washes of Tusche

If you have laid down a light-toned wash of tusche, and have processed the stone with gum-etch, the resulting image may look as if it has been etched away. That is, it has become invisible. You may even have seen some of the color coming off in the etch.

Don't be misled. After you have pulled a few proofs, the tone will most likely return and worse, it will keep on coming back—it will print stronger and stronger with each print until the whole area of tone turns black.

If something like this should happen, it is not enough to treat the stone as under-etched. You will have to repeat treatment *before each print is pulled*. This makes a slow, tedious job of it, but it is the only way you are going to get prints from that particular stone.

Once the tone starts to darken, before the next print, dip a soft rag in weak gum-etch (10 drops acid per ounce) and, keeping the stone damp, *scrub* the areas where the tone is blocking up. Don't worry about damage to the drawing; you can't do anything to it worse than what it is doing to itself.

The gum-etch bites into the excess tone and cleans it away. You will notice at once, in spite of the slurry of ink and water collecting on the stone, that

the drawing has brightened up and become clean and sharp-looking again.

Do this work on the press bed, without moving the stone from its printing position, and keep it wet while working with the gum-etch. When you have cleaned up the drawing, take a plentiful supply of clean water on a rag and sluice it over the stone. Wipe up the press bed with a slop sponge kept handy for that purpose, then dampen the stone and roll it up for printing.

The next proof you pull will be nice and clean and perhaps you will be tempted to continue printing without resorting to the cleaning process. However, this print will block up and be different from the others, so don't do it. Just get used to the idea that you will have to clean up the stone before each print.

If the stone manages to get ahead of you, however—that is, the harder you work, the blacker it gets—give it a final cleaning, ink it up as if for printing, and powder it with rosin and talc. Gum-etch the stone and let it sit in the dried etch until the next day.

Next time you wash out the drawing, do so with *turpentine only*—do *not* use asphaltum. The drawing is obviously too fat already, so there is no sense in making it fatter.

A stone drawn with tusche often presents more printing problems than one drawn with litho pencils and crayons. Learn as you go along and skill will come all the more quickly if you have to use your head a little to fight your way out of a difficulty.

Inequalities in the Stone

The foremost requirement of a litho stone is that the face side be plane and parallel with the back. That is, the stone must have exactly the same thickness all over. A stone that has been abused, either deliberately or through ignorance, can become thicker on one side or end than on the other; it can be thinner or thicker in the middle than around the edges.

You can measure the thickness around the edge with calipers and a machinists' rule. A straightedge laid on edge across the stone will disclose a hollow center if you view it with a table lamp behind the stone. A ruler laid over a humped stone will show light at both ends and dark in the middle when balanced, or one half light and the other half dark when one end is pressed against the stone.

The best cure for a stone out of plane-parallelism is to grind at it until it returns to shape. For a stone that is badly worn, you can take it to a stone yard and have it run through a planer. However, there are ways to pamper a stone and make it seem as if

the face is plane-parallel, even though it is not. The remedy is called "make-ready" and it consists of putting pieces, strips and spots of paper either under or over the stone when printing from it, to compensate for its discrepancies. In reducing paper to size, always *tear* it to give it an edge of diminishing thickness. Do not cut it.

Make-Ready to Correct a Hollow Stone

Study Illus. 138. If the stone is hollow in the middle, it is logical to suppose that filling the hollow from above the backing will equalize the scraper pressure and cause the print to come out right. Use the thinnest tissue paper, adding a piece at a time until the stone prints evenly. If you paste in too much paper, you will reverse the situation and the print will have the appearance of coming from a humped stone.

Make-Ready to Correct a Humped Stone

Illus. 139 shows that when a stone is humped, the center gets *more* pressure than the edges, so the print is darker in the middle. Over the backing, add sheets having their centers torn out, each sheet having a smaller opening than the previous one. By equalizing the difference in stone-thickness between the center and the edges, you can produce a good print. If you have access to a micrometric dial indicator mounted on a surface gauge (Illus. 17), you can measure the difference down to a thousandth of an inch, then measure the thickness of the paper required for correction. Without such an instrument, you will have to proceed by trial and error and will doubtless do quite as well.

Make-Ready to Correct a Corner that Prints Light

If a stone is worn off at one corner, that stone will print lightly, if at all, from the worn corner (Illus. 140). So, all you have to do is paste a triangle (or triangles) to the equivalent corner of a sheet of paper and lay it on top of the backing, under the tympan, when you print. A few trials will determine just how much padding is needed.

Make-Ready for the Longitudinally Wedged Stone

If a stone is wedge-shaped, one *end* being thicker than the other by only a few hundredths of an inch, the result is a print that is darker at the thicker end and lighter at the thinner.

Illus. 141 shows this graphically. Note how the make-ready is pasted down step-wise. If only the end of the stone were supported to the required height,

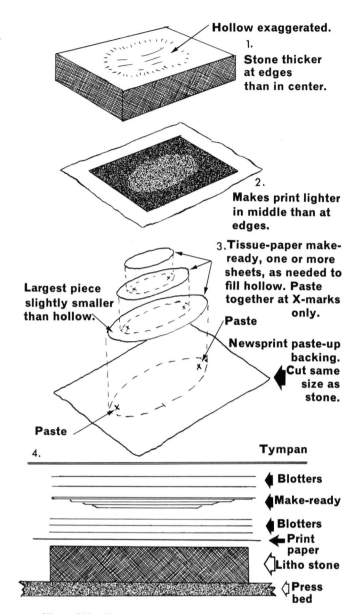

Illus. 138—Make-ready to correct a hollow stone.

the space between would be without support and the stone would surely break while going through the press. Fewer and longer steps may in practice be needed than the number shown at E.

Printing the Laterally Wedged Stone

If one *side* of a stone is thicker or thinner all the way along than the other side, then the stone is shaped like a wedge across its width. There is no difference between printing the laterally wedged stone and the stone that is plane-parallel with its back. This owes itself to the fact that the scraper carrier, as shown in Illus. 142, can tilt 15°–20° to either side of center to compensate. Even if the stone were one half thicker on one side and the other half

thinner on the same side, in a sort of wave form, this feature of the scraper would compensate for it, by tilting first to one side, then to the other.

Make-Ready for the Stone with an Uneven Surface

If a stone has a mattresslike surface, covered with humps and hollows, a different method of attack is required. If the surface is not too humpy (Illus. 143, Fig. 1), you may be able to pull decent proofs from it by increasing the thickness of the backing between the blotters and the tympan. Back up the blotters with a rubber offset blanket, a piece of $\frac{1}{4}''$-thick wool felt etching blanket, or a sheet of foam rubber, backed by two sheets of newsprint. Prepare to apply plenty of pressure. If this does not produce a good print, consider the stone hopeless until it has been smoothed down by coarse grinding.

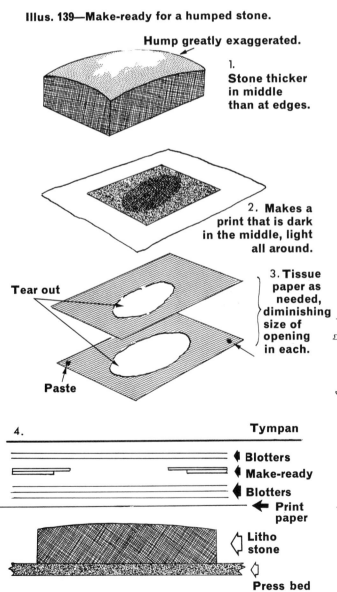

Illus. 139—Make-ready for a humped stone.

Hump greatly exaggerated.

1. Stone thicker in middle than at edges.

2. Makes a print that is dark in the middle, light all around.

3. Tissue paper as needed, diminishing size of opening in each.

Tear out

Paste

4.

Tympan

Blotters

Make-ready

Blotters

Print paper

Litho stone

Press bed

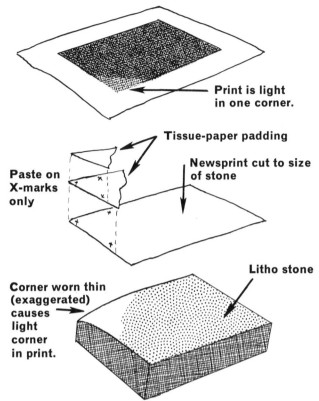

Print is light in one corner.

Paste on X-marks only

Tissue-paper padding

Newsprint cut to size of stone

Litho stone

Corner worn thin (exaggerated) causes light corner in print.

Illus. 140—Make-ready for a corner-worn stone.

Illus. 141—Make-ready for a longitudinally wedged stone.

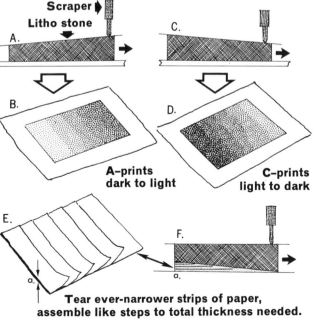

Scraper
Litho stone

A.

B.

A–prints dark to light

C.

D.

C–prints light to dark

E.

F.

Tear ever-narrower strips of paper, assemble like steps to total thickness needed.

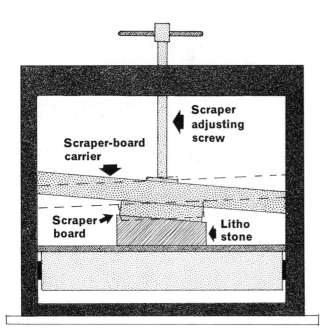

Illus. 142—Cross-section of a laterally wedged stone.

Labels in Illus. 142:
- Scraper adjusting screw
- Scraper-board carrier
- Scraper board
- Litho stone

Light areas in print indicate presence of hollows; dark areas indicate presence of humps

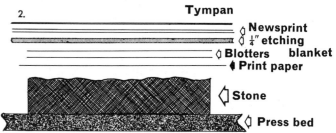

Labels in Illus. 143:
- Tympan
- Newsprint
- ¼″ etching blanket
- Blotters
- Print paper
- Stone
- Press bed

Illus. 143—Make-ready for a stone with uneven surface.

Make-Ready for the Compound Correction of a Stone

Refer to Illus. 17 in Chapter 2. The stone shown is covered with various thickness readings made with a dial indicator. Only the four corner readings are important. The right front corner is the thinnest part of the stone and this is indicated as 0.000″. The left front corner is thicker by 0.042″; the right rear corner by 0.080″, and the left rear corner by 0.125″.

In other words, the maximum thickness of the stone, which is at the left rear corner, is greater by ⅛″ than its minimum thickness! How would you go about making ready for this stone? Would you place the make-ready under the stone or on top of the backing?

Let us analyze the measurements. The stone is in the shape of a double wedge—that is, it is wedge-shaped both longitudinally and laterally. The back edge wedges 0.045″ in its length; the front edge wedges 0.042″ in the same dimension—practically the same.

On the left, the stone is wedged laterally 0.04″, tapering toward the front. From the same corner, the stone is wedged 0.045″ toward the right. The front edge, with different thicknesses, is also wedged 0.04″ in its length (ignore the difference of 0.005″ as it is too small to count).

Therefore, if you lift the entire *right end* of the stone 0.04″, the right end will possess the same taper and thickness as the left end. The stone can be lifted 0.04″ by placing under it a total of 10 sheets of newsprint or 20-lb. bond typing paper, laid down in steps as shown in Illus. 141E.

Analyzing again: The make-ready has corrected the longitudinal wedging and the stone is now a simple, laterally wedged stone. A few paragraphs back, you learned that a laterally wedged stone is printed the same way you print a flat stone, without fuss or trouble; so, what appeared to be a complex problem turned out to be pretty simple, after all.

WARNING: Always be certain in making ready that the stone is supported equally all over the bottom. If you try to imitate the printer of type forms and attempt to raise a sunken center or lower a humped center by placing make-ready under the stone, you run a good chance of breaking the stone, because it is no longer equally supported all over the bottom. Such make-ready works fine for flexible type forms and wood blocks, but the rigid stone cannot bend—it can only break.

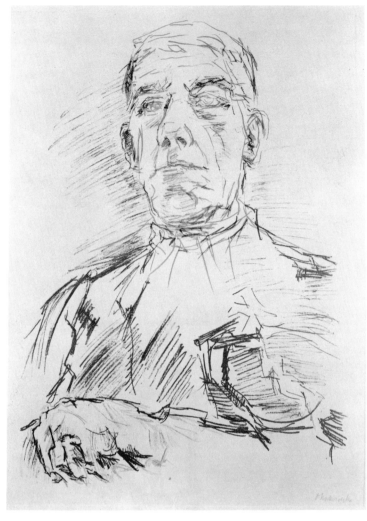

Illus. 144—"Self Portrait," color lithograph by Oskar Kokoschka (Austrian, 1886–). The National Gallery of Art, Washington, D.C. Rosenwald Collection.

Illus. 145—"The Races," lithograph by Edouard Manet (French, 1832–1883). The National Gallery of Art, Washington, D.C. Rosenwald Collection.

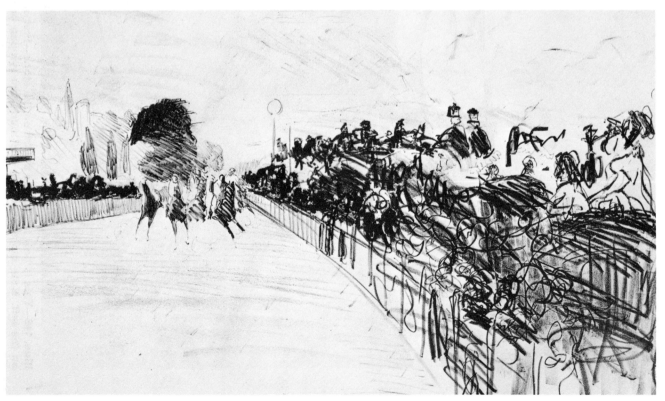

Illus. 146—This is how to register a print on the stone—first one end down and then the other end. Note the auxiliary shelving over the press bed on the left. Note blotter backing and aluminum tympan out of the way but close at hand; (extreme left) blotter pile for drying prints when printing damp lithographs or etchings.

10. PRINTING THE COLOR LITHOGRAPH

Preparing the Stones

Getting a lithographic stone ready to print with colored ink is no problem, so long as you have learned to print the stone with black ink. The stone is drawn on and chemically treated in exactly the same way. The only difference between making a black-and-white print and a print in color is strictly physical—the color print is generally printed from more than one stone.

It is possible to print a color print with just one stone, or with two stones, three, four, five, six—or any number of stones you wish. In every case, each stone is first rolled up with Crayon Black and proofed for the detection of errors or changes that must be made. In the case of a complex color series, the stone can then be washed out and rolled up with colored ink and trials made to determine which ink, or mixture of inks, will be used in the final print. In all cases, whenever you change from black ink to a colored ink, or from a colored ink to an ink of a different color, you must first roll the stone up with ink as if for printing, powder the image with rosin and talc, gum it up with pure gum, then wash out the drawing with turpentine and asphaltum before rolling up in another color of ink. Keep this in mind, for the entire process is necessary—you cannot merely rid the stone of ink with turpentine and roll up in the new color, as the turpentine would ruin the stone for further use.

Paper for the Color Print

Choose paper carefully for your color print. You should by now be familiar with a number of weights and grades of fine, hand-made, rag papers. Since a color print must be made on *dry* paper, choose one that is on the soft side rather than hard, such as Rives BFK or something similar.

The reason you must print on dry paper is because of "register." Wherever you have more than one stone (or plate) to print from, you will have to provide some kind of an arrangement so that all the imprints involved "hit" or land in the right place on the paper. The process of doing this is called "register" or "registration." When all the color imprints hit down in their right places, the print is said to be "in register." If any imprint is printed awry with respect to the others, it is said to be "out

of register." An out-of-register print is worthless and must be discarded immediately.

Now to get on with why it is necessary to print the paper dry. When paper is damped, it stretches. When it subsequently dries, it shrinks, and it must be dried after the first imprint is made in order to permit the ink to dry. If the paper is then damped again for the next imprint, it will again stretch, but not necessarily to the same extent as it did the first time. The result is that one imprint does not fit the other and the print is bound to be out of register.

When the print is made on dry paper, the paper maintains its size throughout the entire printing run of different stones and different colors. Therefore it retains a capacity to register correctly each time it is printed on.

When cutting paper for the color print, there is no need to cut it larger than the stone, as you are going to have to cut off the excess paper anyway to get rid of the unsightly register marks. If you cut the paper smaller than the stone, you will have to crowd your register marks in on the drawing, thus decreasing the chance of good register, for register is easier and more accurate to achieve when the register marks are farther apart. (We will get back to placing register marks on the stone later.)

The Color Print

Just what is a color print? If you print a picture of a frog in green ink, is that a color print? Not really, even though the ink is colored. Actually, it is a green print. If you printed it in black, you would call it a black print. Of course, there is no law against your making green prints, if you like, or red prints, or purple prints, or whatever. It's a matter of taste.

Suppose you have printed a picture or design in one color—black, brown, burnt sienna, or something like that—then painted the colors into the open spaces by hand. Is that a color print? No, it is not, and the pundits and prophets of professional print-making take umbrage at the very thought of your doing this. It is, however, no business of theirs if you want to hand-paint your one-color lithographs. Who are they to make rules for something that is supposed to be a totally individual expression of one's creative ability? You can achieve beautiful results with hand painting and, if you do it well, I, for one, will applaud you. However, *never* call such a print a *color*

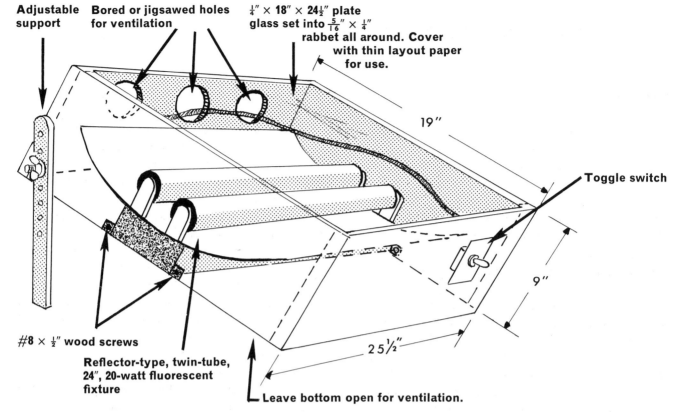

Adjustable support **Bored or jigsawed holes for ventilation** $\frac{1}{4}'' \times 18'' \times 24\frac{1}{2}''$ **plate glass set into $\frac{5}{16}'' \times \frac{1}{4}''$ rabbet all around. Cover with thin layout paper for use.**

19"

Toggle switch

#8 $\times \frac{1}{2}''$ wood screws

Reflector-type, twin-tube, 24", 20-watt fluorescent fixture

9"

25½"

Leave bottom open for ventilation.

Illus. 147—A light-box is a handy accessory for all kinds of tracing jobs. Low-heat fluorescents give even illumination through white layout sheet covering the glass. Made as shown, it can be set on a table, tilted to desired degree and held in position by an adjustable leg at each rear corner.

lithograph—not even a *colored* lithograph; for, to do so smacks of fraudulent description. It is a *hand-painted* lithograph, or a lithograph hand-painted with color washes. That way you will be telling everyone the truth and you will cause fewer hackles to rise.

If you are going to make hand-painted lithographs, you should print them on fine quality, rag watercolor paper such as Arches 140-lb. (or heavier), with hot-pressed or cold-pressed surface. For the painting, you can use regular transparent watercolors, or gouache; or, better still, use acrylic paints. Handle acrylics as watercolors, thinned with water only for brilliant results. If you want, when the paint is thoroughly dry, you can brush it over with several coats of glossy medium to make the colors glow like gems.

The big advantage in using acrylics, of course, is that they are waterproof. Regardless of whether you apply the paints by the aquarelle method (with the paper wet), or paint on dry paper, there is a possibility that, upon drying of the paint, the paper will buckle. With watercolors or gouache, the buckling can be pronounced, and there would be nothing you could do about it. If the color is acrylic paint, however, it not only has a lesser tendency to cause buckling, but if it should, you can correct the

condition easily. Simply soak the print in a tray of water, drain it, and put it between blotters and under a weight to dry. Change blotters as usual when drying prints, and the next day the print will come out dry and flat, ready for mounting and framing. Once they are dry, acrylic paints will not bleed, leach or run when soaked in water.

Color Prints from One Stone

There are two ways to make a color print, using only one stone. In the first, each color is confined to a certain area of the print so that the colored inks can be applied locally to the stone with small, soft-rubber rollers. When each area has been charged with its proper color of ink, lay on the print paper, backing and tympan, and run the stone through the press. All the colors thus print at once and you have not had to worry about register. You can even print on damp paper, as that makes no difference. Also, you can take two or three colors upon the roller at the same time and roll them out simultaneously on the stone for a rainbow effect.

The other way to print multi-color from a single stone is a bit more complicated and carries with it the problem of register, as each color must be printed with a separate press run.

Illus. 148—The turtle has been traced from underlying sheet on parchment tracing paper. Draw in the register marks, using T-square to ensure that lines are perpendicular to each other. Use sharp, hard pencil. The turtle was traced, using a light-box similar in design to Illus. 147.

The design must be conceived in such a manner that the entire drawing goes on the stone at once and the whole design is printed in the first color, which also must be the lightest—say, yellow. Now erase from the stone all parts of the design that will appear in yellow in the print, gum up and wash out the drawing, and roll up with the next lightest color. When the yellow imprint is dry (next day), run the prints again through the press on the same stone, registering as described later on in this chapter. The second color, being opaque, now overlies all parts of the design except those intended to show as yellow. And so, all the parts of the design that are to appear in this second color in the print are removed from the stone, and you continue as before, going through the same manoeuvres for each change of color. If you want to make additions to the stone at various stages of printing, you can do that too.

Colored Inks

A series of colors is printed from a number of stones or plates often in such a manner that each imprint is made on bare paper—that is, no color overprints another. Or, you can calculate overprinting and use transparent inks so that when one is overprinted on another, an intermediate color will appear on the print. For instance, if you print a transparent blue over yellow, the result will be a shade of green. If you print yellow over blue, you will also get green, but it will be green of a different

Illus. 149—Trace register marks off on stone with care, using sharp point and a straightedge. Turtle outline indicates how much of the design is traced off on the yellow-green stone.

Illus. 150—The turtle outline is filled in with #3 litho pencil. Note position of register marks and that they have been drawn with tusche.

shade. Before doing any extensive color printing, you should draw and fill in squares on several stones (in register, of course) and print out the colors you have. Try them in all combinations, alone and on top of each other, until you are familiar with what to expect from printing. If you do such practice exercises, you will find the resulting prints valuable, as you can refer to them whenever a color problem comes up.

Another thing you can do with color is modulate it—that is, increase or decrease the saturation—make it lighter or darker. One way to do this is in the way you lay crayon on the stone to begin with. A light tone of crayon will reproduce a light tone of color and a dark tone of crayon will reproduce a dark tone

of color, both from the same inking. You cannot do this with tusche, as tusche drawing results in absolute density—solid black, or the full strength of the color being printed.

In order to vary the tone of color printed from a tusche image, you must reduce the ink itself to produce a light tint, and darken it for heavier tones. You can mix colored ink with transparent extender or opaque white ink, depending on the result you want. But when you do this, watch out! Do *not* add extender or white to a color. First put down extender or white on the ink slab, then add a tiny bit of color to it and mix thoroughly. A very little color goes a very long way. If the tint must be deeper, add a little more color and mix. Keep doing this until you get

Illus. 151—The key stone (to carry the image in brown ink). The drawing was made with with both tusche and crayon.

100

Illus. 152—Comparison of the drawings on the yellow-green stone and the brown stone (top).

the shade you desire. If you try adding extender or white to a color, you may not have enough in a pound can to weaken the tone.

Whenever you want to find out what a colored ink or a mixed tint really looks like when printed, take a tiny bit on the edge of a palette knife and spread it thinly across a piece of white paper. This will approximate the printed color. You will see what a very little bit of colored ink is needed when extender or white is added to make a reduced tint.

To darken a color, all you need do is add a touch of Crayon Black or burnt umber.

The Color Wheel

In order to make it possible for you to visualize the colors your print will appear in, you must have some idea of what color is and how the different colors are related to each other.

Take a look at Illus. 161. This circle is called a "color wheel" because it shows the color relationships you have to know for successful color printing.

Note the three *primary* colors: RED, YELLOW, and BLUE. All ink colors are composed of mixtures of these colors only. There are no other colors. If you mix a little YELLOW with RED, you get red-orange; add a little more yellow, and the color becomes orange. If you mix a little BLUE with RED, you get red-violet, and so on.

Directly opposite each primary color on the wheel is its *secondary* color. The secondary color for RED is green; for BLUE, orange; for YELLOW, violet. NOTE: *The secondary color for any primary color is composed fifty-fifty of the other two primary colors.*

Here is another important point about the color wheel. Take *any* color indicated here and mix with it the color directly opposite it on the wheel. The

Illus. 153—Print made from the light color stone in black ink.

Illus. 154—Print made from the key stone in black ink.

result will be grey—one color neutralizes the other when both are mixed in equal quantities. Of course, pigment being what it is, mixing two colored pigments together results in mud. You must lighten the tone by mixing small but equal quantities of the pigments with extender or opaque white. By trial mixing, you soon will have the tone of grey desired. By adding a little more of one color than of the other, the tone of grey will lean in the direction of the excess color. Thus, you can make any grey cool or warm in tone, as desired.

Colors across the wheel from each other are called "complementary" colors. Whenever you want to "grey" a color—that is, tone down its brilliance, you do so by adding a little of its complementary color. This practice is used a great deal in oil painting, where objects at a distance are greyed more than those in the foreground, resulting in what is called "aerial perspective"—the apparent stepping back into the distance of objects that are actually painted on the picture plane. This feature, as much as linear perspective, accounts for the splendid appearance of depth in pictures of expert painters. You can utilize this same property of color to produce equivalent effects in your lithographs.

The study of color is both broad and deep and if you plan to do great things with it, you will need more instruction than there is room for here. Find a good text on the subject and study it well.

You will find it impossible to reproduce the same color mixture *exactly* a day, a week, or a month later. If you are selling your prints this is particularly important. You want all your prints to be exactly alike, in case your clients compare prints.

Therefore, however many prints are in your edition, mix enough ink for all and print them all

out at one press session. You can do this easily if you keep the number of prints in the edition down to a reasonable figure. You will have to become pretty well known as an artist, and well sought after, before you can get rid of an edition of 50 or 60 prints. Keep your editions down to 5, 10 or 15 prints at first—just the number you know you can get rid of. (You will give most, if not all, of them away.)

Generally, the ink of an imprint will be dry enough so that you can go ahead and print the next color on the following day. Some inks, however, dry more slowly than others. If a color should take longer than a day to dry in, be sure to wait until it is thoroughly dry before going ahead. If you don't, the tremendous pressure exerted by the scraper is sure to cause the still-damp ink to set off on the stone and you will have to flood the stone continuously with water under the faucet while you scrub the unwanted ink away with turpentine. Burnt umber is notoriously a fast drier, and it is possible for you to speed up a color's drying time by adding a little umber to it.

The use of such additives as Japan drier and cobalt linoleate is to be discouraged. These could seriously affect the life of the print. If time is at a premium, however, and you feel that you simply must use a drier, use only a minimum quantity of *cobalt linoleate*—about $\frac{1}{2}$ drop to a tablespoonful of ink. Drip a drop from the point of a palette knife on the ink slab and scrape up one half and mix it with the ink. Wipe the rest away with a rag.

The Rough

The preliminary drawing you make of your subject is called the "rough." If your color scheme is simple enough that you can hold it all in your head, you do not need to make the rough in color. A black-

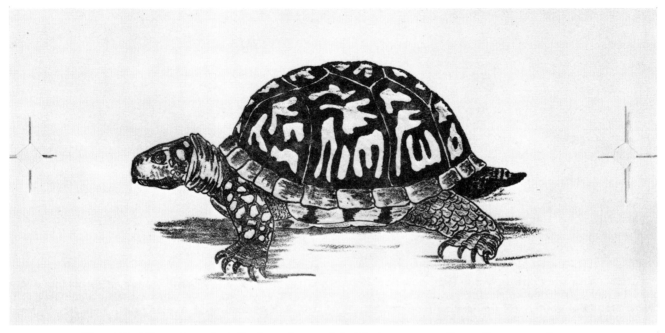

Illus. 155—The color print, the key stone printed in brown over the yellow-green image. Also see back cover.

and-white drawing will do. A color extravaganza, of course, requires a color rough—do it with pastels, colored pencils, or watercolor.

The simplest kind of color print is composed of a one-color figure or design of some kind (black, brown, burnt sienna, etc.) against a background loosely laid in with a suitable color. Either crayon (to take advantage of the grain of the stone) or tusche can be used for this . . . the latter perhaps mixed with mineral water or some non-aqueous vehicle to take advantage of the pattern thus resulting. Make no strenuous attempt at register. Cut the paper to the size of the stone and let the register be loose enough that merely lining the paper up with the stone the next time through will suffice. Needless to say, you will put the background on one stone and the drawing on another—then print the background stone first. Of course, if the background noodling is well separated from the figure, you may be able to ink both in different colors on the same stone.

The next simplest kind of color print is one that utilizes no more than two stones, one carrying the secondary color, the other being the key stone with the main design on it. The turtle printed in two colors (Illus. 155) is a good example of this kind of work. We shall use this print for an example in describing the process; however, you are not obliged to make a print of a turtle in order to follow the directions. Make up your own design—even abstract, if that pleases you—so that it can be printed in two

colors. Let the final color overprint the first color in some places and be printed on bare paper in other places. Use any two colors that you think will fit the situation, one lighter than the other.

The Tracing

Trace the original drawing so that it carries all the detail that is to go down on both stones (or more, if there are any).

If your color scheme is so complex that colors pop up all over the place, then by all means make a separate tracing for each color, even though every additional tracing multiplies your chances of throwing the print out of register. When working with more than one tracing, you must be exceptionally careful not to over-run or under-run when tracing off the lines of the rough.

The principles involved in printing a two-color print, such as the turtle, are the same as those involved in printing four, six, or more colors. Once you attain skill at registering one color upon another, all you have to do is keep repeating the procedure through whatever number of color stones comprise the series.

The turtle, being simple and straightforward in design, does not need a color rough, and only one tracing will suffice for both colors. Use for this a sharp pencil and parchment tracing paper. Pencil onto the tracing all the detail that is to appear in the

Illus. 156—With the light on in the light-box and the print turned upside down on the glass, the register marks stand out boldly and are easy to draw in on the back of the print.

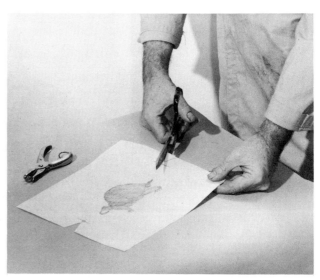

Illus. 157—To use a hand punch in punching out a "register window," scissors must be used to cut a V-notch in each end of the print. This is only one method of preparing a print for register.

key print . . . the markings on the shell, the scales on the legs, etc.

Needless to say, you should center the tracing on a piece of tracing paper cut to the exact size of the stone you plan to print from. In this case, the stone measured 9″ × 12″, and the color print could have been produced with the little box press as well as with a regular scraper press.

After the drawing is completed on the tracing paper, carefully add the register marks (Illus. 148). A register mark is a pair of lines crossed perpendicularly to each other. One is located at each end of the drawing, centered with respect to the width of the stone and located not closer than 1″ to the ends of the stone. This much space is required, because the register marks must print along with the drawing, and therefore have to be located where the scraper can pass over them without running off the end of the stone.

Tracing the First Color on the Stone

Prepare for tracing off onto the stone by attaching a sheet of thin, white paper of the same size to the face side of the tracing. You can stick the two pieces of paper together with a tiny spot of paste or Elmer's glue between them in each corner, or (in the same places) apply a small piece of double-sticking tape—this is a cellulose tape that is sticky on both sides. Lay the assembled sheets on a light-box (Illus. 147) and rub over the drawing with a stick of sanguine Conté crayon. Rub the chalk out with a wad of cotton.

In graining the stones for the turtle, the subject was kept in mind and, after the two stones had been

lapped together with #180 grit, one stone was further lapped with #220 grit and a glass muller. The finer grained stone was used for the undercolor (yellow-green) so that its grain would not conflict with the grain of the overprint. You might follow this procedure with your stones.

For the yellow-green stone—that is, the stone intended to print in that color—it is only necessary to transfer the general outlines of the drawing as the entire outline will be more or less filled in with crayon (Illus. 149). This is so that the brown of the overprint will have yellow-green showing through it, as well as through the openings in the design. The whole area within the outline must now be filled in with #3 litho pencil or crayon (Illus. 150).

In transferring the turtle outline to the stone, you would of course transfer the register marks (Illus. 149). Your first duty in working on the stone is to redraw these over the sanguine marks with *tusche*—make the lines as thin as possible for greater accuracy (Illus. 150). Use a straightedge and ruling pen, or the finest possible drawing pen.

You might have filled in the outline of the turtle with tusche, so that it would print a solid, even coat of color. In that case, you would paint the area in with a brush, allow it to dry, then paint in a second coat to assure complete coverage. However, in this example, I wanted to take advantage of the effect offered by the grain, as well as to fade out some areas and deepen the tone of others. Therefore, pencil was used in a medium grade of hardness (#3) so that the standard etch of 10 drops of nitric acid to an ounce of gum could be used.

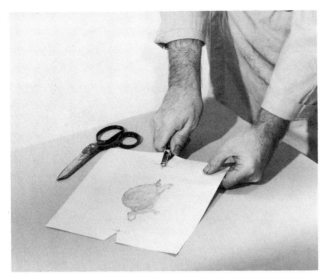

Illus. 158—Use an ordinary hand punch to punch the window precisely over the intersection of the register lines. It will leave a hole $\frac{1}{4}''$ in diameter.

Illus. 159—The X-acto hand punch, tapped lightly with a mallet, punches a large ($\frac{1}{2}''$ dia.) open circle for a register window for easy visibility.

As soon as the drawing was finished, both it and the register marks were dusted with rosin and talc, then etched in the usual way and put aside.

Tracing the Key Stone

Use the same tracing for the key stone that you used in transferring the outline of the turtle to the yellow stone. This time, however, trace through every last bit of detail, for even without the second color, this stone should be able to make a print that would stand alone as a picture of the object it describes. Also take care in tracing off the register marks. After removing the tracing from the stone, measure the distance between the lines of the register marks at the ends of your stone and compare this measurement with the same space on the yellow stone. The distance must be exactly the same on both stones and, if you have been the least bit careless with tracing, they will not be exactly right. If there is any variation at all, now is the time to correct it.

Draw the turtle in any style that pleases you. In this case, the main outlines and details were drawn in with tusche and a fine pen. The dark areas on the shell surrounding the light openings were filled in with tusche also. When the tusche was dry, #0 crayon and #1 pencil were used to strike in the grainy shading (Illus. 151).

Why were these particular grades of crayon and pencil chosen? Because these were the softest available. The softer the crayon, the more etching it requires—a #5 (copal) crayon may need no more than 2 or 3 drops of acid in an ounce of gum arabic. A #4 might take 3 to 6 drops; a #3, 8 to 10 drops;

a #2, 12 to 15 drops; a #1, 18 to 20 drops, and so on. We know, too, that tusche must be etched with about 20 drops of nitric acid to an ounce of gum. Therefore, the softest grades of crayon most closely correspond with the etching requirements of tusche and are the best to be used with it, so that the entire drawing can be treated as if it were done entirely with tusche. The key stone in this case was etched with the 20-drop formula, and subsequent processing followed as described earlier.

Trial Printing

It is not recommended that you make trial proofs from a stone after the first gum etch. Restrain your impatience until all three etching phases have been gone through, then wash out the image with turpentine and asphaltum, roll up with Crayon Black ink and pull enough proofs to show that the stone is printing well and that the drawing is as you want it.

After the last proof is pulled, ink up the stone again as if for one more print, but instead, powder it with rosin and talc and gum it up with a thin coat of pure gum. When you are ready to print in color, wash out the image, roll it up with chrome yellow ink (or whatever light-toned ink you have chosen) and print off as many prints as you will need for your edition.

Whatever number of prints that may be, you should make from 5 to 15% more to take the place of prints spoiled by printing mistakes, mis-register, and so on.

In the case of our example, a number of prints were pulled, some in yellow, some in red and some

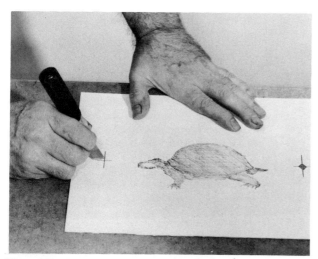

Illus. 160—You can also use an X-acto knife to cut a square or lozenge-shaped window in the print at each register mark.

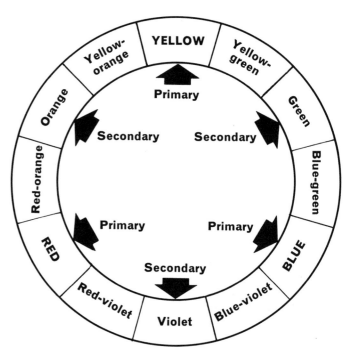

Illus. 161—The color wheel. Any two colors diametrically opposite to each other when mixed together with white produce a tone of grey. Use mostly white, very little color. If a color is too bright, a little of the color opposite it will "grey" it or tone it down.

in green. The dark prints served as models in the photographs where they would show up better than yellow prints and also gave an idea of how different colors would look with the reddish-brown of the key stone.

When you have finished printing the yellow stone, flood it with water, then wash out the image with turpentine, clean the stone, remove the excess water and roll it up with Crayon Black ink. Powder the inked image with rosin and talc, gum up the stone and put it aside until the edition has been printed. You may want to do a few prints over. Do not put a stone away with colored ink on the drawing. The ink will dry and ruin the stone for printing. Always roll it up with a non-drying ink such as Crayon Black or Roll-Up Black.

Preparing the Prints for Printing in Register

How are you going to get the brown turtle-shape to print directly upon the yellow underprint without going askew? The register crosses will serve as guides for perfect matching of the two images. When you inked the yellow stone, you inked the register marks as well as the drawing, and these printed at the same time. But you cannot see the marks through the back of the paper, you say, nor the marks on the stone, either, so how are you going to match the marks when laying the paper on the stone for printing? Good question.

There are several ways to do it. One way is to take a couple of darning needles, stick them eye-end first into a couple of $\frac{5}{16}$" dowels, and secure them in these "handles" with a bit of melted sealing wax.

Twirl one of the needles in the precise intersection

of each register mark on the stone to make a little hollow that will hold the point so that it will not slip.

As soon as the yellow prints are dry—which should be the next day—stick one of the needles through the intersection of each printed register mark. Then take a printed sheet and, from the back, stick the needles through the holes thus made (Illus. 162). Stabilize the points in the holes ground in the stone, straighten up the needles, and let the print drop directly down upon the stone. Hold it carefully to prevent slippage, remove the needles, then rub the back of the sheet lightly to make it adhere to the wet ink on the stone. If you are making a large print, you may need an assistant to help handle the print while you manipulate the needles. Now put on the backing and the tympan and print the sheet with its second image. When you look at what you have done, you should see both images in exact register.

The only advantage of the needle-drop method of register is that it hardly damages the paper with the small needle holes, and you can keep the sheet entire, with the register marks showing. Easier methods of register exist, however, but these cause severe damage to the paper, so that, after printing, you will have to cut off the ends bearing the register marks.

These other methods consist of cutting "register windows" in the paper, and your first step is to

Illus. 162—The "needle-drop" method of register. Darning needles thrust into handles locate the register marks on the stone through the register marks on the print. The print drops down the needles and is registered. Generally requires an assistant but has the advantage of not seriously damaging the paper.

transfer the register marks from the front of the print to the back. You can do this either by laying the print face down on a light-box (Illus. 156) so that you can easily see the marks through the paper and therefore trace them; or, you can lay the print face up on a sheet of graphite or carbon paper and trace over the register marks, using a sharp, hard pencil and a triangle or other straightedge. The graphite or carbon will set off on the back of the print.

The general idea in every case is to cut out the intersection of each register mark so that the lines drawn on the back of the print can be made by sight to coincide with the lines on the stone. One way to do this is to cut a V into each end of the paper to allow a paper punch to reach the intersection of the lines, then punch them out (Illus. 157–158); or, you can lay the print on a piece of untempered hardboard and punch out the intersections with an X-acto hand punch and a light tap or two with a mallet (Illus. 159). The simplest way of all, perhaps, is to cut a square or diamond shape out around the intersection of the register marks (Illus. 160). The openings thus made in the paper allow you to sight directly through them upon the register marks on the stone. It is then easy to bring the two sets of marks into coincidence with each other, the marks on the stone and those on the back of the print.

To do this properly and without smearing the ink, put down one end of the paper first (Illus. 146),

either right or left, as you find most convenient, and line up the marks on the back at that end with the intersection of the register marks on the stone. Then carefully sight the other end down in place and, when the paper is flat upon the stone, the print register marks at both ends should coincide precisely with the register marks on the stone (Illus. 163). Rub the paper lightly to make it stick to the ink, then go ahead with the usual process of printing.

This whole procedure of preparing the prints and registering them on the stone is a lot easier to do than to describe.

Illus. 163—Registering a print by means of the "register windows." Note how the register marks on the back of the print (grey tone) coincide exactly with the register marks on the stone (crossed lines in the lozenge-shaped openings).

Register window

Register marks on back of print

Register marks on the stone

Stone

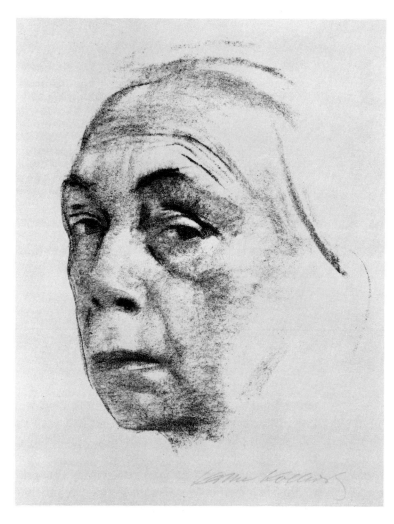

Printing the Key Stone

Before washing out the key stone preparatory to printing in color, roll out the ink you intend to use—in this case a reddish brown called Autumn Brown. It could easily be approximated with a mixture of burnt umber and burnt sienna; or, you may add a little red to burnt umber to liven it up. If the tone of the ink is too lively, however, you can deaden it by adding a tiny bit of blue or black and mixing thoroughly.

If you want to save the stones for future printing, wash the colored ink out of the drawing by flooding the stone with water (best done under the faucet at a sink) and then washing out the drawing with turpentine. Then re-ink with Crayon Black, powder the image with rosin and talc and gum up the stone. If you do not intend to reprint the stones, wash off the ink with water and turpentine and regrain them.

Illus. 165—"No More War" (Nie wider krieg). Käthe Kollwitz (German, 1867–1945). The National Gallery of Art, Washington, D.C. Rosenwald Collection.

11. HOW TO PREPARE LITHO PLATES AND PRINT FROM THEM

General Information

The metal plates used by artist-lithographers are made of a fairly thin gauge of zinc or aluminum. Zinc is harder than aluminum; consequently, it may be re-grained more times before becoming too thin for further use—perhaps 12 or 14 times in all. Zinc is also generally easier to work with and to print, though it tends to scum up worse than aluminum.

In some circles the paper plate is preferred. It is both inexpensive and well suited to classroom use, particularly for adult education courses, for the production of small-run bulletins, and the like.

Advantages of Metal Plates

Many lithographers do not use stones at all but prefer plates entirely. Others are satisfied to use the stone for the key drawing in a color series, then to use metal, or even paper, plates to carry the colors.

Metal plates do have a certain advantage over stones, namely: low initial cost, light weight, no storage problems (simply wrap the plate in newsprint and lay it flat in a drawer or on a shelf). Also they can be printed on a press with a top roller, as well as on the scraper type, and therefore you can print them with an etching press just as you would print a linoleum block or woodcut. Too, metal plates are grained when you buy them. You can draw on them at once.

A full-size metal plate measuring 22″ × 28″ can be cut into smaller sizes on a suitable paper trimmer or with scissors. One such plate will yield four 11″ × 14″ plates, or one 12″ × 16″ and a 16″ × 20″, or two 12″ × 16″ plates and one 11″ × 14″. Keep your fingers off the grained surface when cutting.

The professional trend is toward very large prints—the larger the better. As an amateur or student, you cannot hope to compete with them, and you will find that making relatively small prints is quite as much fun and a lot less expensive and tedious.

A color series printed from plates, or from a combination of stones and plates, is done exactly as if you were printing the entire series from stones, as fully explained in the last chapter.

Disadvantages of Metal Plates

Drawing on the plate is accomplished exactly as on stone, using the same materials. However, if you put down a line or tone that you want to remove immediately, you cannot scratch it away as you can with stone. You must remove the work with a solvent such as benzene, lighter fluid, or lacquer thinner. If you scratch at the drawing on a plate, you will remove the grain, and this work is likely to take ink anyway and to print with a disagreeable-looking smudge. With care, small spots and similar can be removed with a snake slip or Scotch hone sharpened to a point. After the plate has been etched, however, large areas of drawing can be chemically removed, as will be explained.

To all of this add the fact that you cannot lighten a tone by scratching light-printing lines across it. Neither can you scratch your signature with an etching needle into an area of dark tone and have it print white, as you could with a stone. On the plate, the signature would only fill in with ink. The way to get lines on a metal plate to print white in a black area is to remove the color chemically by using an erasing solution (saturated solution of lye). Use the lye in a drawing pen and carefully blot it up after it bubbles. This will remove the tone but leave the grain of the plate. If you sign your name, remember to write it backwards so that it will print the right way round.

Graining Metal Plates

Once upon a time, the offset printing industry made wide use of zinc plates, and every town of any size had its plate-regraining establishment to take care of the plates used by the local printers. Since the invention of the ready-made presensitized photo-lithographic plate, however, the printer no longer has to flow his own plates with photographic emulsion. Moreover, these ready-made plates are so cheap that the printer can afford to throw them away without messing with regraining. As a business, the graining of metal plates has dwindled so far away that perhaps not more than one or two establishments in any country is set up to perform this service. Ask your litho supply dealer for the address of one nearest you. Send your plates off, a bundle at a time, specifying a medium grain.

However, unless you are turning out plate after plate, such a mail-order proposition may not be suitable for you. If you have gotten used to graining stones, you will find it a far easier job to grain a plate, because the drawing just sits on the surface—it

Illus. 166—"The Sketcher," a lithograph made from a zinc plate drawn on with litho pencils and crayons, etched with **AGUM-Z.**

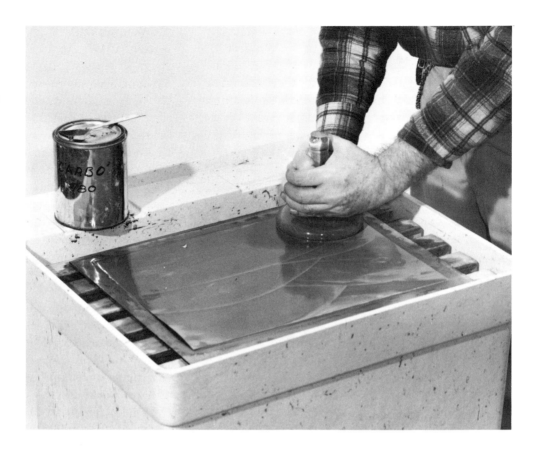

Illus. 167—It takes less time, less effort, and less grinding compound to grain a plate. Note marks on plate indicative of figure-8 movement of the glass muller. Double-strength sheet of glass on the grating supports the plate perfectly flat for graining.

does not sink in as it does into stone. Usually a single charge of #180 carborundum grit and a few minutes of grinding with a 5″ glass muller will do the job speedily.

Use your regular graining sink or tub. Wet the wood grating and lay upon it a sheet of double-strength window glass a couple of inches larger in each dimension than the plate (Illus. 167). Wetting the slats keeps the glass from slipping. Clean the face of the glass thoroughly with shellac thinner to remove any grit or lumps of dirt sticking to it, as these will otherwise punch up the back of the plate and raise points on the surface.

Whenever you finish printing from a plate, gum it up, squeegee the excess gum away, and fan dry. When ready to grain, wash out the drawing with plain turpentine to remove the color, fan dry; then wash the plate free of gum and dirt.

Lay the wet plate face up on the glass in the tub and squeegee it down flat. Sprinkle it with water and #180 carborundum grit and grind with figure-8 strokes, as described in Chapter 2, using a muller of glass or metal. The grinder should not be heavy, and do not put weight on it in grinding, as this leads to scratches. Let the rolling grit do the work. You can also grain the plate to a coarser or finer grain, as with a stone.

Preparing the Press for Printing from Plates

You can print from plates as well as from a stone in the little box press described in Chapter 6. If you have been using the press with a stone, cut the plate the same size and lay it on top of the stone while wet.

When using a regular, scraper-type press, the plate must be set upon a block of some kind for printing (Illus. 169). The reason for this is two-fold: (1) the scraper can be brought down only so far toward the bed, but not far enough to make contact with a plate lying on the bed itself; (2) if the plate lies directly on the bed, or on any flat surface larger than itself, a mess of ink and water will soon collect around it and keep you busy mopping it up. Hence, the block.

Make the block as thick as required by glueing pieces of plywood together (Illus. 169). Before glueing, drill and countersink the bottom piece(s) for a number of #8 × 1¼″ flathead wood screws, spaced about 2″ apart in every direction. After spreading the pieces with glue, pull them tightly together by driving home the screws. Make the glue-up larger than the plate, then trim it to the size of the plate (or, preferably, a sixteenth of an inch smaller in each dimension) with a circular saw. If you plan to print from several different sizes of plates, you will need a separate block for each size.

Surface the top of the block with a piece of Formica, stuck on with contact cement to give it a smooth, hard facing to which the plate will adhere.

You may, if you wish, use a litho stone to support the plate, but if you do this, leave the linoleum on the press bed to protect the stone. You may remove the linoleum covering if you are using the wood block for a support.

If you plan to print with an etching press—or with a combination etching and lithographic press, using the top roller instead of a scraper—you need to make the block of only one thickness of plywood covered with formica (Illus. 171–172). Of course, to accommodate the block, you must raise the roller to the proper printing height, as when printing a wood block.

Also, to keep the block from sliding on the press bed when the pressure is applied, you must arrange something for it to shove against (Illus. 169–172). Or, for a permanent placement of the block, you can drill holes in the press bed and attach the block to it with screws from underneath.

Preparing the Lithographic Plate

If the plate has been stored in the studio for more than two or three weeks since its arrival, or since it was last grained, your first step will be to counter-etch it to re-sensitize the surface. A formula for a counter-etch is given later in this chapter. Counter-etching allows the plate to accept grease pencil and tusche. The need of a plate for counter-etching may be totally invisible, or it may reveal itself by a dark-toned mottling.

Illus. 168 shows a set-up for drawing the plate, with a low bridge under the draughtsman's hand to protect the plate and drawing. The original drawing has been placed in front of the mirror on the left, so that its reversed reflection can be viewed as an aid in working up the reversed drawing. First make a tracing of the original drawing and transfer this to the plate with sanguine Conté crayon on a white sheet over the face of the drawing, as usual.

Etching Zinc and Aluminum Plates with AGUM-Z

You do not use the same chemicals for processing plates that are used on stones. Generally, too, different metals require different chemical formulas. The simplest etch, however, is a proprietary formula called AGUM-Z, and it is used for etching both zinc and aluminum plates. There is nothing to mix—it comes ready to use direct from the bottle and it keeps without spoiling.

1. Pour a small puddle of AGUM-Z on the zinc or aluminum plate—it has about the same consistency as gum arabic—and spread it around with the acid brush or a rag. Keep the etch moving by constant brushing lengthwise and crosswise of the plate, as this reduces the tendency of the plate, particularly zinc, to scum. After two minutes or so, depending on the depth of tone of the drawing, pick up the excess etch with newsprint as usual, wipe down the plate with the edge of your palm, then with a clean, soft rag. Fan the plate dry.

2. Wash out the drawing with turpentine and asphaltum in the usual manner.

3. Wipe the excess turpentine and color from the plate with a rag and fan it dry.

4. Flood the plate with cold water from the faucet and wash it clean.

5. Take the dripping plate immediately to the press and place it wet and face up on the block prepared for it (Illus. 170).

6. Wipe away excess water with a sponge, damp the plate for inking and give it three inkings of Crayon Black ink.

Be very careful at this stage of handling the plate not to let it get dry while the drawing is unprotected by ink, or it will blind out quickly and you will never get a print from it.

Although one etching is generally recommended when using AGUM-Z, a particularly heavy drawing or a tusche drawing can be etched again after you powder the drawing with rosin and talc. If the plate slips on the block, apply the inking roller lightly, rolling it toward yourself if necessary, until the plate is fully inked. Once you are ready to print, the plate has to go through the press only once to be pressed down firmly on the glass-smooth surface of the block. With all the air and excess water squeezed out from under it, the plate is held in place by suction.

Both zinc and aluminum plates require a slow build-up of printing strength of the image, just like the stone, so pull three or four proofs on dry newsprint before turning to your damped printing paper.

If the plate tends to give trouble, such as filling in, scumming, etc., ink it fully, powder it with rosin and talc, and gum up with AGUM-Z. Let the plate sit a half hour, then wash it out with turpentine and asphaltum and go back to printing.

Never place a sheet of wet paper under the plate. It will not keep it from slipping any more than the bare metal against the surface of the block. Such a paper carries an excessive amount of water. After squeezing out, this will run back on the plate, spoiling both the print and the blotter backing. Once the water is squeezed out, the plate will slip anyway,

wrinkling the paper, and the wrinkles will come through the plate.

Printing Litho Plates with a Top-Roller Press

The really nice thing about printing from plates with a top-roller press is that you can dispense with the messy, greasy tympan. If you are working with a combination press (Illus. 172), leave the side screws elevated so that the roller swings freely from the center screw and can tilt from side to side to compensate for any inequality in the thickness of the block. If you are printing with an etching press, the ends of the roller must be supported on springs so that it can be adjusted to the necessary printing height above the bed; thus, it has no freedom of tilt. If weak places show in the print, you must work them out by applying make-ready to the underside of the block, the same as if you were printing a woodcut in a letterpress.

Illus. 171–172 show the set-up for printing with a top roller. It is the same as for printing with a scraper, except that the greasy tympan is replaced by a piece of untempered hardboard, placed smooth-side down on the backing.

If using a combination press, move the bed forward until the leading edge of the block is under the roller, then pull down the side lever to bring the roller into contact with the hardboard pad and apply the necessary printing pressure. The required amount of pressure feels about the same as for the scraper.

Start the press and let the plate grind through, but stop the motor (or hand turning) before the roller runs off the trailing edge of the block. Return the side lever to vertical to release pressure and remove the print as usual.

If using an etching press, hold the pad down on the block as it feeds under the top roller to prevent its being thrust askew. A good idea is to bevel the leading and trailing edges of the hardboard pad, as this will reduce the shock of contact with, and release from, the roller. As the block runs out on the far side of the roller, hold it down to restrain any tendency it may have to jump as it escapes the pressure of the roller.

Whether you are using a scraper or a top roller, do not make the blotter backing and the tympan or hardboard pad any larger than the size of the plate, particularly if the block is thin, as you must be able to see the block to know when to stop the press (this is not important with an etching press). However, overhanging blotters have a tendency to soak up water squeezed out from under the plate, forcing a change to dry ones. Also, it is a waste of paper to cut it larger than the plate, as it will only pick up ink from the edges of the plate and the margins will have to be trimmed.

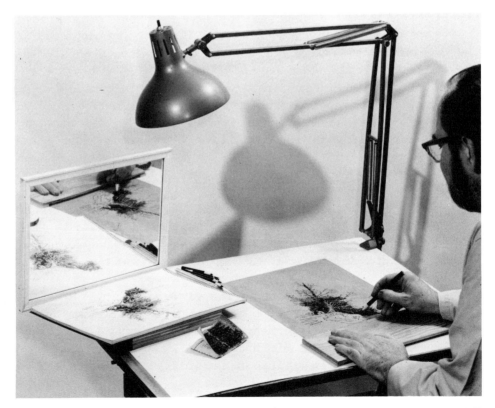

Illus. 168—Drawing the lithographic plate. Note the plywood bridge supporting the drawing hand. Placed before a mirror, the original drawing (left) is reflected in reverse for greater fidelity in copying.

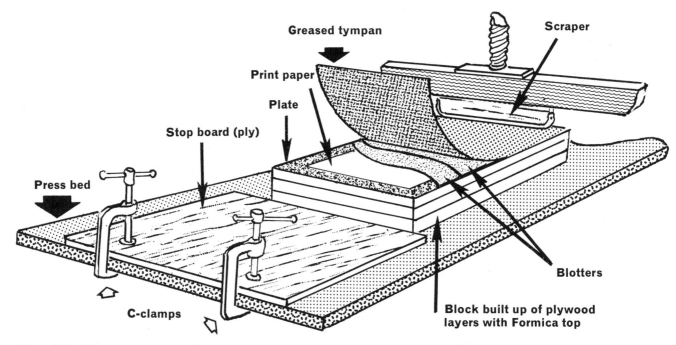

Illus. 169—This cut-away drawing shows the press set-up for printing a litho plate on a scraper-type press. The stop board restrains the block to the middle of the press bed, and the block elevates the plate so that it can be reached by the scraper.

It is good practice, therefore, to cut the print paper smaller than the plate by an inch in each dimension. In printing, water may be squeezed from under the plate, over the edge and spoil the print paper. Cutting the print paper to a size smaller than the plate will prevent this. Also, the edges of the plate often take ink from the roller and unless this is cleaned off before each print is made, it will set off on the margins of the paper, necessitating trimming when dry. When the paper is smaller than the plate, it cannot pick up ink from the edges when going through the press.

Printing Difficulties

Zinc plates have a natural tendency to scum—much more than aluminum or stone. If the roller deposits a little scum on the margins of the plate, wash it off with a wet rag or scrub with a dry fingertip.

Once a plate starts to scum, however, it gets worse with each print, not better. The first time this happens, re-etch the plate. If the plate continues to scum, clean it off before each print until the scum gets too heavy to remove easily. Then ink the plate fully, as if for printing, and pour a little AGUM-Z on it (or whatever etch you are using) and, with a clean rag, scrub it around on the plate, loosening and removing the scum. Check your progress by wiping the etch aside here and there and when the plate looks clean (in about two minutes), wash the etch away with a clean rag and plenty of water, rinsing the rag often. Make sure all the etch is washed away.

You can do this without removing the plate from the press and so save yourself the nuisance of re-setting it on the block. Mop up the slop on the press bed, then damp the plate properly and roll on a single inking. This is all the ink you need to pull a normal print following the treatment. If the plate starts to scum up again a few prints later, repeat the cleansing treatment as often as needed until the entire edition has been printed.

To store the plate for future printing, roll up fully with ink, powder with rosin and talc, and gum it up with pure gum arabic.

Phosphoric-Acid Etch for Zinc Plates

There are many chemical formulas that you can mix yourself. Here is the simplest of all: add 60 drops of phosphoric acid (85%) to 2 ounces of gum arabic. This is enough to etch a 12″ × 16″ plate twice. Let the solution stand overnight, at least, before you use it.

The First Etch.

1. Powder the crayon or tusche drawing on the zinc plate with rosin and talc, then pour about an ounce of the etch on the plate. Brush it out quickly with the acid brush, in both directions, into a smooth, even coat. Etch for 1 to 2 minutes, depending on the depth of tone of the drawing, constantly brushing the etch out in all directions to minimize the possibility of scumming. The action of the etch must take place evenly over the entire surface of the plate.

At the end of the etching period, pick up the excess etch with newsprint, discard the paper, then lay down another sheet, brush your hand across it, and pick it up immediately. Do not let the paper sit on the plate too long or it may stick. Smooth the etch out into a thin coat with the edge of your palm, and follow this by brisk, but not hard, rubbing with a soft, clean cloth. Fan dry.

2. Let the plate sit in the dried etch for at least a half hour, then wash off the etch, fan the plate dry, and gum up with pure gum arabic. Squeegee to a smooth, even coat, and fan dry.

3. Wash out the drawing with turpentine and asphaltum.

4. Roll up with Crayon Black ink and powder with rosin and talc.

The Second Etch.

Repeat all of the steps above, using the other half of the etch. After gumming up with pure gum arabic, either let the plate sit until you are ready to print, or wash out the drawing, roll up with ink, and start printing immediately.

The Chromic-Acid/Phosphoric-Acid Etch for Zinc Plates

This is a more powerful etch because of the addition of chromic acid flakes to the formula. Since chromic acid is akin to sulphuric acid, it is equally dangerous to handle; perhaps even more so, as there is a dry dust in the contents which, if stirred into the air by careless handling, may be breathed in or may settle on the skin or in the eyes. For this reason, many lithographers will not use it. It is advisable to wear rubber gloves and a respirator, if you have one—or tie a doubled handkerchief around your breathing apertures while mixing the solution. The formula is as follows:

$\frac{1}{2}$ oz. (avoirdupois) chromic acid flakes
$\frac{1}{2}$ fluid oz. phosphoric acid (85%)
Mix in 2 oz. water and add to:
9 oz. gum arabic solution

NOTE: This formula must be used within 3 hours of mixing. For procedure, follow the same processing steps given for the simple phosphoric-acid etch above.

The Ammonium Etch for Zinc Plates

An ammonium-based formula is mixed up as follows:

$\frac{1}{4}$ oz. ammonium nitrate (by weight)
$\frac{1}{4}$ oz. ammonium bi-phosphate (by weight)
5 fluid oz. gum arabic solution

Etch 1 or 2 minutes with one half (or less) of the formula; then, following the steps given above, re-etch with the same formula.

Illus. 170—This photograph translates Illus. 168 into reality and shows the plate ready for printing, laid on the Formica top of its supporting block. Note blotter backing at upper right and plastic clip for picking up print paper to avoid finger marks. The tympan is shown under the scraper. Also, damping sponge and water buckets are under the press bed.

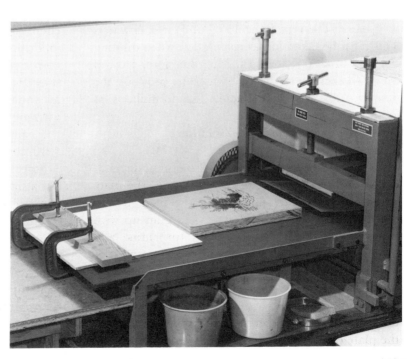

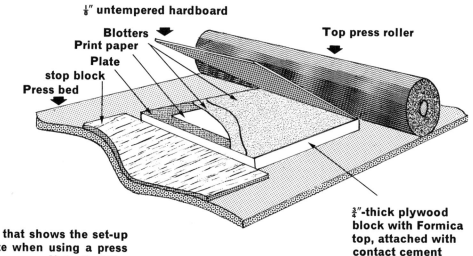

Blotters
Print paper
Plate
stop block
Press bed

Top press roller

¾″-thick plywood
block with Formica
top, attached with
contact cement

Illus. 171—A cut-away drawing that shows the set-up for printing a lithographic plate when using a press with a top roller instead of a scraper. Note that the only difference is, a sheet of thin hardboard replaces the greased tympan.

Etching Aluminum Plates

The lower initial cost of aluminum plates is an attractive inducement to their use. The simple etch for aluminum is similar to the plain phosphoric-acid for zinc, but it must be made a great deal weaker. In order to have a measurable amount when using the acid in small quantities, reduce the strength of the original acid to a 20% phosphoric acid solution.

Phosphoric acid (or orthophosphoric acid— H_3PO_4 in the pure state is a deliquescent, crystalline compound. The liquid, a syrupy form of the acid made by adding water to it to facilitate bottling, is 85% pure. The remaining 15%, of course, is water. This must be taken into consideration when diluting the acid to a 20% strength. Mix, therefore, 1 oz. of the 85% acid with 3¼ oz. water to produce the desired 20% phosphoric acid. The formula is as follows:

½ oz. 20% phosphoric acid solution
5 oz. gum arabic

Etch the aluminum plate 1 to 2 minutes, depending on the weight of the drawing. Powder the plate with rosin and talc, then apply the first etch as described above, clean the plate, and gum up with pure gum arabic. Wash out with turpentine and asphaltum. Roll up with Crayon Black ink; powder the inked drawing and re-etch for the same length of time, using the same etch solution. Wash off the etch, dry the plate, gum up with pure gum, and wash out the drawing with turpentine and asphaltum. Wash the plate clean, ink it up and go ahead and print.

Removing Drawn Areas from Zinc Plates

Before any plate, zinc or aluminum, is etched, you can remove part or all of the drawing with a solvent such as benzol, lighter fluid, lacquer thinner, etc., and redraw as desired. Solvents do not harm the grain of the plate.

After the plate has been etched, any spots in the drawing or in the margin can be carefully abraded away with snake slip and water. For very tiny spots, use a sharp stick of Scotch hone and water.

If, however, you wish to redraw where you have removed any part of the drawing, you must use chemicals to take off the unwanted drawing. Mix the following formula with great care, as lye is extremely corrosive and must not be allowed to get on your skin or in your eyes. You can buy lye (caustic soda) at your grocery store—but be sure to read the warnings on the label before you use it.

½ oz. by weight lye (caustic soda)
10 fluid oz. water

Store the solution in a glass bottle. For use, pour out a small quantity in a 1-oz. glass graduate. Equip yourself with some cotton swabs (Q-tips)—round toothpicks with cotton wrapped around one end. Wear rubber gloves and dip the swab in the lye solution and rub it on the part of the drawing to be removed. To remove a *small* area, use a bare toothpick, dip it in lye solution and let the fluid run down the toothpick by touching it to the desired spot on the plate.

When the reaction starts, the solution will begin to

bubble or effervesce. Flood the plate immediately with water, washing away the solution (the lye solution must not be allowed to run over parts of the drawing where it is not wanted). Rub the treated area gently with a soft cloth, removing as much of the drawing as will come off. Repeat the application of lye, washing off, and rubbing, as often as needed, until the unwanted parts of the drawing have been entirely removed from the plate.

Roll the plate up with ink, powder the drawing, and etch the entire plate, using the same etch as previously.

To make white lines or spots in a dark-toned area or one that prints black, dip a clean drawing pen into the lye solution and draw with it in the desired places. Let the lines bubble up strongly, wash off the plate under the faucet with cold water, fan it dry, and re-etch.

Removing Drawn Areas from Etched Aluminum Plates

The procedure is the same as for treating zinc plates, as noted in the paragraph above. A different chemical must be used, however. Instead of lye, use straight sulphuric acid—and handle with care!

Counter-Etching the Etched Metal Plate

After chemical removal of part of a drawing, you may want to replace the vanished material with a new design. Or, you may simply want to add some new drawing to areas that were not drawn on before. In either case, the plate must be counter-etched before you can make such additions. Counter-etching resensitizes the plate so that it will again accept grease in the form of crayon or tusche. You must use a different counter-etch solution for zinc

Illus. 172—Sandwiched between a sheet of hardboard, blotters, print paper, and supporting block with Formica top, the plate is starting its run through the press. Note the side lever is down, in the "pressure on" position.

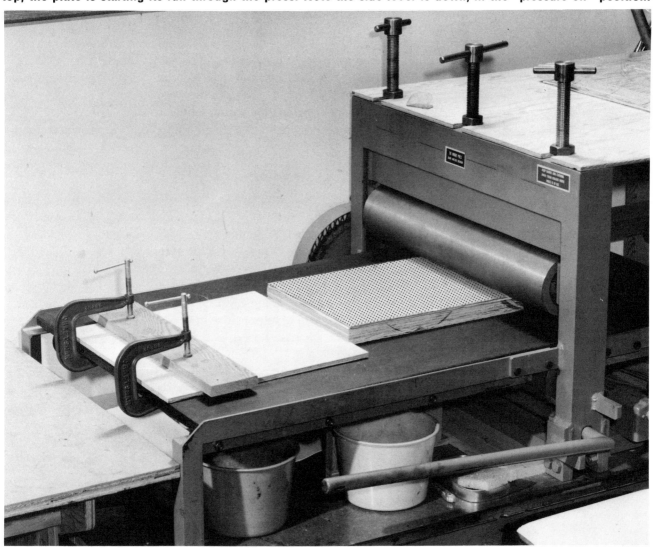

and aluminum. Here is the counter-etch formula for zinc plates:

1 teaspoon potassium alum

1 pint water

2 or 3 drops nitric acid

The counter-etch for aluminum is made up by first dissolving in a few ounces of water as much oxalic acid crystals as will dissolve. This results in a saturated solution. Then take:

1 fl. oz. saturated solution of oxalic acid

25 oz. water

Or, you may use a solution of $\frac{1}{2}$ oz. glacial acetic acid in 10 oz. water; or 1 oz. sulphuric acid in 10 oz. water.

These solutions can be stored in glass bottles of suitable size, with plastic screwtops.

In counter-etching the plate, if the amount of redrawing done is small and localized, local counter-etching with a sable brush will do. Apply the appropriate solution, leave it on for about 2 minutes, then wipe it up with a damp rag or sponge. Dry the spots, powder them with rosin and talc, then re-etch locally for 2 minutes, using the same etch used originally on the plate. After etching, wash the plate thoroughly, gum up with pure gum arabic, squeegee off the excess, and fan dry. Then wash out the entire drawing with turpentine and asphaltum, roll it up with ink and print.

If the area is large, or if the additions concern lines and spots scattered over the plate, flood the whole plate with counter-etch for 2 minutes. Wash off the solution under the faucet, dry the plate, make additions as desired with crayon or tusche, powder the new drawing, and re-etch the entire plate for 2 minutes. Wash off the etch while it is still wet, gum up with pure gum arabic, squeegee off the excess, fan dry, and wash out the drawing with turpentine and asphaltum; then ink up and print.

Counter-Etching Undrawn Plates

If you have stored a plate more than 2 or 3 weeks since it was grained, it is safer to counter-etch it before drawing on it. Any plate that shows mottled spots indicative of oxidation should be counter-etched before being drawn upon.

Use the appropriate counter-etch solution—for zinc or aluminum—flooding the plate with it for 2 minutes. Then wash quickly in cold water under a running faucet.

After counter-etching, the plate will probably show streaks and mottle owing to uneven activity of the counter-etch, but this does no harm. Dry the plate, draw on it, and go ahead with regular processing.

Paper Plates

Lith-O-Sketch paper plates are available at lithographic supply houses, along with a full line of plate solution, gum solution, tusche, black and color printing inks, and several sizes of polyurethane brayers.

Handle the paper plate as you would a metal plate—that is, keep your fingers away from the sensitive surface. Draw on the plate with regular litho pencils, crayons and tusche.

Lay a piece of cardboard in the middle of the press bed and lay the drawn plate on top of it. Apply Lith-O-Sketch Plate Solution (the etch) with a brush, spreading it on smoothly and evenly. Wipe it down to a thin coat with a soft rag, then give the plate an inking with a polyurethane or rubber roller while the coating is still wet. Each time, after inking the plate, roll the brayer on clean newsprint to remove the excess plate solution, then roll it again on the ink slab. Recoat the plate with solution before each inking, wipe it down with a rag, and apply ink. Give the plate two or three inkings, then fan it dry, lay on a sheet of newsprint, the blotter backing and the greased tympan or hardboard pad (depending on whether you are printing with scraper or roller). Use a fairly heavy press pressure.

As when printing stones or metal plates, three or four proofs must be pulled before the drawing comes up to full printing strength. The plate cannot be used for another drawing, but may be gummed up with Lith-O-Sketch Gum Solution or gum arabic for reprinting at some future time.

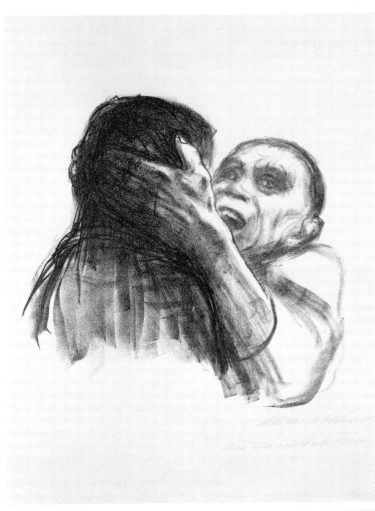

Illus. 173—"Death Cycle: Death as a Friend," lithograph, 1934-35, by Käthe Kollwitz (German, 1867-1945). The National Gallery of Art, Washington, D.C. Rosenwald Collection.

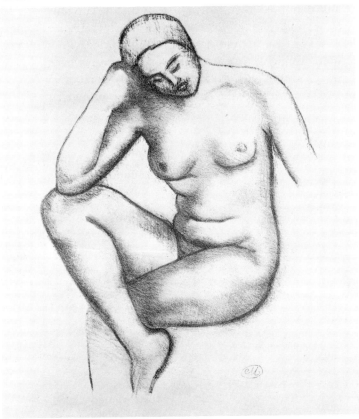

Illus. 174—Nude (Illustration for Ovid's "L'Art d'aimer"), lithograph by Aristide Maillol (French, 1861–1944). The National Gallery of Art, Washington, D.C. Rosenwald Collection.

12. WHAT TO DO WITH YOUR PRINTS

Do not sell or give away a print that is unmounted merely because it will save you a few cents for mounting board and a few minutes of time (unless, of course, the customer or recipient asks for it unmounted). If a print is worth giving away, it is worth dressing up for the occasion, and if it is worth selling, nothing will so snap it up out of the rut of mediocrity as a properly cut mat.

Don't give away frames (they are expensive) nor deliver a print to a gallery in a frame. If the gallery people want the print framed (and never frame a print without first mounting it in a mat) they can take care of the job themselves. If you frame a print, you must charge for the frame and your time and trouble with it. Then the gallery charges the customer again for the frame, and he winds up paying for it twice, a practice which is unfair both to the customer and to the artist.

To sell your work, pick out a gallery that seems to handle the type of work you do. Then, with a bundle of mounted prints under your arm, go in and talk them over with the proprietor. Don't be bashful; he will be delighted to get prints he feels that he can sell.

How much should you charge for a print? In the first place, *you* should set the selling price. Professional lithographers are selling prints for anywhere from $35.00 (£15) to $250.00 (£100) each and more, but don't get the idea that you can plunge in and do that. If you make small prints—8″ × 10″ to 12″ × 16″—you can expect a range of maybe $3 (£1) to $10 (£4), considering that you are an amateur or a beginner. The gallery people will help you decide on a price—they know the market and what it will pay for the kind of work you do. In figuring a price, consider the size of the print, the number of plates and colors involved, and the adequacy of your work when compared with that of other printmakers. The number of prints in the edition also has an influence on the price.

Some galleries split the selling price of the print down the middle with you. Others are more kindly disposed and may take on your work at a 60–40 split, with you getting the 60%. Some galleries take as little as $33\frac{1}{3}$% and 25%, but these somehow do not manage to stay in business very long.

Mounting the Print

If you plan to sell your work, there is only one kind of mat board you should use. It is called Museum Board and is available in three thicknesses—2-ply, 4-ply, and 6-ply, and two colors: bone white and cream. Two-ply is rather thin for anything but very small prints, and 6-ply is rather too thick (and expensive) for any but the largest prints. Choose the cream-colored board; few prints can stand to compete with the glare of white board. Museum Board

Illus. 175—Hold the straightedge firmly and draw the knife point along the lines marking the cut-out. Hardboard under the mat protects the table top.

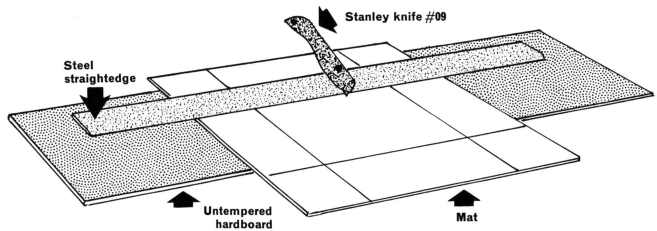

Stanley knife #09

Steel straightedge

Untempered hardboard

Mat

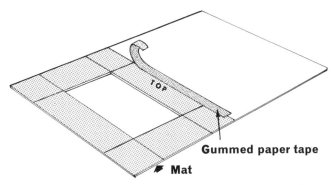

Illus. 176—Lay the mat back up on a table, top edge contacting the edge of the backing. Hinge the mount together with 1" gummed paper tape.

is made of 100% rag stock, so it is understandably expensive. A lot of art supply shops do not carry it at all, because most of their customers don't want a board that expensive. You may have to order it in, or purchase it directly from the manufacturer in lots of 25 sheets, each measuring 30" × 40".

A mount consists of a piece of Museum Board in which an opening has been cut to show the print, and a backing board. Use a good grade of illustration board for backing—it has a white-paper facing that enhances the appearance of the print and is not so likely as straw-board to stain the print paper.

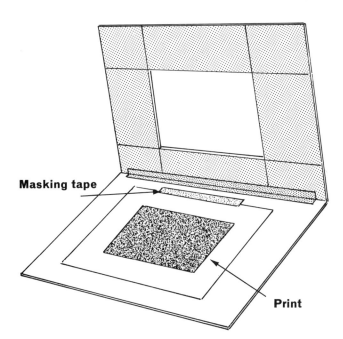

Illus. 177—Attach the print to the backing along the top edge only, as shown, with masking tape overlapping the print paper only ⅛".

In cutting the mat, allow an opening about ¼" to ⅜" wide around the print area to show the print paper. The two side margins and the top of the mount should be the same width, while the bottom margin, below the print, should be a little deeper. A large print, 12" × 16" printed area or larger, is often delivered precisely centered in the mount. Rather than resorting to rules of proportion to determine the width of the mat around the print, choose a width that looks good to your eye and at the same time will make the mount a size to fit into a standard-size frame—8" × 10", 8½" × 11", 9" × 12", 10" × 12", 11" × 14", 12" × 16", 14" × 18", and so on. Any frame is expensive, but custom-made frames are even more so.

Before matting the print, number it, title it (if it has a title), and sign it. A print without an edition number or a signature has no value as an original work of art. Suppose you plan 25 prints to the edition—25 is then the edition number. Number the

Illus. 178—Non-marring clamp for use in glueing mounts together, made of spring clothespin with flats glued to the jaws.

first print 1/25 directly below the bottom, left-hand corner of the printed area. Number the second print 2/25, and so on. If you make a surplus of prints over 25, you can select two or three and label these Artist's Proof/I, Artist's Proof/II and so on, in the lower left corner. The number of artist's proofs should not amount to more than about 5% of the total edition number. These prints are to be kept for your own use, or sold at a higher price than the others, as pleases you.

Write the title under the center of the print. If the print has no title, write, "Untitled" or leave the space blank. Under the right-hand corner of the print, write your signature in the way you wish to be

Illus. 179—Make your own mat hangers. A—strip of 1″-wide gummed paper tape. B—fold over 1″, wet gum and press together. C—strapping tape (X) sticks down to folded paper strip. Rub down smooth. D—punch a ¼″ hole through the two layers of strapping tape and two layers of paper tape. E—stick the finished hanger to the back of the mount with the gummed extension, then secure with a strip of Magic Cellulose Tape crosswise (Y).

known in the art world. If you like flossy little additions, you can put a comma after your name and add the abbreviation, "Imp." This stands for "impressit," Latin for "he printed it." You can put the date on the print or not, as you choose. If you do, it goes right after your name and before the "Imp." Do all this writing in pencil of such a degree of hardness that it will not overwhelm the print above it. A 2H pencil is very good for this.

Cutting the Mat

First examine both sides of the Museum Board. If flaws, blemishes, or dark spots show up on one side where they will be visible after the center of the mat is cut out, turn the board over. Both sides are of equal quality. When you have figured the size of the opening, carefully measure off the margins and mark them on the *back side* of the mat with pencil, carrying the lines from edge to edge. This will let you check your measurements directly by holding the edge of the mat to the print itself, so that you can see at a glance whether the print will fit into the space allowed for it or not.

Professional establishments use mat-cutting devices, but these are expensive and hardly for the amateur. Very good for your purpose is a 42″ stainless steel straightedge and a Stanley knife No. 09. This has a relatively thin blade, hence less tendency

to punch up the edge of the cut than some of the heavier bladed knives. It uses the Stanley No. 910 Break-Away Blades, consisting of 11 blades in one. As soon as a point gets dull, break it off with pliers, and a new point is presented for instant use.

Buy a sheet of 4 ft. × 8 ft., ⅛″-thick, untempered hardboard and ask the dealer to saw it into foot-wide strips, across the width, giving you eight strips. Put one of these under the mat to protect the table top whenever you are cutting out the opening. When the hardboard pad gets well cut up, throw it away and start with a fresh strip.

Cut the mat carefully, holding the straightedge firmly on the line, while you draw the point from one crossline to the next. Do not try to cut all the way through the mat in one stroke. Make the first stroke light—a guide for subsequent strokes. Another stroke or two will let the point through. When all four sides have been cut, remove the straightedge and carefully cut the corners free.

If the edges around the opening are in the least bulged, smooth them down with a bone folder, a smooth length of hardwood, or, best of all, an agate—a tumble-polished stone big enough to hold in your hand.

Try to work as clean as you can—always wash your hands before handling mat board. However, the pure rag Museum Board wears like iron and, if

it gets smudged, you can even use a gritty ink eraser to remove stubborn stains, though most smudges yield to an ordinary dry-cleaner or soft-gum eraser (such as Artgum, not a kneaded eraser).

Making the Mount

Cut a piece of illustration board the same size as the mat. Whether your print is of a horizontal or vertical format, one edge of the mount will be designated as the top, since it is at the top of the print. Attach the top edge of the mat to an equivalent edge of the backing with a 1″-wide strip of gummed paper that will serve as a hinge (Illus. 176). Now fold the mat down on the backing and insert the print between the two. Adjust it until centered in the opening, then take a strip of $\frac{3}{4}$″ wide masking tape about half as long as the top edge of the print. Hold the print immovable with one hand through the mat opening and lift up the mat with the other. Carefully change hands without moving the print, and open the mount all the way. Press the strip of masking tape down along the top of the print, from about the middle both ways (Illus. 177), but do not overlap the print paper by more than $\frac{1}{8}$″.

If the mounted print is to be framed immediately, it can be left open. However, if the print is to be displayed in the mount only, then the latter must be glued together to keep it from warping. Apply spots of Elmer's glue to the backing, about every 2″ all round the three open edges, then close the mat on the backing and weight down until the glue sets.

Very useful for glueing mounts shut are a number of clamps around the edges, each made of a spring clothespin and a couple of flat strips of wood glued to the jaws. Do not use plain clothespins, as the small jaw surface will bite into the mat and mar it. If you do not have a circular saw for cutting the thin strips of jaw material ($\frac{1}{16}$″ × $\frac{1}{2}$″ × $1\frac{1}{2}$″), you can buy ice cream sticks or tongue depressors and cut them into $1\frac{1}{2}$″ lengths by scoring across with the mat knife and breaking them off. To make the clamp, hold two such strips together, apply glue to the jaws of the clothespin, then clamp it squarely on the middle of the sticks (Illus. 178). In very little time, you can make a hundred or more of these little clamps (and very inexpensively).

Mat Hangers

You can buy mat hangers, consisting of a cloth patch with glue on the back and a wire loop for hanging. However, Illus. 178 shows how to construct an easy-to-make mat hanger out of 1″-wide gummed paper tape and $\frac{3}{4}$″-wide strapping tape. The latter is an opaque, yellowish-tinted, cellulose tape of great strength, available practically everywhere. When the strapping tape is folded around the paper tape, it provides a strong hinge and a body of such strength that the hanging hole, punched in with a paper punch, will not tear out. The paper tape supplies rigidity to the mat hanger, which is otherwise lacking with the strapping tape alone.

APPENDIX

Resumé of Stone Processing

1. Grain the stone(s).
2. Draw with litho pencil, crayon, and/or tusche.
3. Powder drawing with rosin and talc.
4. *First Gum Etch.* Etch 4 minutes, blot, rub down, fan dry.
5. Let stone sit in dry etch for 24 hours or more.
6. (Next day). Roll out ink on ink slab.
7. Wash old etch from stone and fan dry.
8. Gum up with pure gum arabic (or AGUM-O). Squeegee to a thin coating and fan dry.
9. Wash out drawing with turpentine and asphaltum; fan dry.
10. Flood stone with water, rub gently with a rag to remove gum and smeared dirt from the stone.
11. Sponge excess water from stone; roll up with three inkings of Crayon Black ink.
12. Powder inked drawing with rosin and talc.
13. Clean excess powder from margins with damp sponge.
14. Erase ink marks, blots, etc., from margins and drawing with snake slip and water, or Scotch hone.
15. *The Water Etch.* Add 20 drops nitric acid to 1 oz. water. Brush on margins for 2 minutes, then flush drawing for a few seconds to 1 minute, depending on tone of drawing.
16. *Second Gum Etch.* Same as first gum-etch or a little stronger. Etch 3 minutes, blot, wipe, fan dry. Let sit ½ hour to 4 hours or overnight.
17. Wash etch from stone; fan dry.
18. Gum up with pure gum arabic; squeegee; fan dry.
19. Wash out drawing with turpentine and asphaltum.
20. Roll up with ink and print.

Resumé of Plate Processing

1. Draw with litho pencil, crayon or tusche on grained plate.
2. Powder drawing with rosin and talc.
3. *First Etch.* Etch 1 to 2 minutes, depending on tone of drawing. Blot; wipe down; and fan dry.
4. Let sit ½ hour or longer (or until next day if desired).
5. Wash off etch and fan dry.
6. Gum up with pure gum arabic; squeegee; fan dry.
7. Wash out drawing with turpentine and asphaltum.
8. Ink the drawing to full tonal strength with Crayon Black.
9. Powder inked drawing with rosin and talc.
10. *Second Etch.* Repeat the etch as given above, using the same formula for the same length of time.
11. Let sit ½ hour or longer.
12. Wash out drawing with turpentine and asphaltum.
13. Roll up with ink and print.

Resumé of Procedure for Transferring a Drawing to a Stone or Plate

1. Counter-etch the stone or plate for 2 minutes, rinse, dry.
2. Damp stone or plate slightly.
3. Lay drawing to be transferred face down on stone or plate.
4. Lay on damp sheet of newsprint, backing, tympan.
5. Run through the press; stop; reverse the run; stop.
6. Remove the sheet of newsprint, replace backing.
7. Increase pressure slightly, make 3 round trips through press.
8. Remove backing, slightly dampen back of transfer paper.
9. Increase pressure slightly; 3 more round trips through press.
10. Damp transfer paper again; 3 more round trips through press.
11. Make corrections, additions, etc., on stone or plate.
12. Powder the transfer with rosin and talc.
13. Gum up with pure gum arabic or AGUM-O (stone only).
14. Let sit several hours or overnight.
15. Carefully wash off gum with damp sponge.
16. Roll up with Crayon Black until a strong image shows.
17. Powder with rosin and talc.
18. Etch *stone* with 10 drops nitric acid to 1 oz. gum arabic or AGUM-O. Use AGUM-Z or other suitable etch for a plate. Blot; wipe down; fan dry. Let sit in etch until next day.
19. Continue the processing—if a stone, from step 6 to end in *Resumé of Stone Processing*, above. If a plate, continue from step 4 to end of *Resumé of Plate Processing*, above.

Resumé of Inking Cycle

1. Roll out ink on ink slab.
2. Damp stone. Roll 3 to 5 passes over the drawing.
3. Damp stone. Roll ink roller on ink slab to pick up more ink.
4. Damp stone. Roll 3 to 5 passes over the drawing.
5. Damp stone. Roll ink roller on ink slab.
6. Damp stone. Roll 3 to 5 passes over the drawing.
7. Fan stone dry and print.

Resumé of Printing Cycle

1. Lay print paper face down on dry stone or plate, rub back lightly to adhere it to ink.
2. Place 2 blotters (or 4–6 sheets newsprint) on top of print paper.
3. Lay on the greased tympan (or hardboard roller pad).
4. Move press bed until leading edge of stone or plate is under scraper (roller).
5. Pull down side lever to apply pressure.
6. Turn motor on to *Forward* (crank by hand through the press).
7. Stop press when scraper (roller) reaches near trailing edge of stone (plate).
8. Release pressure, pull bed back to starting position.
9. Remove backing from stone.
10. Wet stone with sponge while in process of removing the print.
11. Examine the print.
12. Place print in dry-blotter bank, under plywood weight, to dry. Continue inking and printing until the edition is printed.

The Materials Used in Lithography

Chemicals and Processing Materials

Gum arabic, for etching and gumming up stones and plates.

AGUM-O, proprietary formula to replace gum arabic.

AGUM-Z, proprietary formula for etching plates.

Nitric acid, for etching stones and counter-etching zinc plates.

Phosphoric acid, for etching zinc and aluminum plates.

Chromic acid flakes, for etching zinc plates.

Potassium alum, for counter-etching zinc plates.

Oxalic acid, for counter-etching aluminum plates.

Lye (caustic soda), for erasing etched drawing on stone and zinc.

Sulphuric acid, for counter-etching and erasing etched drawing on aluminum.

Lith-O-Plate solutions, for processing and working paper plates.

Acetic acid, glacial, 28%, for counter-etching stone and aluminum.

Vinegar, white, distilled, 5% strength, for counter-etching stone.

Talc (French Chalk), for protecting drawing while etching.

Powdered rosin, for protecting drawing while etching.

Liquid asphaltum, for "fattening up" the printing image when washing out the drawing.

Solvents

Benzol, shellac thinner, lacquer thinner, lighter fluid, etc., for removing unetched drawing from stone or plate.

Kerosene (called paraffin in Britain), for cleaning ink slab, roller, ink knives, etc.

Turpentine, for washing out drawing, cleaning ink rollers.

Drawing Materials

Korn's litho pencils, Nos. 1, 2, 3, 4, 5.

Korn's litho crayons, Nos. 0, 1, 2, 3, 4, 5.

Korn's Liquid Lithographic Tusche (drawing ink).

Korn's Lithographic Stick Tusche.

Distilled water, tap water, mineral water, or solvents (which see) for vehicle.

Korn's Litho Rubbing Ink, Soft, Medium, Hard.

Colored wax crayons, wax base pencils, etc. (for experiment).

Red sable brushes, #0–6, for applying tusche.

Drawing pens and holders, for drawing with tusche.

Sanguine Conté crayons, for transferring tracing to stone or plate.

Scrapers, such as etching needle, knife, razor blade, etc.

Stones, Plates, and Related Materials

Lithographic stones, grey or yellow, in size desired.

Zinc and/or aluminum and paper plates.

Levigator (optional), for grinding large litho stones.

Silicon Carbide (Carborundum) grit: #60 (very coarse), #80, #100, #180, #220, #F, #FF, #FFF (very fine).

Scotch hones, $\frac{1}{8}''$ to $\frac{1}{4}''$ square, for cleaning and making corrections on stones and plates. $1''$ square for finishing edges of stones.

Snake slips, for making erasures on stones and plates.

Pumice, lump, for smoothing the edges of stones.

Pumice, powdered, for applying a slick surface to stones.

Rasp, $12''$, for rounding edges of stone.

File, mill bastard, $12''$, for smoothing edges of stone.

File card, for cleaning stone dust from files.

Processing Tools and Vessels

Eye dropper, for measuring acid into etch formulas.

Graduates, 2 oz. and 4 oz. with 8 oz. (optional).

Squeegees, 2, one for removing clean water from stones and plates, the other for removing excess *pure* gum from stones and plates. Keep them separate!

Rubberset brush, 3″, for brushing acid etch on stones and plates.

Rags.

Cellulose sponges.

Inking Materials

Crayon Black ink, Roll-up Black, Stone Black, etc.

Colored Inks, Brown, Burnt Umber, Burnt Sienna, Red, Green, Blue, Yellow, etc.

Ink slab, large, flat stone or sheet of $\frac{1}{4}$″ thick glass, 20″ × 24″.

Lithographic varnish, Nos. 00, 3, 5 and 7, for breaking in leather rollers and brayers and reducing inks that are too stiff.

Litho pattern hand ink roller, 12″ or 14″, for inking stones and plates. Made of leather, rubber, plastic, etc.

Brayers, smaller than rollers, for inking stones and plates, made of leather, rubber, composition, polyurethane (for paper plates).

Putty knife, flexible blade, for mixing ink.

Wall scraper, stiff blade, 3″ wide, for scraping ink slab.

Palette knife, for adding ink or litho varnish to mix.

Magnesia (magnesium carbonate), ink additive for stiffening ink that is too soft.

Paper Department

Newsprint, for use in processing, proofing, protecting, etc.

Rag paper, for printing (Rives Heavyweight, Rives BFK, Copperplate, etc.)

Blotters, white, 19″ × 24″, for use in printing and drying prints.

Paper trimmer (cutter) with 24″ blade.

42″ stainless steel straightedge, for cutting mats.

Stanley knife No. 09, with extra blades No. 910, for cutting mats.

Plastic sheet, 5-mil polyethylene, for use in damping paper.

Plastic wrapped pieces of plywood, for holding damp prints flat.

The Press and its Equipment

The box press described in Chapter 6, a scraper-type, lithographic proofing press,

or a combination scraper-and-top-roller press (or etching press for plates).

Wood scrapers, lengths as needed.

Scraper leather, to shoe the scrapers.

Press board, flashing aluminum, thin sheet zinc or brass for tympans.

Tympan grease, mutton tallow, lubricating (lube) grease, lard, etc., for greasing the tympan and scraper leather.

Two plastic buckets, 2-qt. capacity, for use in damping stones and plates.

Cellulose sponge, for damping stones and plates.

8″ electric fan, for quick drying of stone or plate in processing and printing.

Rock salt or beer, add to the damping water in warm weather to retard drying.

Lithographic Suppliers

United States

Andrews/Nelson/Whitehead
7 Laight Street
New York, N.Y. 10013
 lithographic papers, exclusive distributor for Barcham Green and other foreign manufacturers

Craftool, Inc.
1 Industrial Rd.
Wood-Ridge, N.J. 07072
 general lithographic supplies

Sam Flax, Inc.
25 E. 28th St.
New York, N.Y. 10016
 general lithographic supplies, inks, tusche, art and transfer papers, plates, lithographic presses, press repairs, rollers, box-wood scrapers

Graphic Chemical & Ink Co.
P.O. Box 27
Villa Park, Ill. 60181
 general lithographic supplies, inks, tusche, offset, art and transfer papers, plates, stones, lithographic presses, press repair, rollers, roller recovering, benelux and birch scrapers

Wm. Korn, Inc.
260 West St.
New York, N.Y. 10013
 tusche, litho pencils and crayons

Rembrandt Graphic Arts Co., Inc.
Stockton, N.J. 08559
 general lithographic supplies, AGUM-O, AGUM-Z

Sinclair & Valentine
14930 Marquardt Ave.
Santa Fe Springs, Calif. 90670
 general lithographic supplies, inks, tusche, plates

England

Howson-Algraphy Ltd.
Ring Road, Seacroft
Leeds, LS14 IND
 general lithographic supplies, tusche and plates

Hunter-Penrose-Littlejohn Ltd.
7 Spa Road
Bermondsey
London, S.E.16
 general lithographic supplies, inks, tusche, offset and transfer papers, plates, lithographic presses, press repair, rollers, roller recovering

INDEX